THE LAYOUT LOOK BOOK

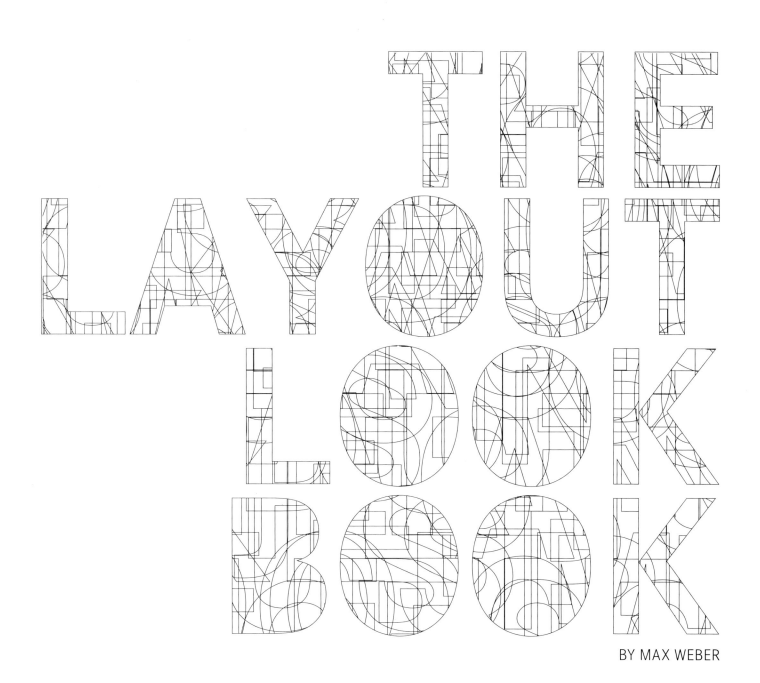

THE LAYOUT LOOK BOOK

BY MAX WEBER

COLLINS | DESIGN

An Imprint of HarperCollins*Publishers*

THE LAYOUT LOOK BOOK
Copyright © 2007 by COLLINS DESIGN and maomao Publications

First Edition published in 2007 by
Collins Design
An Imprint of HarperCollins*Publishers*
10 East 53rd Street
New York, NY 10022
Tel.: (212) 207-7000
Fax: (212) 207-7654
CollinsDesign@harpercollins.com
www.harpercollins.com

Distributed throughout the world by
HarperCollins*Publishers*
10 East 53rd Street
New York, NY 10022
Fax: (212) 207-7654

Packaged by
maomao Publications
c/ Tallers 22 bis, 3º 1ª
08001 Barcelona, Spain
Tel.: +34 934 815 722
Fax: +34 933 174 208

Editor & Designer
Max Weber

Texts
Sebastian Weber
Max Weber

Translation
Nadja Leonard

Editorial Coordinator
Catherine Collin

Library of Congress Control Number: 2006934671

ISBN-10: 0-06-114975-6
ISBN-13: 978-0-06-114975-7

Printed by

First Printing, 2007

The Layout Look Book //

The Layout Look Book offers a look at the panorama of current print design, scanning a wide range of different projects from China to New York, from the simple postcard to the campaign poster, from the emerging to the established artist. It is neither a lexicon nor an analysis, but provides a snapshot of this fast, multifaceted and highly present sector of the design industry.

The network within this industry is very close. Current trends are registered with seismographic precision on numerous Internet forums; creative people throughout the world communicate and cooperate via digital data paths. The bandwidth of Internet has increased to such an extent that even high-resolution graphics and extensive publications may reach the other side of the globe within a few seconds. Someone designing in Amsterdam knows what is going on in New York; someone writing a book in Malaysia knows the projects in Bern.

This exchange is not limited to virtual space; the personal network functions similarly. There is a cooperation among young highly creative designers, and one single name can be found on different projects and in different places. Projects like Rinzen RMX depend on this type of exchange. Publications like the *Made Magazine* and institutions like the Benetton Communication Research Center Fabrica in Italy encourage it. Inspiring examples like designer Uwe Loesch work as tutors with the aim of creating an active dialogue with young talent.

This international networking is facilitated by a unification of digital instruments, and this affects the entire business. Offices throughout the world tend to work with the same small range of high-performance software. Those programs are easy to operate and have done away with many technical obstacles designers had to deal with in the past. Graphic designers do not have to bother with traditional (i.e., paper) copies anymore but they deliver their layout drafts to printers digitally.

Technical barriers have been reduced extensively and therefore the number of people working with graphic design has grown. It is not only graphic artists who work in graphic design, but also architects, musicians and a variety of different artists and people who just want to give it a go.

Conversely, graphic designers also produce more than "just" graphic design. Many of them have incorporated Web design, animation, movies and events into their repertoire. The creation of hybrid forms is a logical consequence: the swift production of a book becomes an event. Mixed forms are developed: "bookazines" or books that include DVDs, posters or other design objects.

The same factors that make this creative diversity possible also abet the risks of an internationally design as well as artistic arbitrariness. If the same few software programs are used throughout the planet, then graphic designers are tempted to create their design along the same lines. Standardization of software risks the assimilation of aesthetics without individuality. Furthermore, if this software eventually automates many of the creative methods that previously required technical know-how, and can be used by anybody, specialization becomes redundant. Everybody knows everything, and somebody who knows everything is consequently tempted to do everything.

For that reason some of the most interesting works stand out due to the absence of digital performance. Sara De Bondt's newsletter for the British Council was created by crayon on paper, Stiletto's photographs are taken from handmade 3D-objects and Stefan Sagmeister printed on newspaper material with a hot iron. In other cases, top quality is obtained by concrete technical expertise even if projects are developed by digital means, as can be seen in the work of celebrated print specialist Michael C. Place, whose design style developed along with his experience in silkscreen printing.

Those projects of creative determination are *The Layout Look Book*'s actual eye-catchers. There was no objective rule for the selection of the various works. *The Layout Look Book* does not search for a specific style—and it has no restriction as to special formats or methods. It focuses instead on outstanding projects that rise above the mainstream of print design due to a refreshing character, conceptual elegance or sophistication.

However, flipping through the pages of the finished book, the selection does show a common ground: at the core of the works there is an unambiguous idea that is visualized appropriately and without vanity. The most convincing design is not the one that is obtained for the sake of designing but the one that is self-confident enough to fade from the spotlight. The creators of such works are distinguished by the efficiency of their visual language.

Despite the book's focus on the projects, it also offers information on the offices and individuals that designed them. In many cases the designers talk about themselves and answer questions regarding their work methods, roots, preferences and aversions.

Yet the most transparent message about the design is expressed by the works themselves, and the major space in this book is reserved for them.

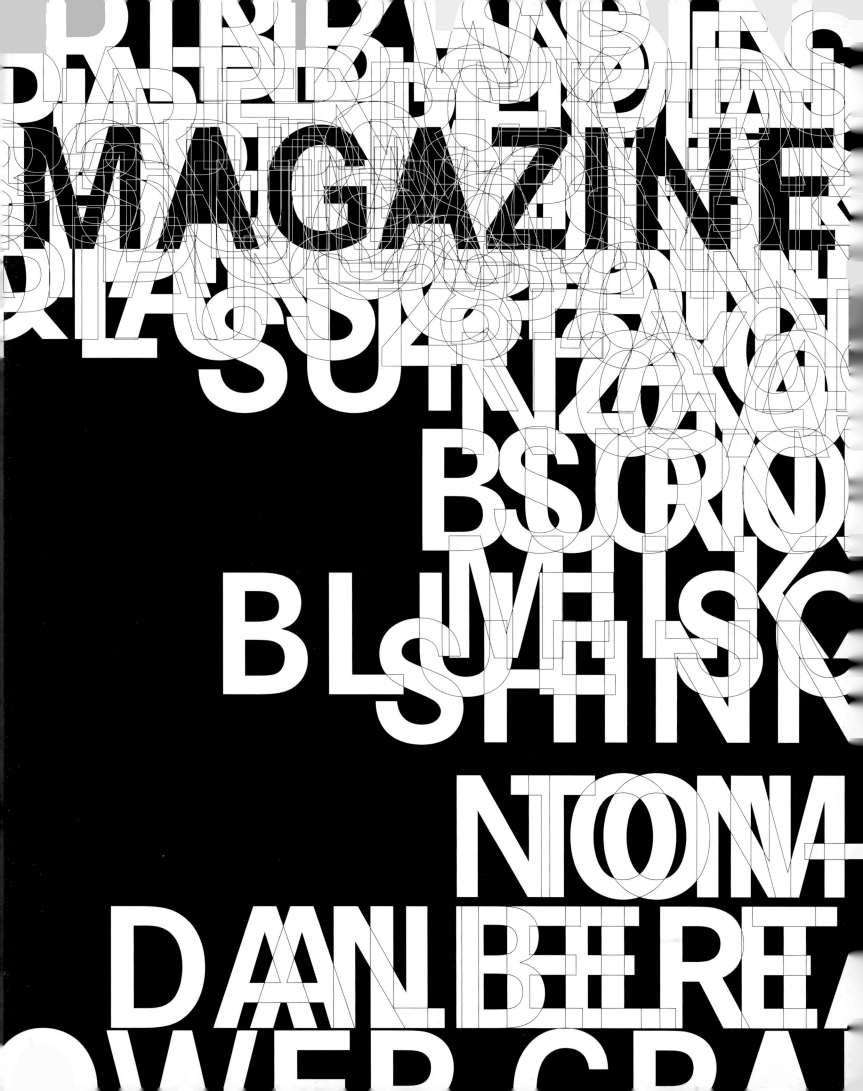

TRUTHS AND ONE LIE

VERITÀ E UNA BUGIA

FAB MAGAZINE / MAY-JUNE 2004

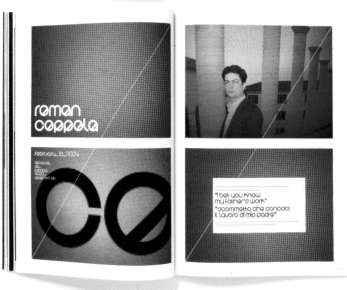

The Benetton Communication Research Center "Fabrica" in Italy is considered an international meeting place and talent incubator for promising artists in the areas of design, film, music and text. Fabrica's Department for Visual Communication has been publishing the quarterly magazine *FAB* since May 2004. The Chinese designer Javon Mo was responsible for the first three issues, as well as for the development of the logotypes. Today Javon Mo is head of the design firm Milkxhake in Hong Kong. The magazine is bilingual (Italian and English) and primarily features photos, short stories and interviews for a young target group.

FAB / JAN–FEB–MAR 2005

IDEALS IDEALI

BEWARE OF IDEALS.
THE BEST THEY CAN DO
IS TO BE JUST THE SAME
AS YOUR EXPECTATIONS./
DIFFIDATE DEGLI IDEALI.
IL MASSIMO CHE POSSONO
FARE È QUELLO DI
CORRISPONDERE ALLE
VOSTRE ASPETTATIVE.

Fabrica
is an ideal
place and,
like all
ideal
places,
it stops
being ideal
as soon as
it takes on
real forms.

Knowing this we
thought it would
be interesting to
try and talk about
some ideal concepts
like art, love, family,
heroes, and ideals.

Fabrica
è un luogo
ideale e,
come tutti
i luoghi
ideali,
smette
di essere
tale non
appena
prende
sembianze
reali.

Consapevoli
di questo,
ci è sembrato
interessante

starting from a
unique, sometimes
paradoxical point
of view.

We understood
then that there
is only one possible
road to take in
order to survive:
the disappearance of
all the destruction
of an ideal story.

provare a parlare
di alcuni concetti
ideali come l'arte,
l'amore, la famiglia,
gli eroi, gli ideali
raccontandoli a
partire da punti
di vista inediti,
a volte paradossali.

Abbiamo capito
allora che c'è solo
una strada da
prendere per
sopravvivere: alla
delusione deriva
dalla distruzione
di un ideale: quella
dell'ironia.

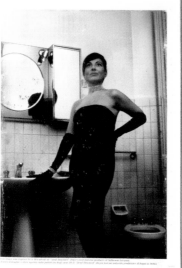

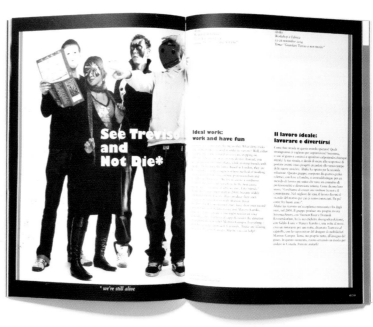

See Treviso
and
Not Die*

* we're still alive

Ideal work:
work and have fun

Il lavoro ideale:
lavorare e divertirsi

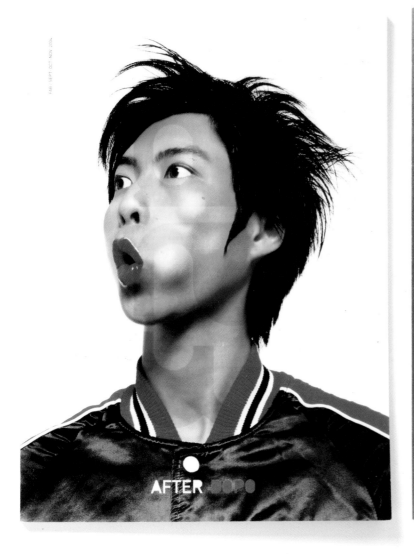

AND THEN, AFTER ALL, THERE WAS STILL SOMETHING ELSE WE WANTED TO SAY. / E POI, DOPO TUTTO, C'ERA QUALCOS'ALTRO CHE VOLEVAMO DIRE.

Milkxhake // Hong Kong, China // www.milkxhake.org //

Our motto is: "Mix it a better world." "Mix" has always been our culture, so our design is "Mix," too. Even though we are Chinese, we have grown up under strong influences from both Eastern and Western culture. We don't care too much about East and West, because sometimes we are neither. To us, it is interesting ideas that make good design. Inspiration can be found anywhere. Our working environment looks like chaos—lots of design books and magazines on our desks. If a student asked for advice, we would say: Be true to yourself and your works. Keep thinking, dreaming and mixing.

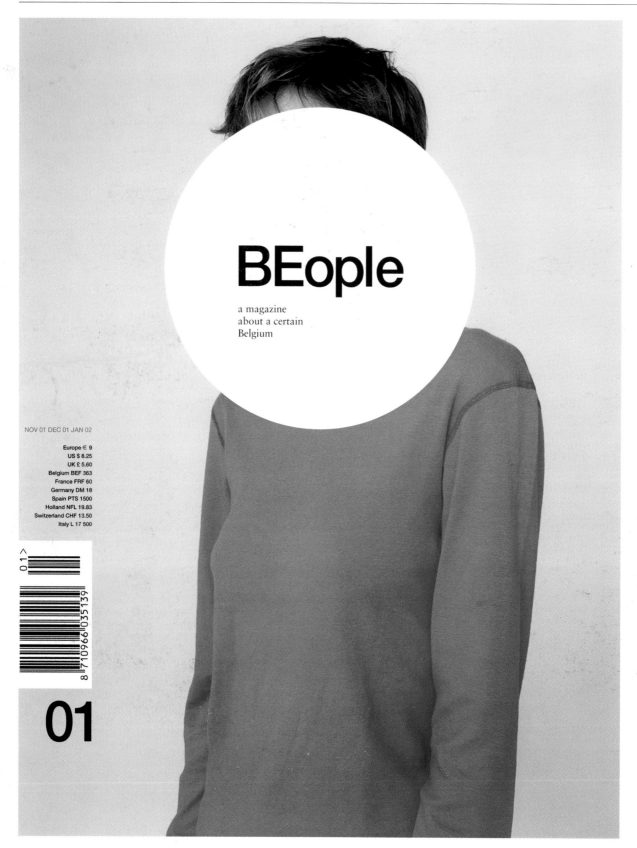

BEople

a magazine
about a certain
Belgium

NOV 01 DEC 01 JAN 02

Europe € 9
US $ 8.25
UK £ 5.60
Belgium BEF 363
France FRF 60
Germany DM 18
Spain PTS 1500
Holland NFL 19.83
Switzerland CHF 13.50
Italy L 17 500

01 >

8 710966 035139

01

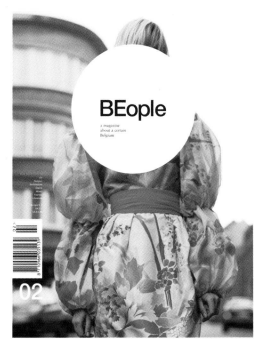

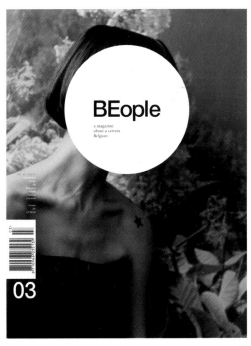

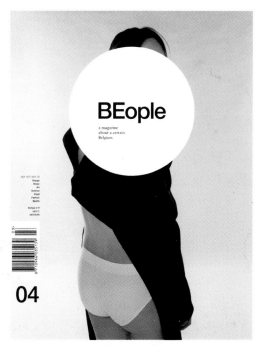

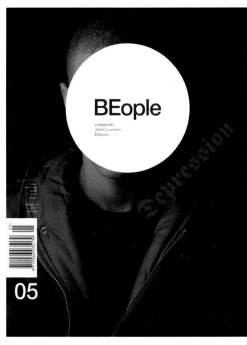

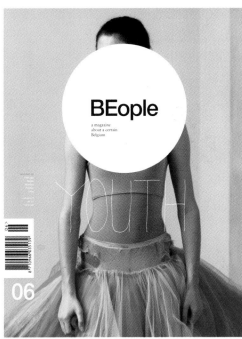

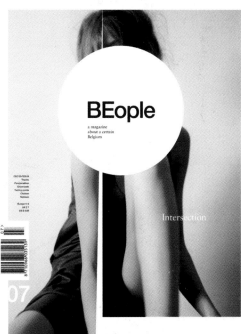

BEople magazine //

The title of the magazine *BEople* published by the Brussels-based design firm Base is a shortening of "Belgian People," thereby immediately providing reference to the focus of the contents of the quarterly publication: a view of remarkable Belgian personalities within all creative fields such as design, music, art, science, fashion and sports. Aside from its editorial quality, the *BEople* magazine sets itself apart from the mass of competing lifestyle magazines by means of various design peculiarities. For example, a white circle, which always conceals the face of the title model, immediately brings attention to the title of the publication.

 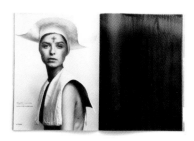

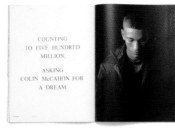

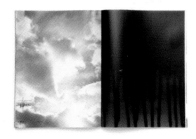 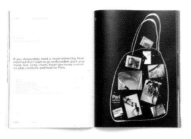 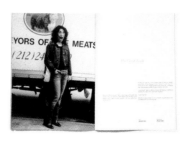 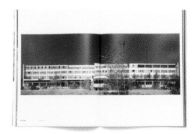

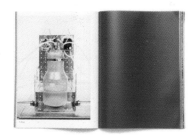 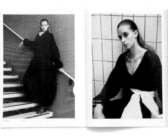 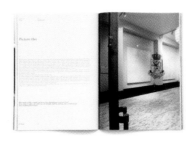

Base // Brussels, Belgium // New York, United States // Barcelona, Spain // Madrid, Spain // Paris, France // www.basedesign.com //

Base is a large design company with approximately thirty-five employees and offices in Brussels, New York, Barcelona, Madrid and Paris. It was created in Brussels in 1993 and has specialized in creative direction and brand development. In 2004, Base expanded by adding its own text department, BaseWORDS. In 2005, the film and motion graphics department, BaseMOTION, as well as BaseLAB were added, in which custom-made fonts are developed. With all of these competencies, there is actually nothing that Base does not do: from logos and font design to animations and film, to complex brand designs and advertising campaigns for international companies. Beyond this, Base carries out its own projects, such as publishing *BEople* magazine or a prize-winning book about the fashion photographer Serge Leblon.

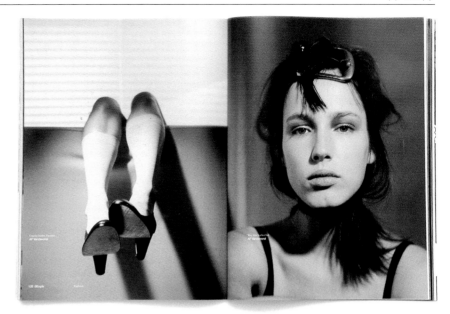

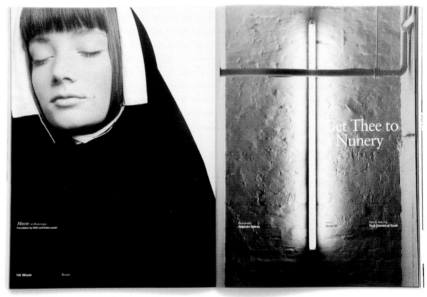

Get Thee to a Nunery

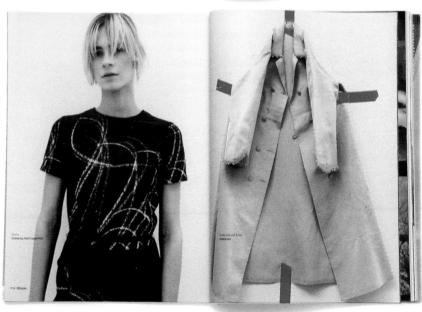

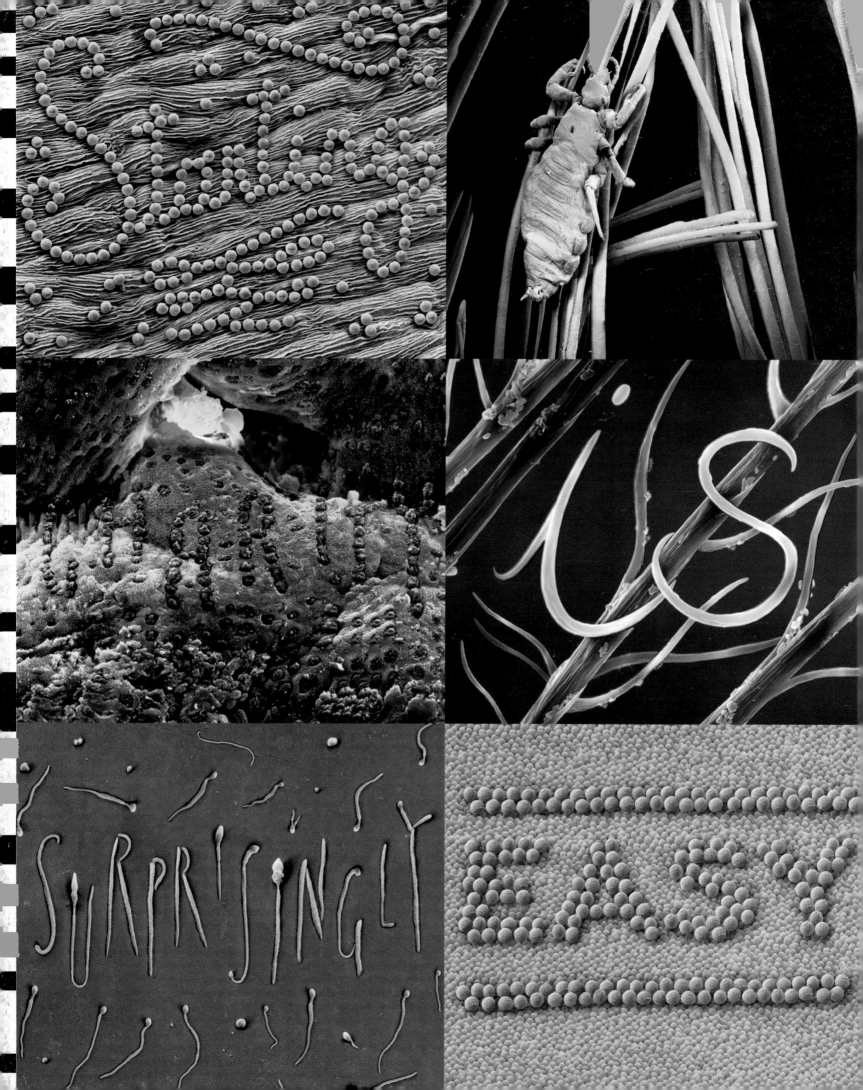

.copy // 2005 //

The magazine *.copy* of the Austrian telecommunications company Telekom Austria, organizes its content into six areas called "labs," which it separates in the publication by means of specially designed double pages. These "lab portals" are devoted to art and are commissioned, every month, from a different internationally renowned artist. Also, the New York-based graphic designer Stefan Sagmeister has already designed several such lab portals. In the example shown, the publication's double pages build upon the phrase: "Starting/a/charity/is/surprisingly/easy."

Sagmeister Inc. // Stefan Sagmeister // New York, United States // www.sagmeister.com //

Sagmeister Inc. is a small design firm in New York that—contrary to many of its competitors—wants to remain small. The founder, designer Stefan Sagmeister, often honored for his distinguished work, sees the opportunity to select his own clients and to work with great dedication on each project. Sagmeister was born in Austria in 1962, studied in Vienna and New York, and worked for Leo Burnett in Hong Kong and later for design icon Tibor Kalman before opening his own firm in 1993. His work for bands like the Rolling Stones, Aerosmith, Lou Reed, Pat Metheny and others has been honored with all the major international design prizes and has earned four Grammy nominations. Despite tremendous success, in the year 2000, Sagmeister granted himself a full year without customers in order to have time to experiment and produce his own book. After this time-out, he wants more attention to be paid to the social responsibility of design work, by working, for example, for companies who commit themselves socially. Sagmeister's strengths are strong, dedicated, often humorous and surprising ideas that are clearly based on strong concepts.

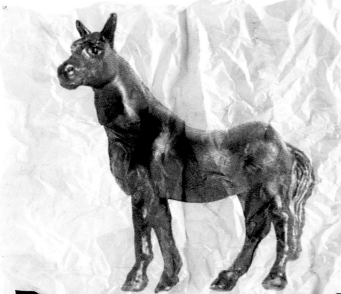

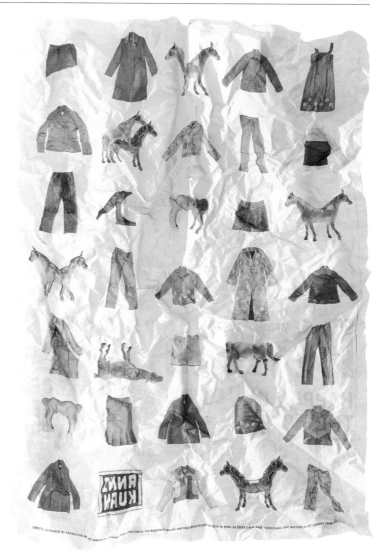

ANNI KUAN

HAPPILY INVITES YOU IN THIS YEAR OF THE HORSE TO THE FASHION COTERIE TO PREVIEW THE FALL AND WINTER 2002 COLLECTION FROM SUNDAY, FEB 24 2002 TO TUESDAY, FEB 26 2002, PIER 92, BOOTH #1638, NEW YORK CITY

REPRESENTED BY

CYNTHIA OCONNOR & COMPANY
141 WEST 36TH STREET, SUITE 12A
NEW YORK CITY, NY 10018
TEL 212·594 4999 FAX 212·594 0770

ANNI KUAN STUDIO
242 WEST 38TH STREET
11TH FLOOR
NEW YORK CITY, NY 10018
TEL 212·704 4038
FAX 212·704 0651

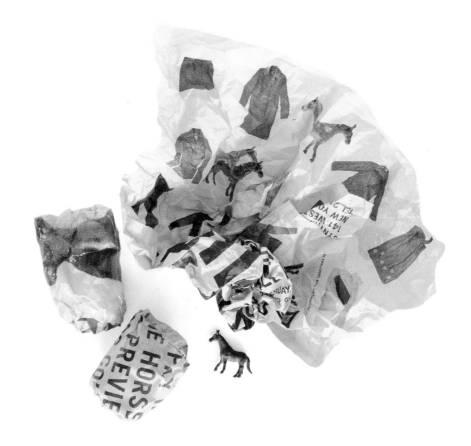

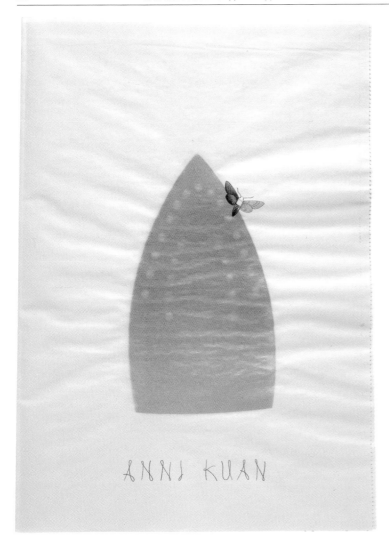

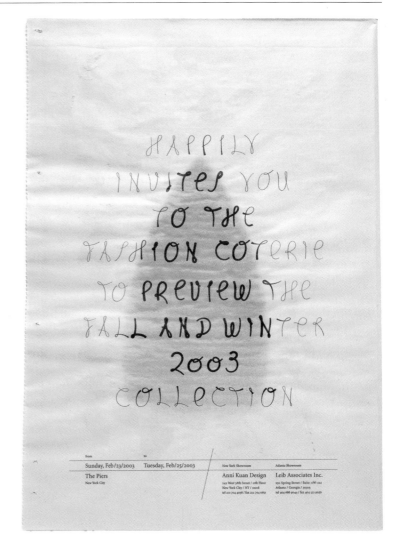

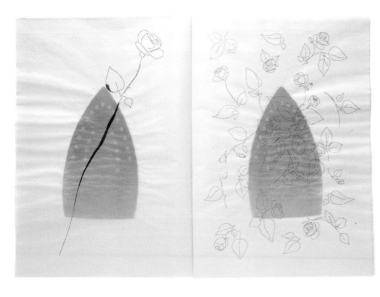

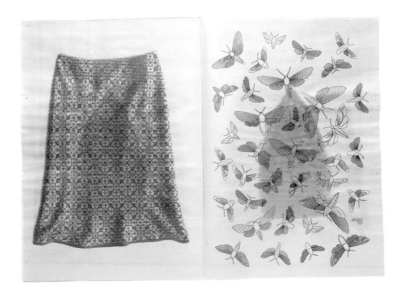

Anni Kuan // 2002 // 2003 //

The first advertising brochure for the New York-based fashion designer Anni Kuan had to be realized with a budget that was hardly enough to print postcards. The graphic design firm Sagmeister Inc. solved the challenge by printing at a cost-effective newspaper printer and then having a student fold each issue for 12¢ on a hanger and packing each copy in plastic film like dry cleaning. In the following projects for Anni Kuan, Sagmeister Inc. remained true to the adopted path: to show the collection in the Year of the Horse. Small plastic horses were wrapped in sheets of newspaper, upon which the invitation and collection pattern were printed. For the 2003 winter catalog, Sagmeister Inc. developed a cost-effective print method: using irons, they burned an unmistakable impression directly through the sixteen pages of newspaper of the catalog.

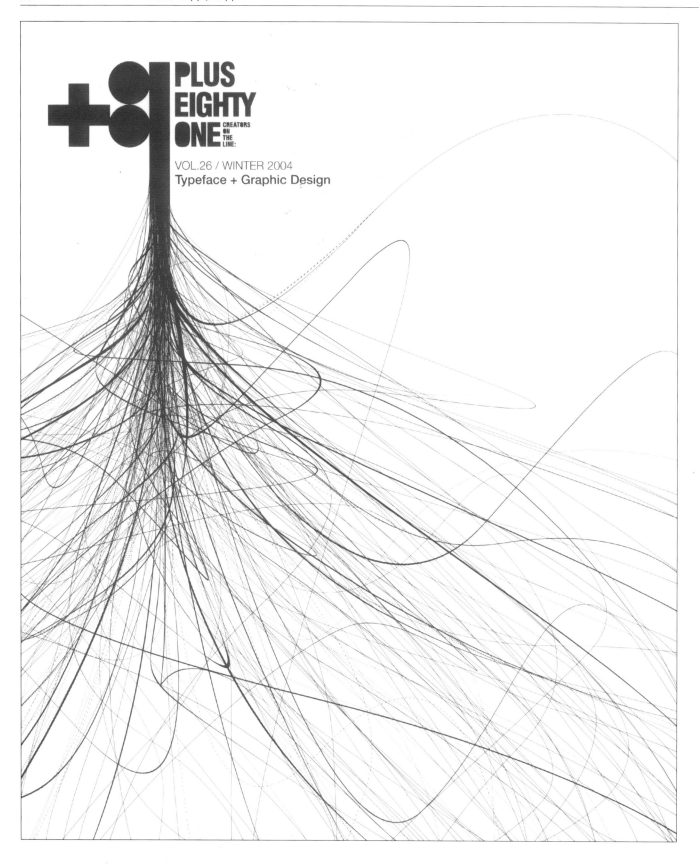

PLUS EIGHTY ONE CREATORS ON THE LINE:

VOL.26 / WINTER 2004
Typeface + Graphic Design

Plus Eighty One //

The design magazine *+81* is named after the international telephone code for Japan and thereby refers to its origin, Tokyo. The quarterly publication presents internationally renowned designers and artists in interviews and portfolios. A declared goal of the publisher, Satoru Yamashita, is to document important creative types and their work for the future. A new addition to the portfolio of *+81* magazine is the *+81*

E-code booklets, which place a special emphasis on ecological topics in connection with design. Satoru Yamashita also commits himself editorially to environmentally conscious production techniques in the various areas of visual communication. *+81* magazine is published in English and Japanese.

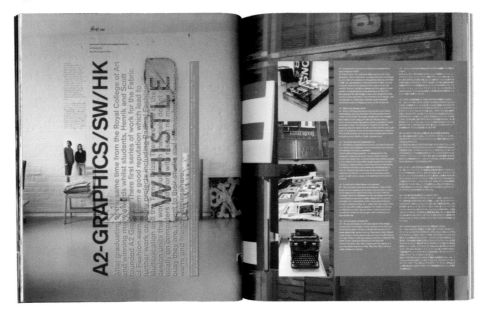

+81 PLUS EIGHTY ONE CREATORS ON THE LINE:

VOL.32 / SUMMER 2006
Graphics the World Over

Plus 81 **magazine** // Satoru Yamashita // Tokyo, Japan // www.plus81.com //

"I think, for young graphic designers, it is good to see and feel as much quality work as possible. From past to present. One of my own early influences is Makoto Saito's work [Reknown graphic designer from Tokyo, whose posters are included in the permanent collections of top museums worldwide, such as the MoMA New York, San Francisco Museum of Modern Art and many others].

"Good print design is agreeable and beautiful as well as fresh and provocative. What inspires me? Artwork and nature. My working environment looks like a ship's cabin. I believe, if you can't make things move forward in one week, you will not be able to do it forever."

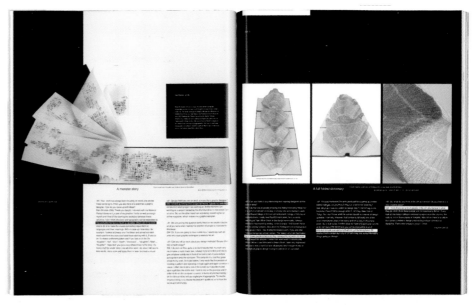

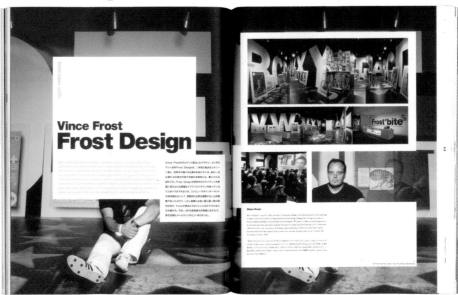

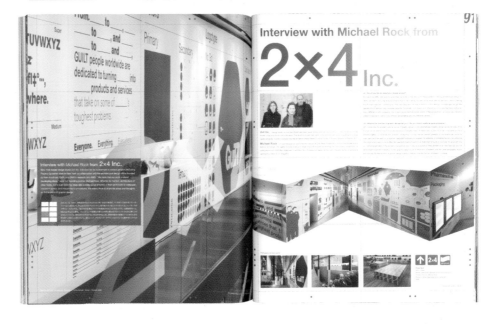

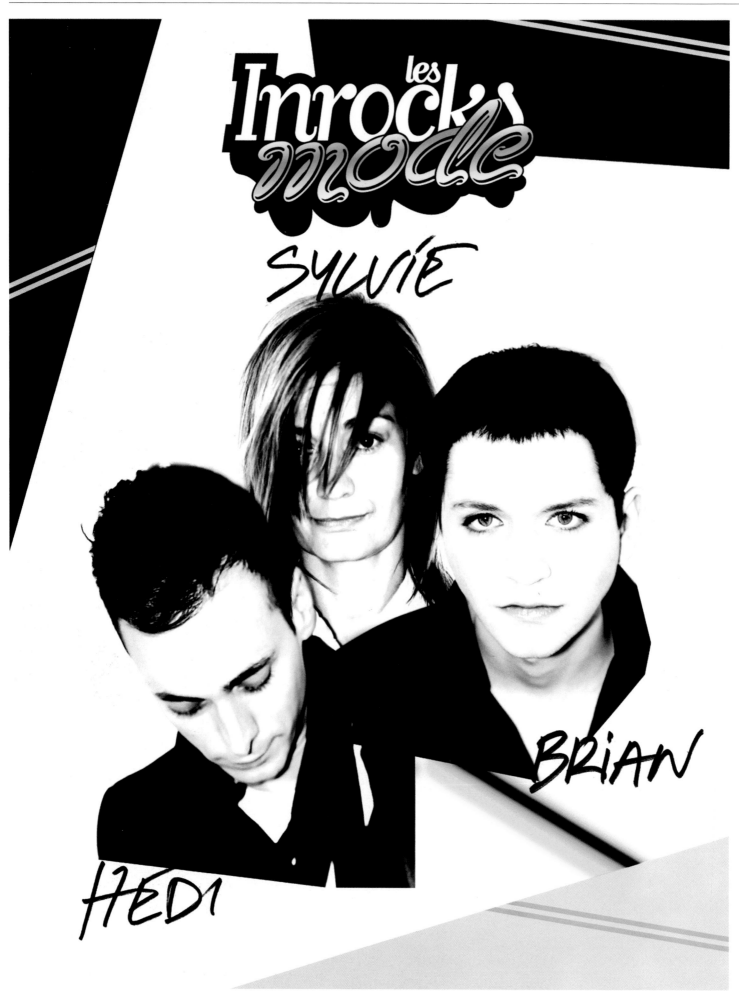

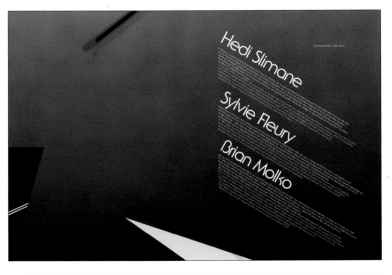

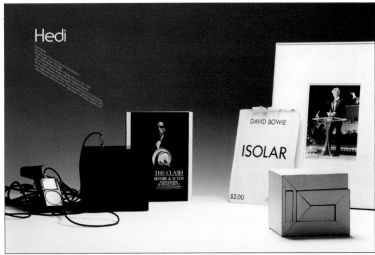

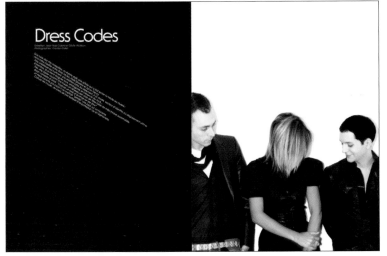

Inrocks Mode //

In a sixteen-page supplement to the French culture magazine, *Inrocks Mode*, the Paris-based designer Laurent Fetis showcased a selection of international fashion designers, artists and musicians, whose artistic work refers to the world of haute couture and thereby offers an unconventional view on the high-gloss world of ready-to-wear.

Laurent Fetis // Paris, France // www.laurentfetis.com //

Laurent Fetis was born in 1970, studied at the College of Architecture in Versailles and the National College of Decorative Arts in Paris and opened his own design studio in 1999. His versatile operating field as a designer reaches from print media for musicians and artists to campaigns for international companies, to film titles for Roman Coppola. Renowned galleries and museums from Paris to Tokyo show his work, and a book about his work was published under the title *ABC+* by Die Gestalten Verlag publishers in Germany.

"My work is very intuitive. I am not interested in style or trends. Instead, I work with ideas. Each work I do is rooted in a strong idea of the project. What inspires me? Life."

NEO2

CREATIVE GE**NEO**RATION Marzo 2006 3€ (Spain)

España: 3€
Portugal: 4€
France: 6€
England: 4£
Italy: 4,13€
Holland: 6,27€
Austria: 5,15€
USA: 7$
Switzerland: 10Fs
Morocco: 60Mad
Canada: 10,25$Can

51

JOE COLOMBO
PETER SAVILLE
SPIKE LEE
ASCII DISKO
BRET EASTON ELLIS
VIAJAR POR ESPAÑA
ARTE CHINO
MULTICOLOR

**51
MODA ✕ NEO
COLECCIONES**

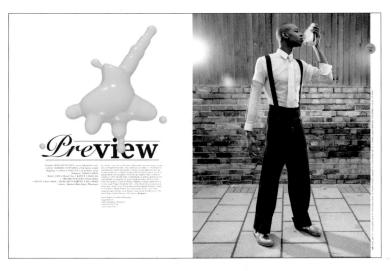

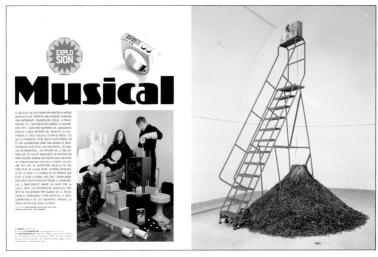

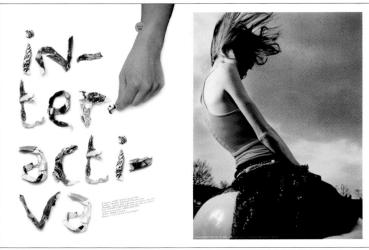

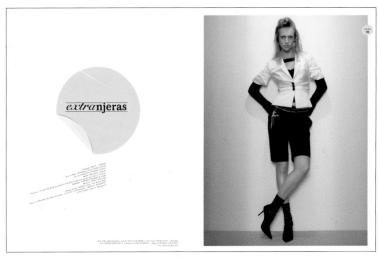

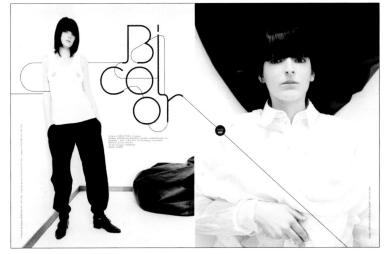

Neo2 //

Ramon Fano, Javier Abio and Ruben Manrique of the Spanish design firm Ipsum Planet are the publishers and graphic designers of their own magazine, *Neo2*, which they developed slowly but surely over the past thirteen years from a small trend magazine to international popularity. The first issue in 1993–at the time still under the title *Neomania*–was a two-color, 64-page think fanzine. Today *Neo2* is a bilingual circulation of 60,000 issues with international distribution. It is one of Spain's most important trend magazines. The focus of the contents is in the areas of design, architecture, music and art.

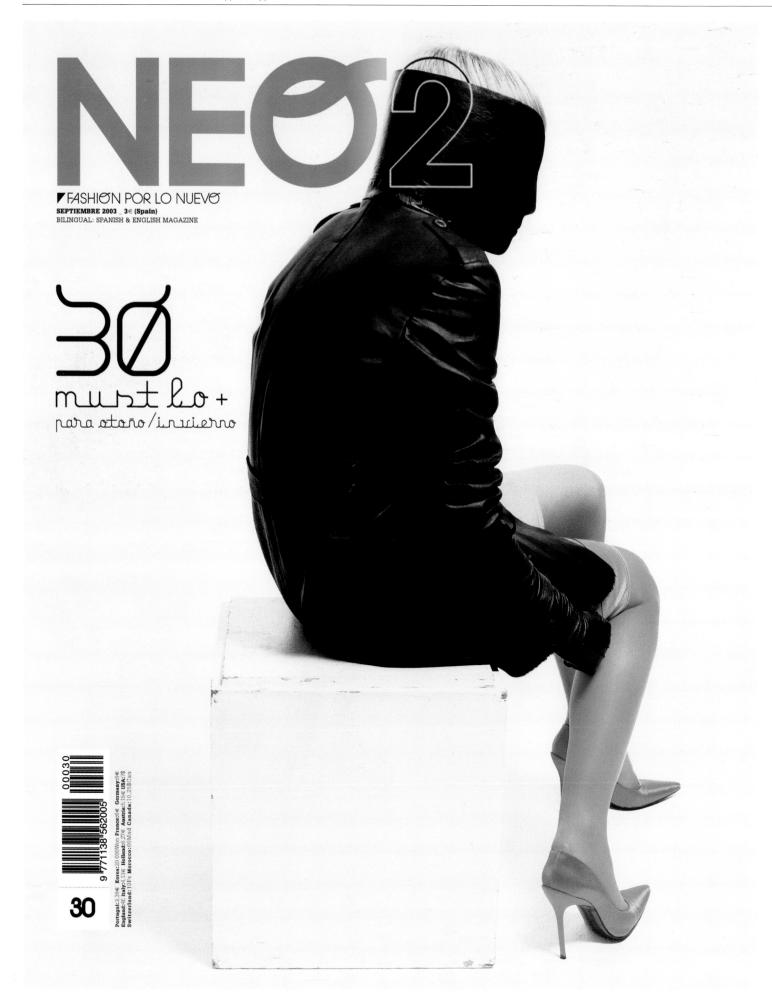

NEO2

▰ FASHION POR LO NUEVO

SEPTIEMBRE 2003 _ 3€ **(Spain)**
BILINGUAL: SPANISH & ENGLISH MAGAZINE

30

must lo +
para otoño/invierno

00030

9 771138 562005

Portugal:3.3€ **Korea:**20.000Won **Francesa:**8€ **Germany:**8€
England:4£ **Italy:**4.13€ **Holland:**6.27€ **Austria:**5.15€ **USA:**7$
Switzerland:10Fs **Morocco:**60Mad **Canada:**10.25$Can

30

COLABORADOR DEL MES / LEWIS

ADNEO

VELVETBANANA

YO, SI FUERA DISEÑADOR, HARÍA CAMISETAS. COMO GARY FERNÁNDEZ. BUSCARÍA UN BUEN CONCEPTO, Y HARÍA CAMISETAS. COMO GARY FERNÁNDEZ. LUEGO CREARÍA UNA BUENA IMAGEN DE MARCA, CON FOTOS CHULAS. COMO GARY FERNÁNDEZ

El concepto de las camisetas VelvetBanana es la música pop-rock: diseños que pretenden reflejar la energía y vitalidad de los conciertos de las bandas favoritas de los fundadores de esta nueva firma de camisetas, Gary Fernández y Nina Zieling. Gary se ocupa más de la parte creativa, y Nina de los negocios. El nombre de la marca supongo que es cosa de Gary: un homenaje a la Velvet Underground, y su primer álbum, Banana. La primera colección de VelvetBanana ya está en la calle. Una pequeña localidad americana próxima a Detroit, Ann Arbor, sirvió de decorado e inspiración para su creación durante el verano 05. Precisamente donde nació Iggy Pop. De hecho esta primera colección es un homenaje a esta leyenda del pop-rock. Por supuesto, la colección tiene banda sonora: Iggy Pop & The Stooges, Interpol, The White Stripes, The Strokes, Bloc Party, Kasabian, Yeah Yeah Yeahs, The Dirtbombs, Blood Brothers, Starling Electrics, Air, Kills, Kings of Leon y Black Rebel Motorcycle Club. Pues eso, me parece muy bien que hagan camisetas. Al fin y al cabo es lo que nos ponemos, para todo, para estudiar, para currar y para bailar. <www.velvetbanana.net> Texto: Mongólmeri · Fotógrafo: Bruno Ochaita · Modelos: Alexandra Tarsstorre + Mariana Resende + Elena Martínez + Nina Zieling

Ipsum Planet // Madrid, Spain // www.neo2.es //

Ipsum Planet was founded in 1994 by Ramón Fano, Javier Abio and Rubén Manrique. Its early work was related to record companies and electronic music clubs. Nowadays, its work is mostly linked to the world of fashion and art.

What we consider quality in print design? A good idea applied in a coherent way to meet the needs of a client or a product. Good investigation. Freshness. Good print.

A motto? Javier Abio: "Search for the balance between works that give you the money to live and others that give you the opportunity to create interesting things." Ruben Manrique: "Do your best. If it doesn't become the best, at least you have tried." Ramon Fano: "Have fun!"

What advice would we give to students of graphic design? Ramon Fano: "Enjoy working." Ruben Manrique: "Take good notes of what the teachers say and do whatever you want." Javier Abio: "Travel, cook, consume all the visual things around you, get out of the 2D and create something in 3D."

Five things we are crazy about?

Ramon: "flirt / my partner / neo2 / my fotolog / my friends"

Javier Abio: "plants / magazines / food / design / Internet"

Ruben Manrique: "my children / nature / mountainbike / fun parties / a good wine"

SLEAZENATION

Inside Vice City

The exclusive story, gossip and secrets behind the new Grand Theft Auto

UK Bass

Miami to Milton Keynes: In booty we trust

Urban warfare

Takin' it to the streets

THE HEAT IS ON

Corey Feldman
Zippy & George
Erlend Øye
Yohji Yamamoto
Bobby Conn

JAN/FEB 2003 £3.95 MADE IN THE UK

01

771460 473062

Crack Village
The Majesticons
Chiwete Ejiofor
Ray Johnson
Readers Wifes

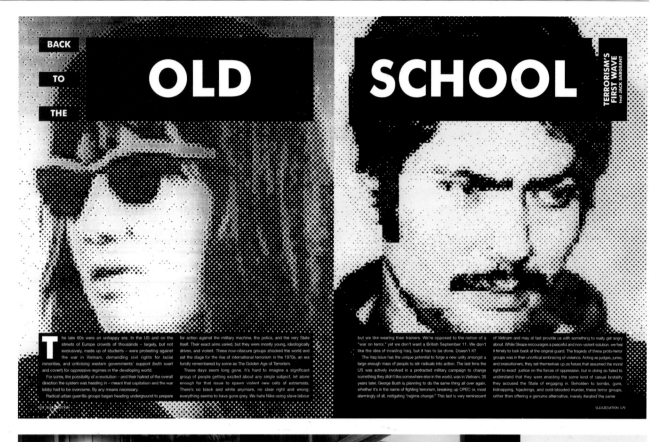

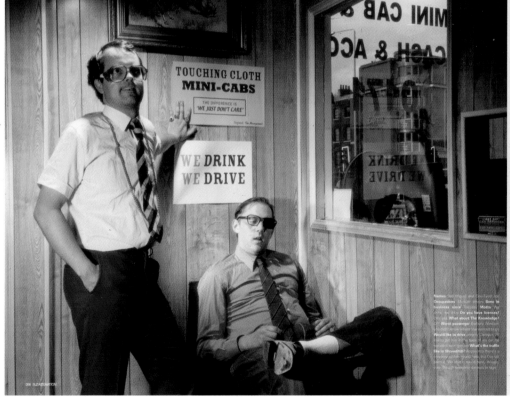

Sleazenation was a monthly London-based lifestyle magazine whose slogan – "An ideal for living through fashion, art, music and design" – refers not only to the emphasis of the content but also the ironic humor of the magazine. London-based designer Patrick Duffy worked for *Sleazenation* for three years and contributed substantially to the look and success of the magazine. First as a newcomer under the artistic direction of Scott King, who worked on the redesign of the image, Duffy later became Art Director himself, until leaving the magazine in 2003 to devote time to other projects.

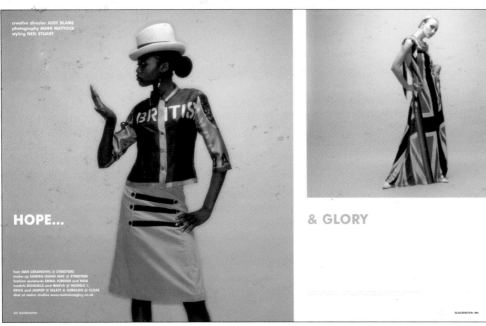

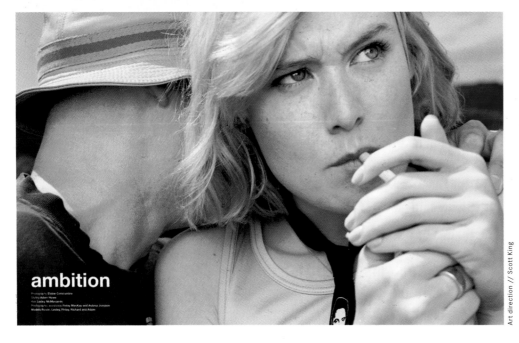

SLEAZENATION

Inside Vice City

The exclusive story, gossip and secrets behind the new Grand Theft Auto

UK Bass

Miami to Milton Keynes: In booty we trust

Urban warfare

Takin' it to the streets

THE HEAT IS ON

Corey Feldman
Zippy & George
Erlend Øye
Yohji Yamamoto
Bobby Conn

JAN/FEB 2003 £3.95 MADE IN THE UK

01

7 771460 473062

Crack Village
The Majesticons
Chiwete Ejiofor
Ray Johnson
Readers Wifes

FUSED MAGAZINE

ISSUE 24

MUSIC, FUNCTION, FASHION
LIFESTYLE, DESIGN, ART, CULTURE

HTTP://WWW.FUSEDMAGAZINE.COM
HTTP://WWW.FUSEDMAGAZINE.COM/STORE

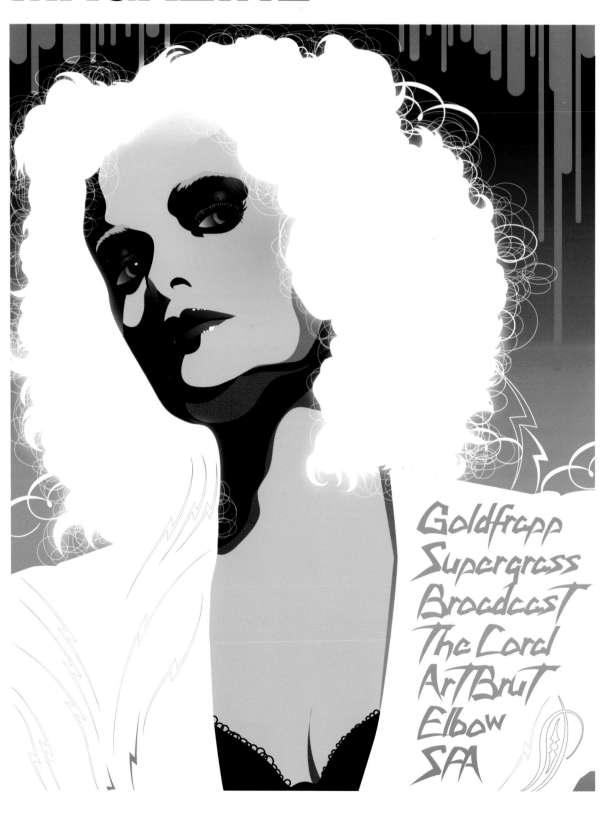

Goldfrapp
Supergrass
Broadcast
The Coral
Art Brut
Elbow
SFA

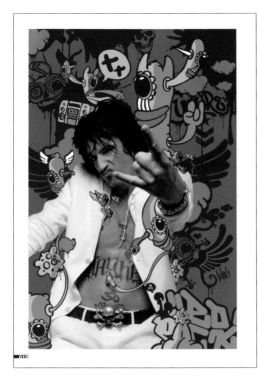

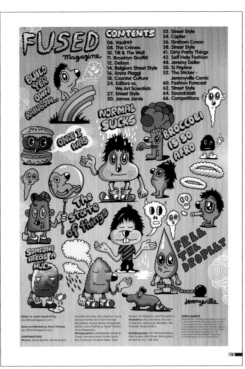

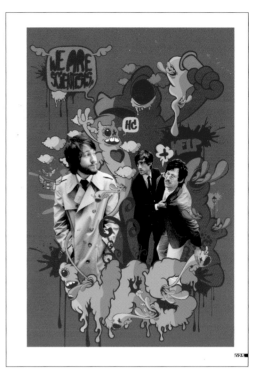

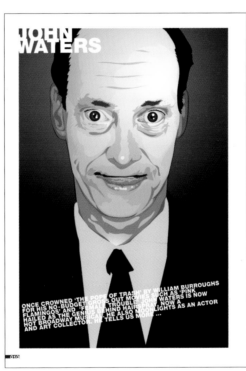

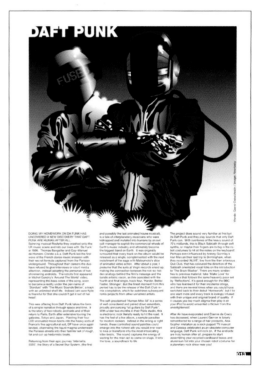

Fused Magazine is a complimentary regional culture and lifestyle magazine from Birmingham, UK, with music, art, fashion and culture as the emphasis of its contents. It was created in the year 2000 by the former art student David O'Coy with the objective of creating a trend magazine that, despite its complimentary distribution, would fulfill high claims of quality in terms of contents and design. Because of this, *Fused Magazine*, unlike many other complimentary magazines, was designed with great attention to detail and on high-quality paper in good print quality. For the illustrations, acclaimed international graphic designers were selected as partners. A brand symbol of the magazine is the renunciation of photos in the cover design: *Fused Magazine* uses only illustrations for its covers, which clearly differentiates it from all competing products. These illustrations have become so beloved that they are pirated on posters, flyers and T-shirts—and, in an unconfirmed report by David O'Coy, even on Brad Pitt's office wall.

FUSED MAGAZINE

ISSUE 26

MUSIC, FUNCTION, FASHION
LIFESTYLE, DESIGN, ART, CULTURE

HTTP://WWW.FUSEDMAGAZINE.COM
HTTP://WWW.FUSEDMAGAZINE.COM/STORE

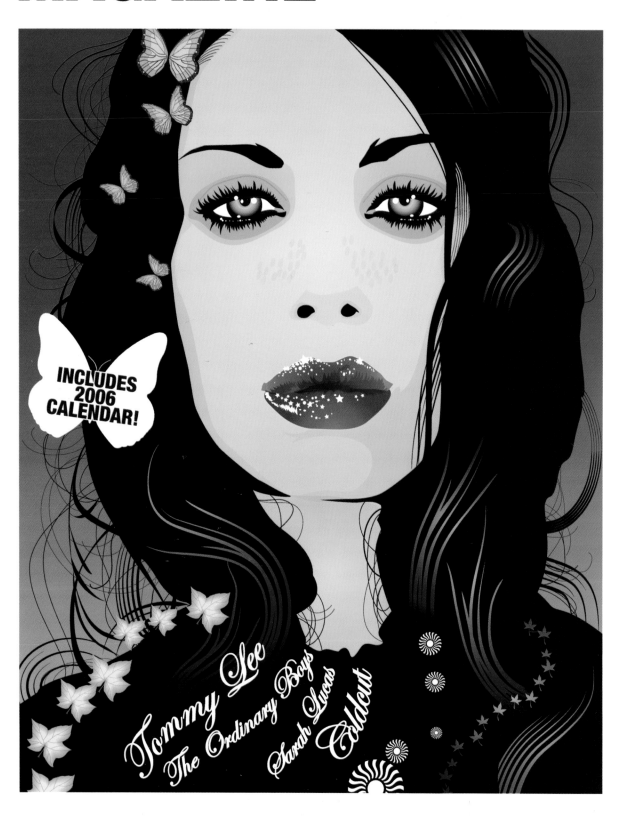

INCLUDES 2006 CALENDAR!

Tommy Lee
The Ordinary Boys
Sarah Lucas
Coldcut

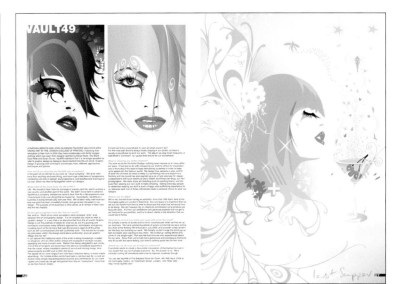

Fused Magazine // Birmingham, United Kingdom // www.fusedmagazine.com //

"My early influences? I studied fine art and was massively influenced by Warhol, Larry Rivers and the pop artists. Also Malcolm McLaren's theory that everything should be made up of the 3 S's: Sex, Style and Subversion. Add in a bit of John Waters and early eighties electro pop and away we go! At the moment you ask, I have a mountain of music CDs on my desktop, a packet of 'erotic' playing cards and a signed photo of Bob Grant (RIP) from On the Buses. We work within a 'creative' office complex called the Greenhouse and are surrounded by like-minded people and creative businesses. The fused HQ has blown up images of past covers and illustrations produced by Newtasty all over the walls. There are hundreds of design and art books, mountains of CDs and lovely Apple computers of varying shades on every desk.Good design is stylish design. Nothing too fussy or messy. Too many people are afraid of white space. We love it! My list of Top-5s changes by the minute, but at 3:34 on 28/4/06 they are:Copter (www.coptercentral.com) / Jeremyville (www.jeremyville.com) / Nick Cave / Charles Bukowski / Primal Scream."

Kitten catalog // 2001 //

The relaxed streetwear look of the Australian fashion label Kitten, founded in 1999, is characterized by the distinguished style of the illustrations that Kitten prints on its T-shirts. Some of these illustrations come from the design firm Rinzen, which also created the catalog for the summer 2001 collection. In this catalog, Rinzen blurs the lines between illustration and photography, thereby advancing the look of fashion so that the catalog not only represents the clothing but becomes a fashion object in and of itself.

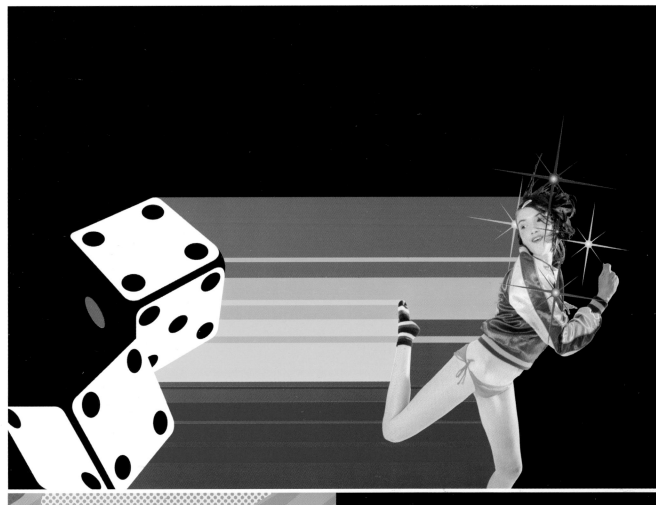

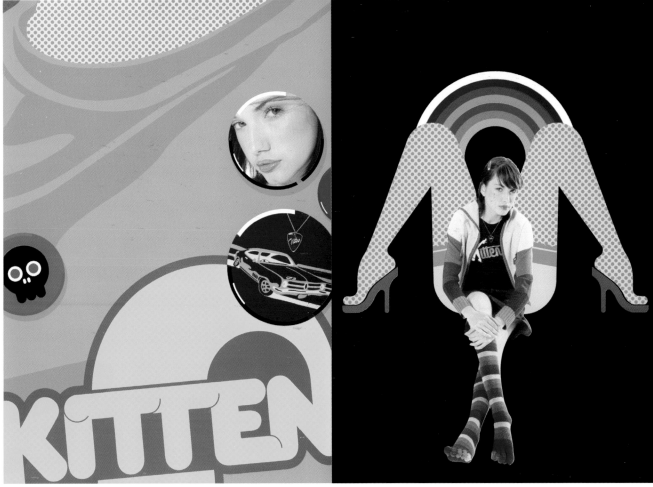

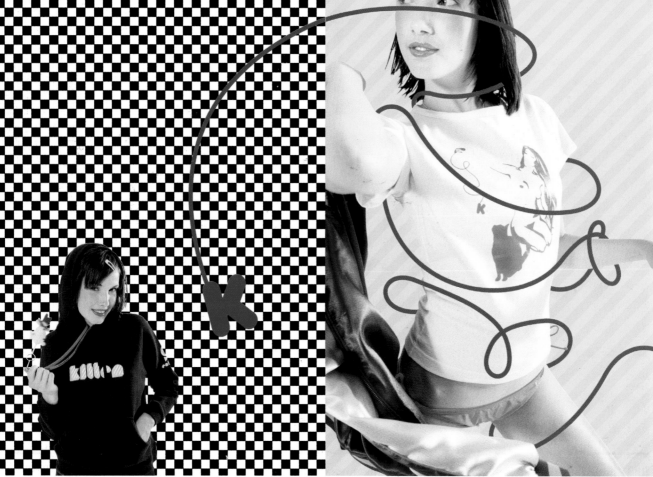

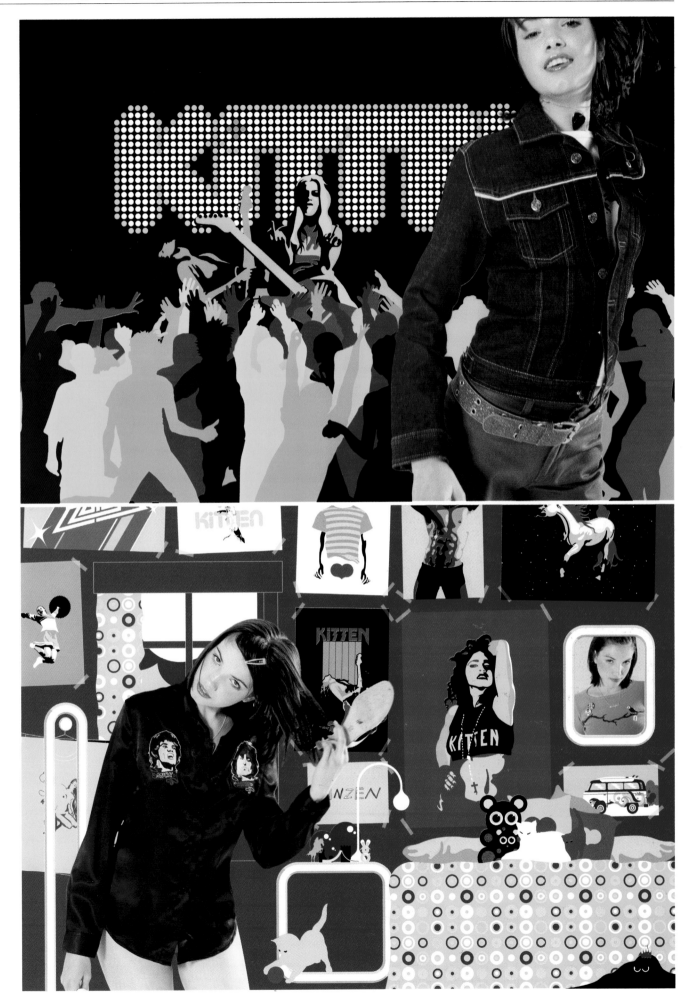

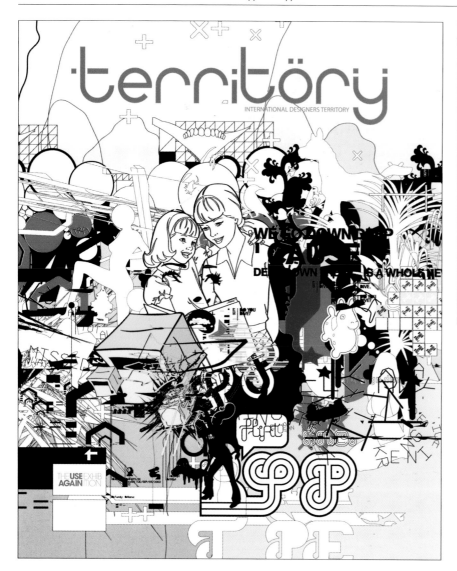

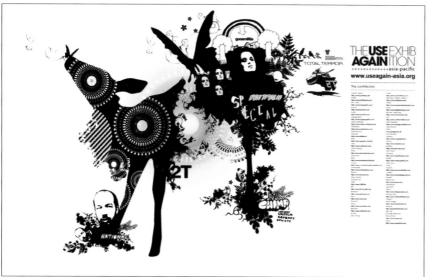

Territory //

The Malaysian design group Bigbrosworkshop (BBWS) is behind the *Territory* design bookazine. They created their multimedia magazine as a playing field for hand-picked designers from all over the world. New talents from Malaysia are granted exactly as much attention as established designers. Each issue is dedicated to its own topic and grants the featured designers as much freedom as possible. Within a few editions, the *Territory* design bookazine developed from a local secret to a global cult object. Today it stands as the first internationally ranked Malaysian design magazine.

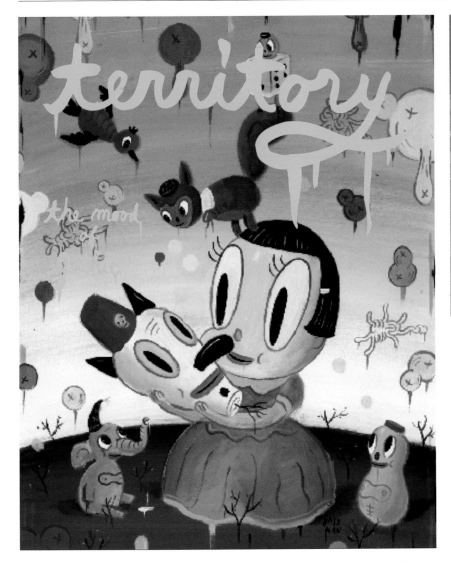

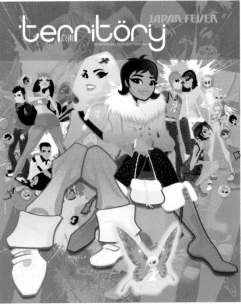

Bigbrosworkshop // Kuala Lumpur, Malaysia // New Zealand // www.bigbrosworkshop.com //

I believe play creates the perfect environment for creativity. At BBWS having fun while working is a normal trait.

My office looks like a storeroom more than a proper design house. It's more like an underground base factory. I have many toys that I've collected through the years and I place them all over my desktop and elsewhere. I also have stickers, papers, pens, vitamin pills, books, cigarettes and files.

During my early years, I was greatly influenced by the local design community and the working culture here which was, sad to say, somewhat slow and lacking in confidence.

This compelled me to experiment and venture into new ideas and concepts. A good print design is a design that can instill confidence in people.

The worst kind of nightmare I can face usually happens when I'm handling a design conference. It's a lot of pressure. And I find it a great challenge to be put in a situation when I have to handle tasks that are usually done by five people.

Five things I'm crazy about? I love people with crazy thoughts and ideas. / I'm crazy about extreme park rides / crazy about toys and designer products / crazy about food / crazy about developing designer products!

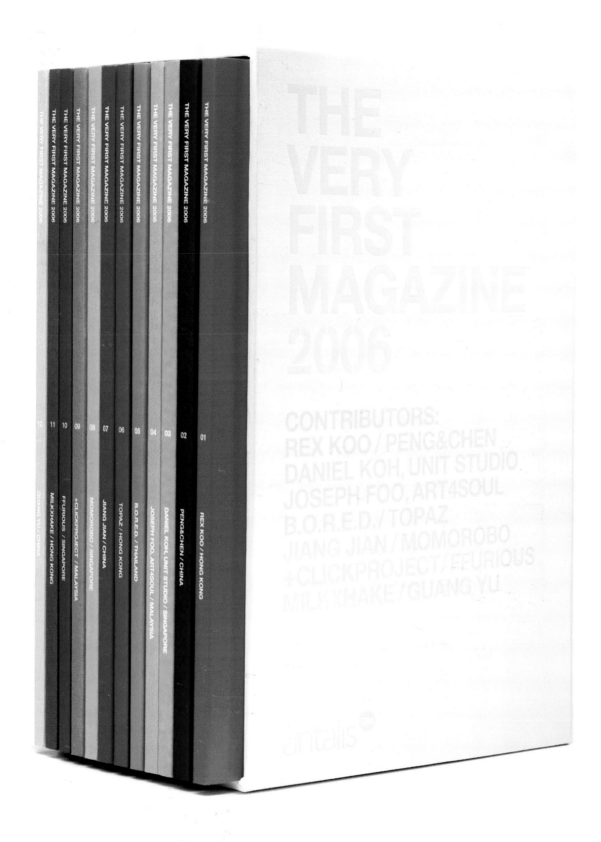

The Very First Magazine 2006 //

For the year 2006, the global paper company Antalis Ltd. gave a calendar to the design firm Milkxhake as an order. Instead of sketching a conventional calendar, the graphic designers from Hong Kong mixed the concept of a calendar with that of a magazine and developed "The Very First Magazine 2006." The entire calendar consists of its own magazine for each month. Each booklet was designed by a de-signer from the Asia-Pacific Rim. The result reflects the different backgrounds and working styles of the designers, from Hong Kong, China, Singapore, Malaysia and Thailand. Despite the limited edition of 1,000 copies, the project drew substantial attention from the design scene after Milkxhake made the magazine available for download on a website.

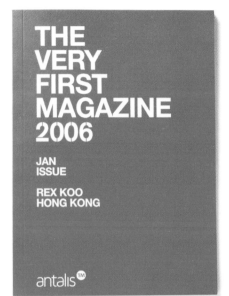

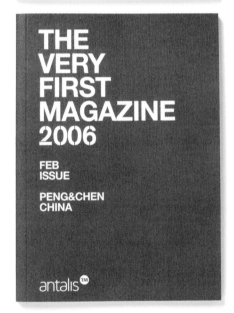

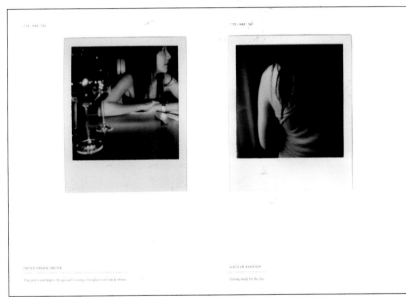

THE
VERY
FIRST
MAGAZINE
2006

APR
ISSUE

JOSEPH FOO,
ART4SOUL
MALAYSIA

antalis

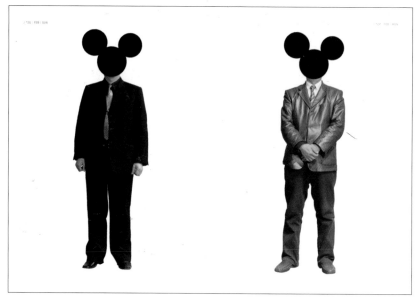

THE
VERY
FIRST
MAGAZINE
2006

MAY
ISSUE

B.O.R.E.D.
THAILAND

antalis

THE
VERY
FIRST
MAGAZINE
2006

JUN
ISSUE

TOPAZ
HONG KONG

antalis

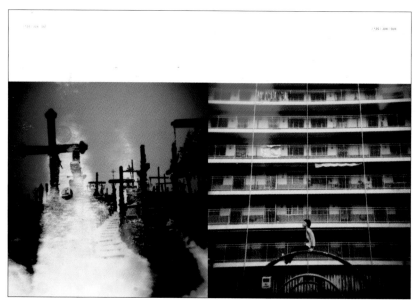

THE
VERY
FIRST
MAGAZINE
2006

JUL
ISSUE

JIANG JIAN
CHINA

antalis™

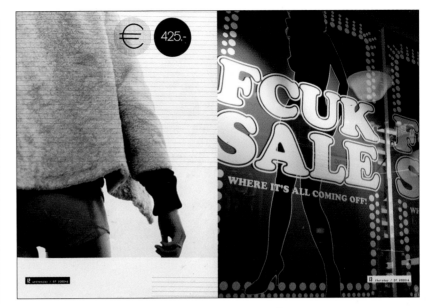

THE
VERY
FIRST
MAGAZINE
2006

AUG
ISSUE

MOMOROBO
SINGAPORE

antalis™

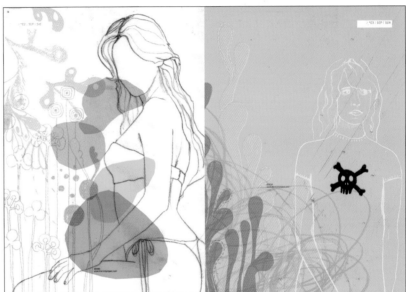

THE
VERY
FIRST
MAGAZINE
2006

SEP
ISSUE

+CLICKPROJECT
MALAYSIA

antalis™

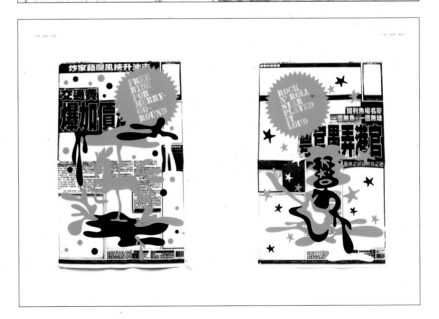

THE
VERY
FIRST
MAGAZINE
2006

OCT
ISSUE

FFURIOUS
SINGAPORE

antalis™

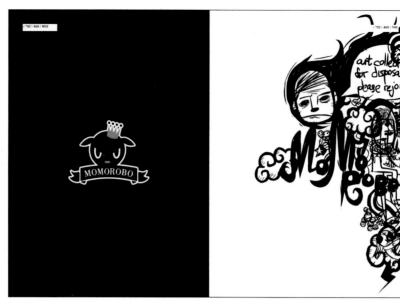

THE
VERY
FIRST
MAGAZINE
2006

NOV
ISSUE

MILKXHAKE
HONG KONG

antalis™

THE
VERY
FIRST
MAGAZINE
2006

DEC
ISSUE

GUANG YU
CHINA

antalis™

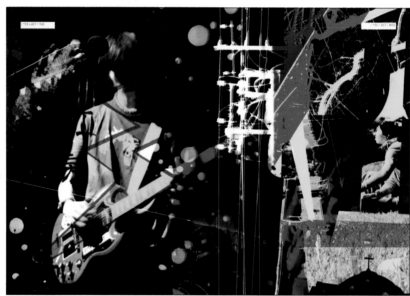

Changes of Mind:
Belief and Transformation
7 July — 25 August 2005

NATHAN
COLEY
ROBERTO
CUOGHI
**DOUGLAS
GORDON
MARIKO
MORI**
OLAF
NICOLAI
**PIETRO
ROCCASALVA**
MAGDA
TOTHOVA
**BILL
VIOLA**

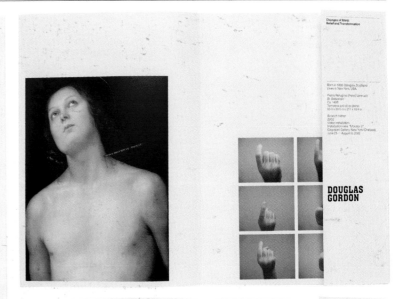

DOUGLAS
GORDON

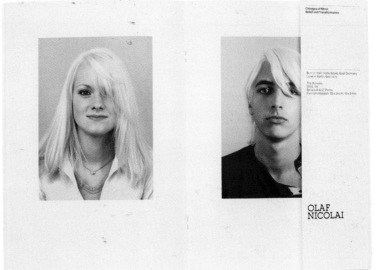

OLAF
NICOLAI

Changes of Mind //

"Changes of Mind" was the title of a group exhibition of international artists on the topics of identity and change in the London gallery Haunch of Venison. Since the personal, geographical and spiritual background of the artists themselves were visible in their works, variety and change of identity were not only topics but also features of the exhibition. In the design of the catalog, the London-based graphic design firm Spin emphasized this feature by giving each artist his/her own page. The cover features a grid of overlapping outlines signifying the positions of the images within the catalog. The fold acts as a built-in bookmark and allows for a clear separation of text and image.

RCA Catalog // 2001 //

The Royal College of Art (RCA) is a renowned university for art and design in London. For a catalog for the department of "Communication Art & Design," the binational design firm Brighten the Corners gave a DIN A4 page to design as desired to every artist participating. All textual information was printed on the back of the graphics and the thirty-eight sheets of paper are placed on top of one another without being anchored. In this way, the collection can be read as a conventional catalog or be taken apart and be used as a loose collection of images.

Brighten the Corners // Anastasios Billy Kiossoglou, Frank Philippin // London, United Kingdom // Stuttgart, Germany // www.brightenthecorners.com //

Brighten the Corners are Anastasios Billy Kiossoglou and Frank Philippin. Established in 1999, we are a small organisation that handles both large- and small-scale projects. Whether designing a book, a stamp or branding an organisation, our belief is that communication should be clear and direct, that good design always makes a difference.
What we consider good design?
Billy: When everything is so good, you don't even notice it.
Frank: Something which has been thought through on every level.
Early influences?
Billy: Lucky Luke and Asterix.
Frank: Jesus and Jan Tschichold

A motto: Get with the times! Sing along!
What inspires us: Frank: That totally depends, but potentially everything that happens around me.
What aggravates us: Billy: Rotis Sans Serif being everywhere
Frank: That totally depends, but potentially everything that happens around me.
Our nightmare: Billy: Rotis Semi Serif being everywhere
Frank: 1.FC Köln not winning the Soccer Champions League in my life time.
5 Things we are crazy about:
Billy: Sabon Italic / Sabon Regular / Fresh bread / Butter / Univers Regular
Frank: Tomatoes / Wine / 1. FC Köln / Steaks / Univers Regular

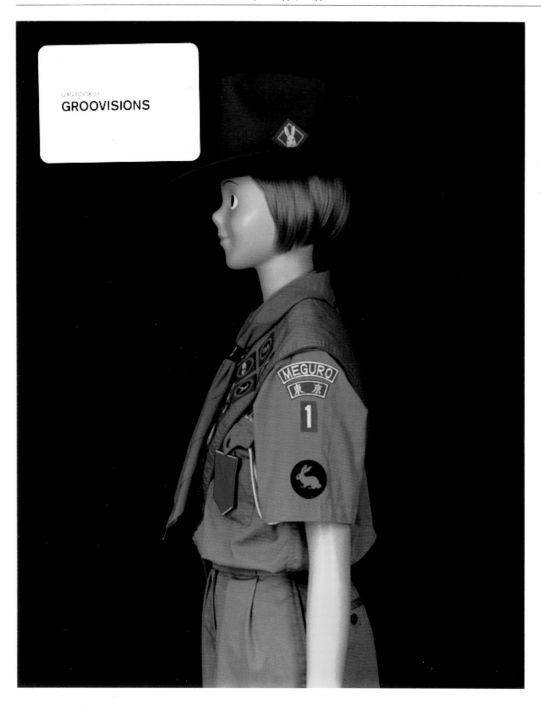

GAS BOOK 31
GROOVISIONS

Gas Books //

In 1996, Japan's Gasbook series began to show multimedia and computer-oriented artists in a format, which can only be inadequately referred to as a "book." The Gasbooks, always delivered in unconventional packaging, contain only not printed material, but also CD-ROMs, DVDs, videos, posters and even T-shirts or design objects. Sold in art book shops around the world, the Gasbooks, with their abundance of inspiring material, soon drew the attention of the international design community. Motivated by the success of the first eleven issues, in 2001 the initiative extended to the Gas Project, which now also produces DVDs, T-shirts, exhibitions and even TV programs. Today Gas As Interface Co., Ltd., has become a major player in the design industry, bringing together artists, cities and the public around the world.

Gas As Interface Co., Ltd. // Yumiko Ohchi // Tokyo, Japan // www.hellogas.com //

I want our work to be fair, surprising, modest. We want to keep continuing communications. When the artists, the customers and us–Gas As Interface–deepen communication, that is what motivates me.

What inspires me? All the people I cooperate with. The nature around us. What my working environment looks like? Like a grove of a village shrine.

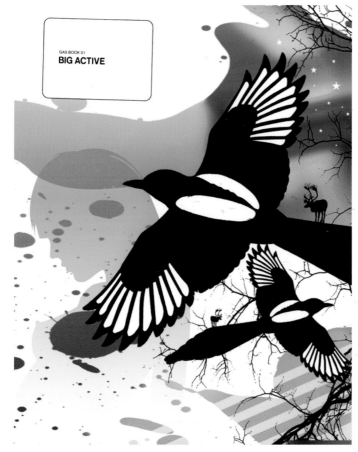

GAS BOOK 01
BIG ACTIVE

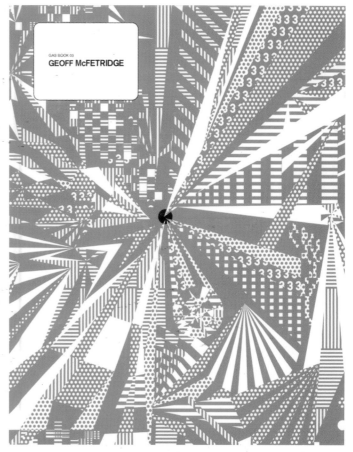

GAS BOOK 03
GEOFF McFETRIDGE

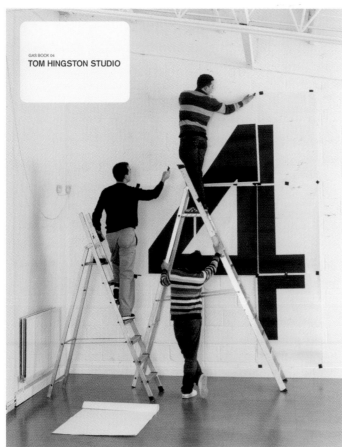

GAS BOOK 04
TOM HINGSTON STUDIO

GAS BOOK 07
TOMATO

GAS BOOK 06
ILLDOZER

GAS BOOK 07
UKAWA NAOHIRO

GAS BOOK 08
BLUE SOURCE

GAS BOOK 10
RYAN
McGINNESS

GAS BOOK 10
WORK IN PROGRESS

GAS BOOK 11
MIKE MILLS

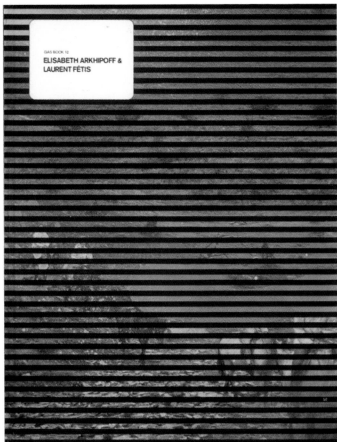

GAS BOOK 12
**ELISABETH ARKHIPOFF &
LAURENT FÉTIS**

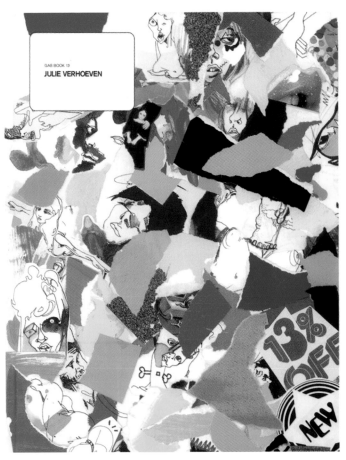

GAS BOOK 13
JULIE VERHOEVEN

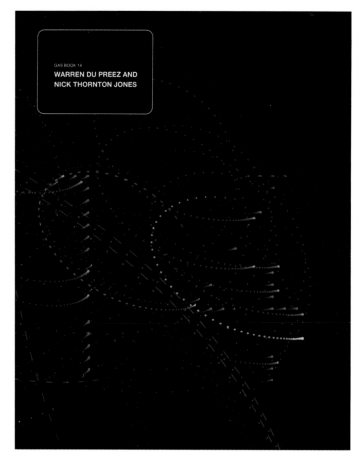

GAS BOOK 14

WARREN DU PREEZ AND
NICK THORNTON JONES

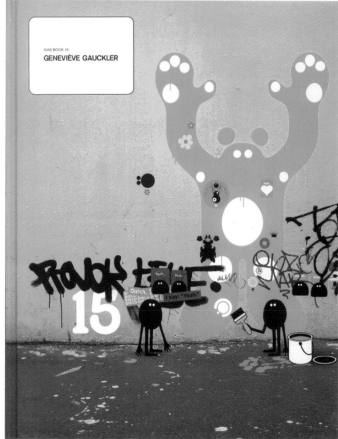

GAS BOOK 15

GENEVIÈVE GAUCKLER

GAS BOOK 16

MAROK

16

ON.

GAS BOOK 17

PERKS AND MINI
FERGADELIC

ISBN4-86083-189-6

C3072 ¥2800E

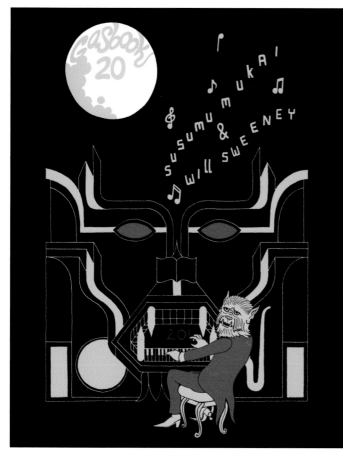

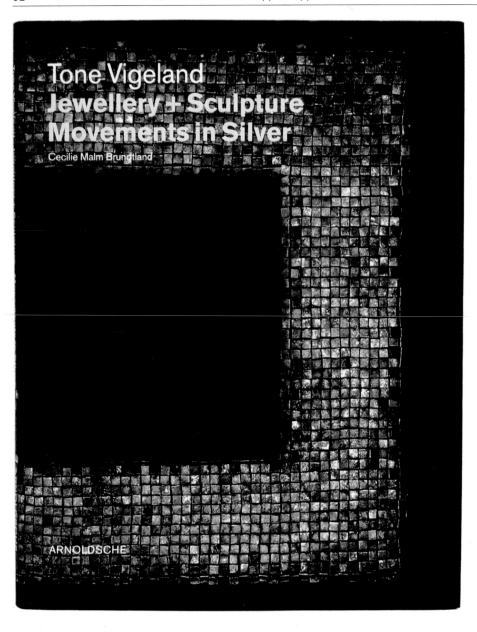

Tone Vigeland
Jewellery + Sculpture
Movements in Silver
Cecilie Malm Brundtland

ARNOLDSCHE

Movements in Silver // 2004 //

In 2003, the German publishing house, Verlag Arnold Art Publishers dedicated an extensive monograph to the artist, Tone Vigeland, which she allowed to be designed by Brighten the Corners, a graphic design firm with offices in Stuttgart and London. The monograph presents the nearly comprehensive work of the Norwegian, spanning nearly fifty years, from her beginnings in the tradition of Scandinavian design to her jewelry creations, to her more recent sculptures. Textures, forms and color impressions of the artist's work are reflected subtly in the design of the book, which Brighten the Corners created on two different kinds of paper.

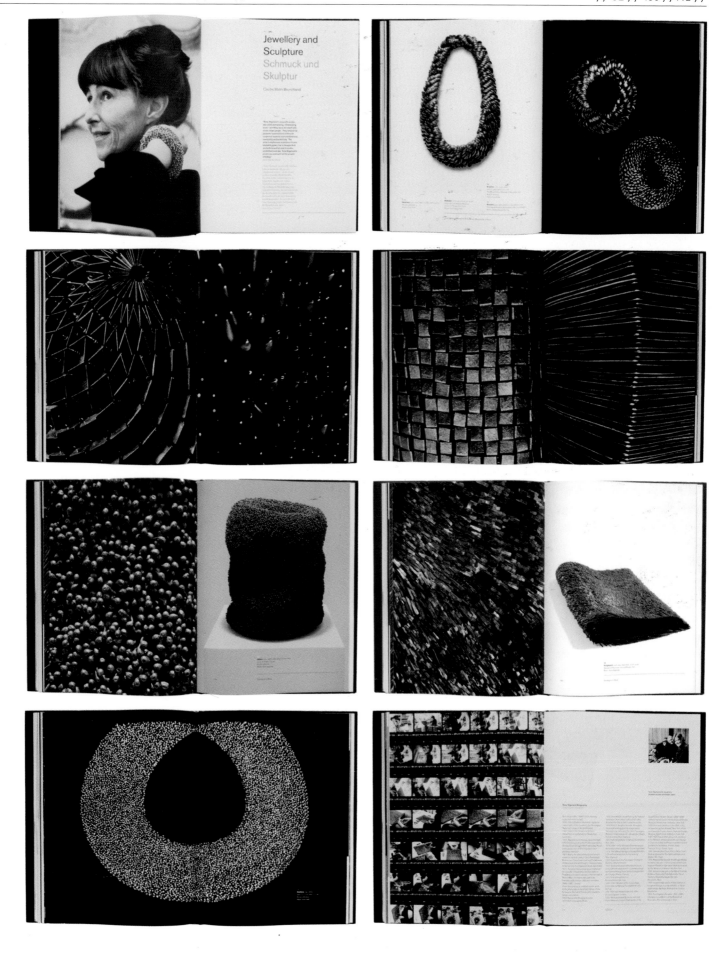

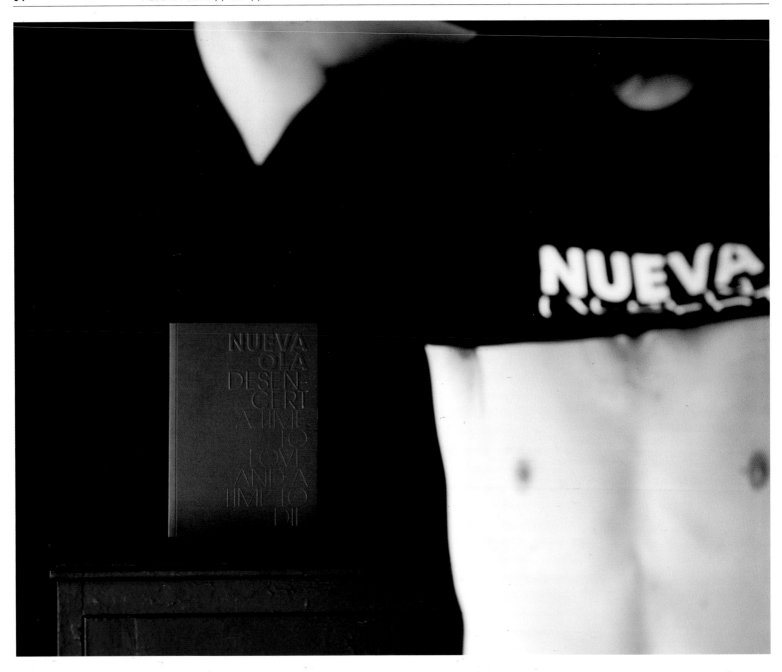

Nueva Ola //

With the development of the catalog *Nueva Ola* showcasing works by the Spanish media artist Joan Morey, the designer Albert Folch from Barcelona placed his design work completely in the service of the aesthetic of the artist. By transporting Joan Morey's strict aesthetic characteristics–in close co-operation with the artist himself–into a book format, he created a catalog that is not only a documentation of works of art but serves itself as a work by the artist. Accordingly, the edition is limited to 500 numbered and handmarked copies. Moreover, Joan Morey's commitment goes so far that he made the photographs of the catalog shown here personally for the *Layout Look Book*.

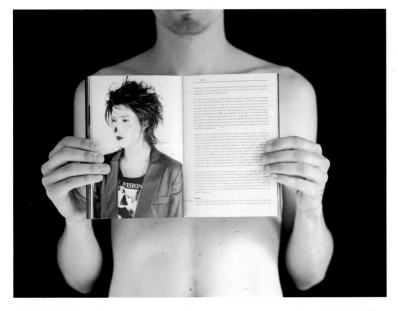

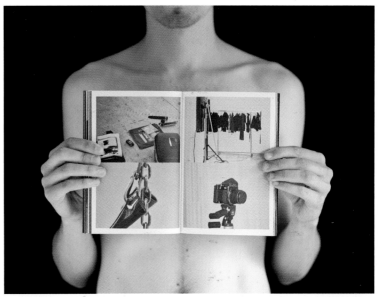

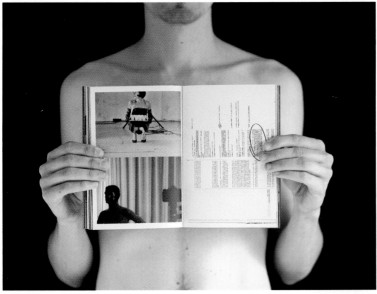

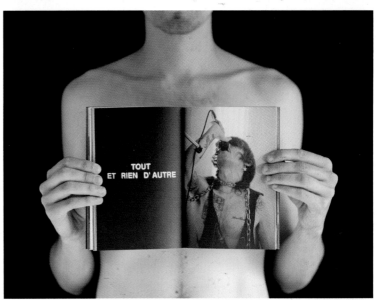

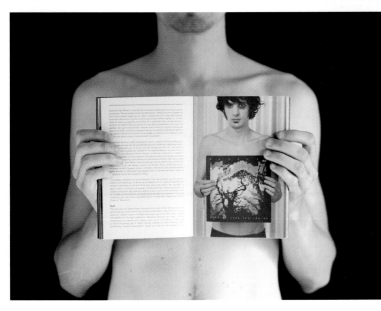

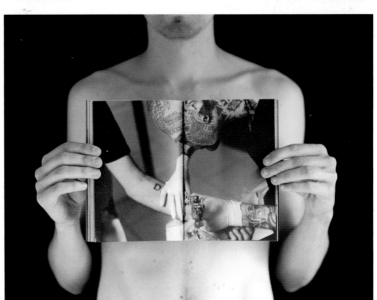

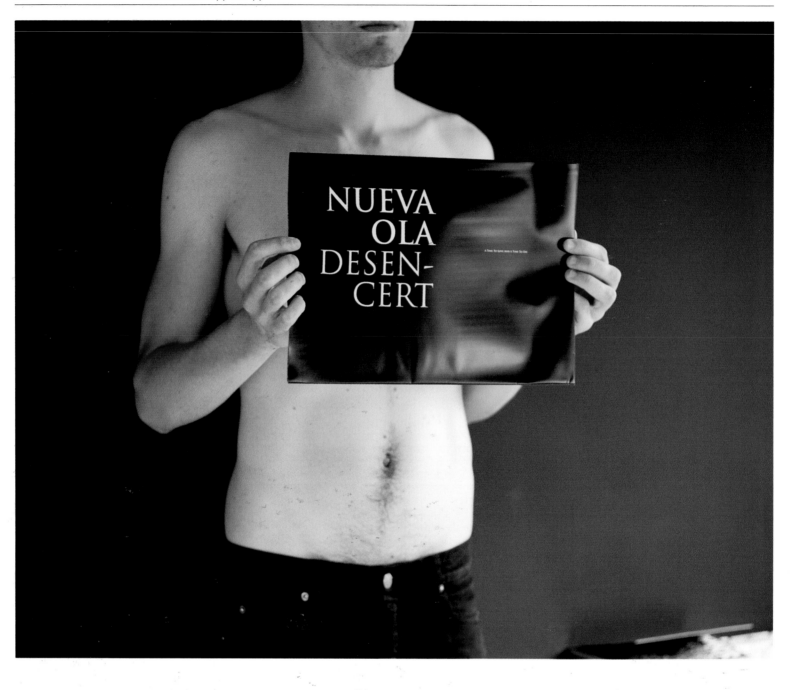

Albert Folch // Barcelona, Spain // www.albertfolch.com //

For me, good print design means leaving style and good taste by the wayside. These concepts are too subjective to be able to judge something using them. What I would ask for and hope to offer are: comprehensibility and subtlety. I believe that in every graphic work, functionality and healthy human understanding should prevail. Adapted naturally to the order and the requirements of each project. Good typographic work (i.e., a good application and legibility of the typology) are key for all of these requirements.

Actually all of the projects that I have done have many aspects with which I am satisfied. But I am particularly pleased with certain projects. For example with the catalog and graphic appearance of *Nueva Ola* and the very close cooperation with Joan Morey who gave me this commission. Also the catalogs, *Chikaku, Le Paradis Perdu*, *El Edad Perversa*, *True Freaks* and the website of Ignacio Uriarte are some the projects with which I am very content. Without devaluating or underestimating something else, I would like to emphasize the website, www.adlerfresneda.com, since this was my first request for a website, and the result was very satisfying for the client and myself.

What inspires me? Rhythm, work and pressure. In order to be able to work, I need areas, which are not overloaded visually. This is why I try to hide all of the things I need to work or at least not have them right in front of me. My office is a small 30-m² space in Poblenou, the former industrial district of Barcelona. I always have a white wall in front of me. The shelf with all the books, magazines, etc., is located behind me. What does the rest of my work environment look like? Like everywhere in the world…a large table, full of paper.

I would tell design students that a long path lies ahead of them following their design studies. School offers only an overview of what one can find for oneself. It is very important to carefully select the firm for which one wants to work in the beginning. Because this is where one acquires contact with the client, completes a project, presentation, solution and execution.

Five things that I'm crazy about?

Galapagos Islands (I was never there, but I'd love to go there sometime) / Grand Canyon of Colorado (likewise) / Friendly people / The colors black, white and red / Music.

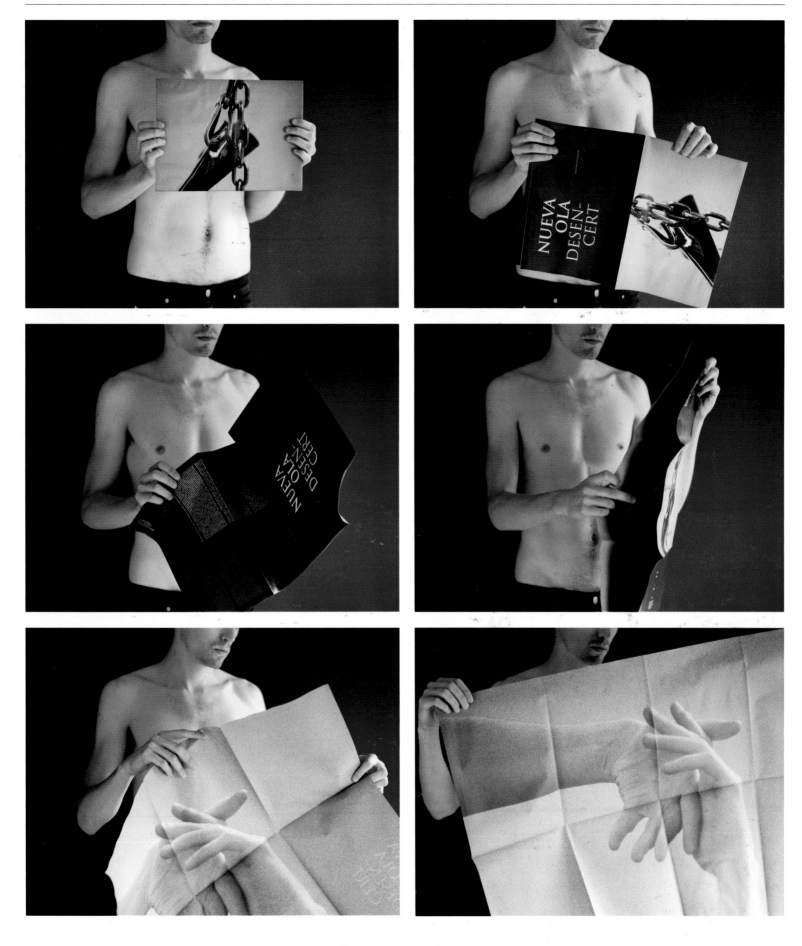

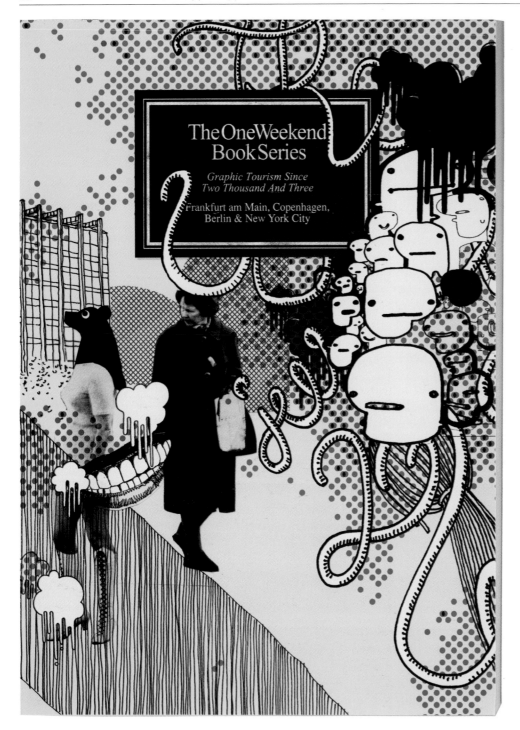

2points // Martin Lorenz // Barcelona, Spain // www.twopoints.net //

One of the earliest influences I recall has been the work of Lyonal Feininger. In particular his work for the *New York Times*. At that time I didn't really know what fascinated me in his work, but looking back I think it was his way of constructing a world. And also his way of constructing a page in which this world was placed.

Being born in Hannover, Germany, Kurt Schwitters was always present. His attitude to creation, not caring about stylistic restrictions, his energy and his need to investigate never stopped being an influence.

Everything can be inspiring. In my opinion, inspiration is the ability to convert perceived information into usable ideas. If you got an idea, which is important to you, fight for it.

The most exciting project at the moment is probably The One Weekend Book Series, as it finally attracts a great deal of attention. It has always been a great opportunity to work with other creatives, explore together, far away from the professional routine.

The advice I give most often to my students is don't go for the obvious solution, always try to reach another level.

Five things I am crazy about?

The place where I live, Barcelona / The love of my life, my wife, and my cats / The passion for creation and communication / The food of the different regions of this world / The coffee I drank in Milan.

The One Weekend Book Series // 2006 //

For every issue of The One Weekend Book Series, the designer Martin Lorenz of Grafik-büro 2points, travels to another city. Once there, he allows himself and a guest artist a total of 48 hours to capture the flair of the city in a 48-page visual travel diary. By means of designs, photos, collages and texts, these kinds of personal city portraits of Frankfurt, Copenhagen, New York, The Hague, Milan and Barcelona have been created.

After the first issues were only available in a few select book shops, the Spanish publishing house Actar became interested in The One Weekend Book Series and published a collection of the first five volumes, including additional material and interviews with the authors. In the meantime, the production of new issues receives so much attention that they are produced as live events.

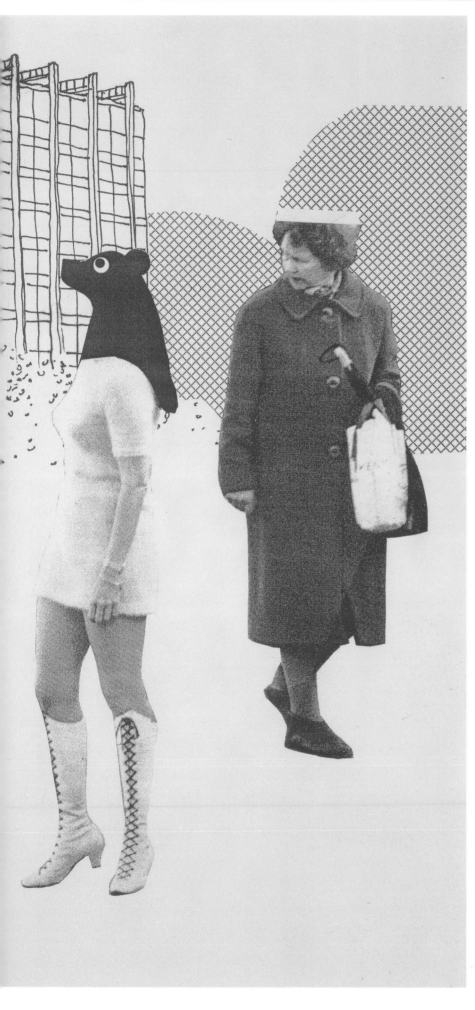

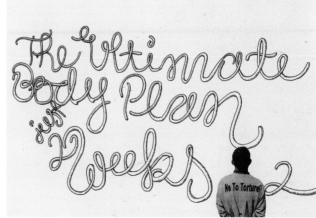

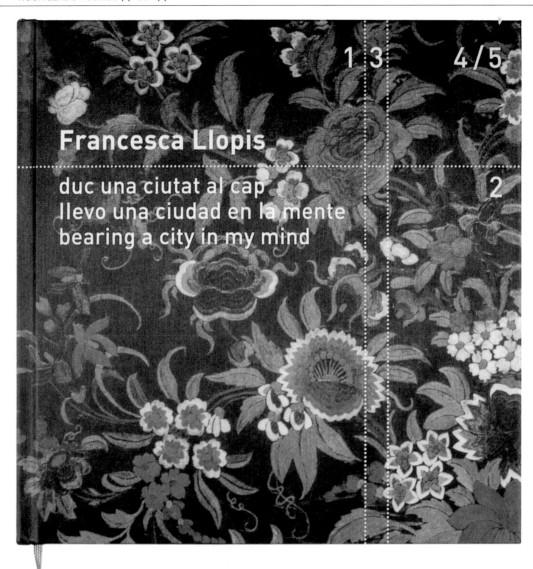

Francesca Llopis: _Bearing a City in My Mind_ // 2006 //

For the design of the catalog of the artist Francesca Llopis, the Barcelona-based graphic designer Rosa Llado Surós spent a great deal of time with the artist herself. Together they experimented with numerous variations of technical elabora-tion until finding the ideal translation of her ideas in a book of various papers and stampings.

Rosa Lladó i Surós // Barcelona, Spain // www.salondethe.net //

For me print design is successful when there is a good relationship between design and contents. Plus good printing and good binding.
For eleven years, I worked for Ramon Prat of Actar in Barcelona. Everything important, I learned from him. In addition, I like Dutch design. I admire Irma Boom in particular.
For each of my projects, I look for the graphic solution that best explains the project. In so doing, I can be inspired by all possible things. By stories, which I like, by street life, by graphics that I see around me every day, by books, by the Internet.
What kind of advice would I give to students? It's a very stressful job, which requires many hours of work. You really have to bring a lot of enthusiasm to the table. What's most important is to be able to bring new enthusiasm to each project that one undertakes.

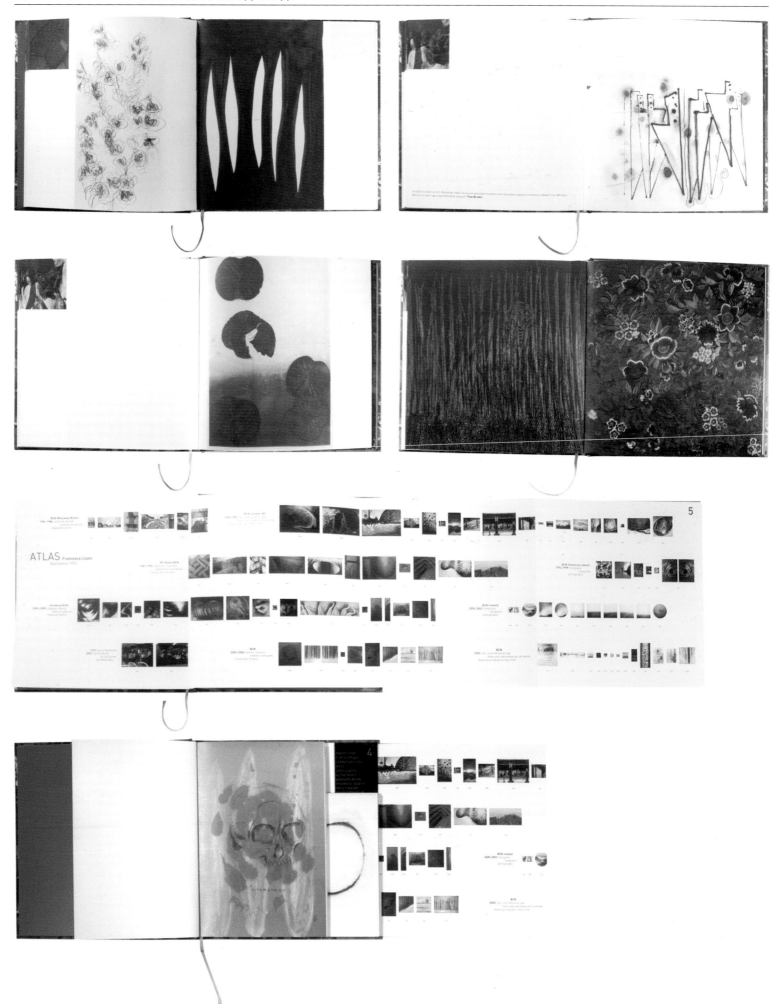

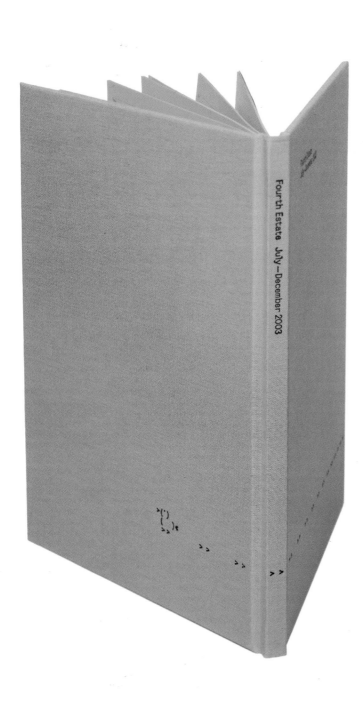

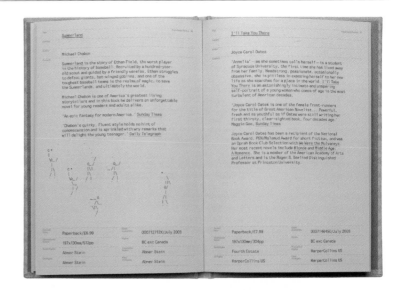

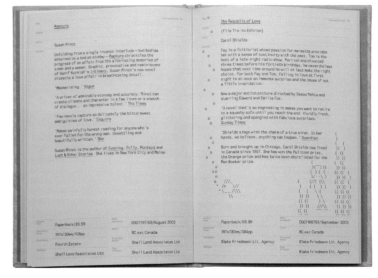

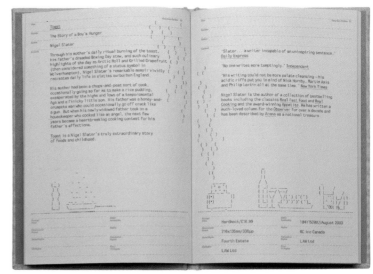

Fourth Estate // 2003 //

The publishing house Fourth Estate founded its reputation on the publishing of sophisticated American novelists in England, America and Australia. For the publishing catalog of the year 2003, the London-based design company Tom Hingston Studio found a visual vocabulary that recalls the traditional handicraft of novelists: typewriter and paper. In terms of typography and illustrations, the entire catalog is designed so as to look as though it were created on a typewriter. The book is illustrated only by means of numerous so-called ASCII-type images. This results in numerous pictograms only from the arrangement of writing and spaces on the paper. Also the sleekness of the typographic design, as well as the colors and quality of the paper highlight this impression of timelessness that lies outside the hectic nature of digital communication.

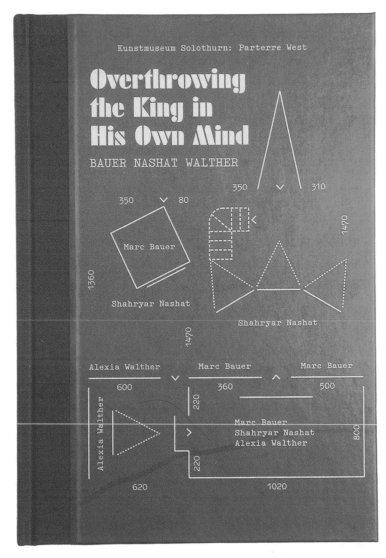

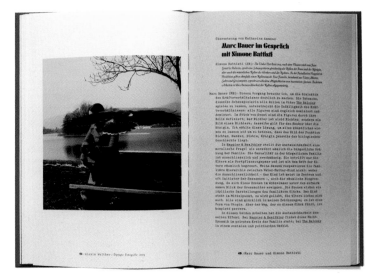

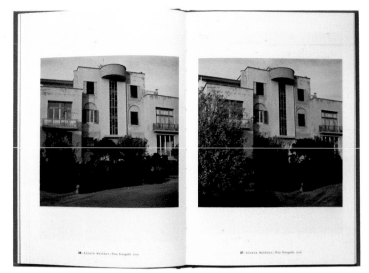

Overthrowing the King in His Own Mind *// 2005 //*

"Overthrowing the King in His Own Mind" was a group exhibition of the artists Marc Bauer, honored with the Federal Art Prize of Switzerland, Shahryar Nashat and Alexia Walther in the art museum of Solothurn. In the design of the 112-page exhibition catalog, the London-based graphic designer Sara De Bondt referred in various ways directly to the exhibited works. Based on one of the exhibited works, for example, the background color in the last part of the book runs from black to white over sixteen pages. The design of the space assumed substantial significance in the exhibition. Sara De Bondt reflected this fact by printing the schematic sketches of the two floors including the placement of the works of art in gold on the cover of the book.

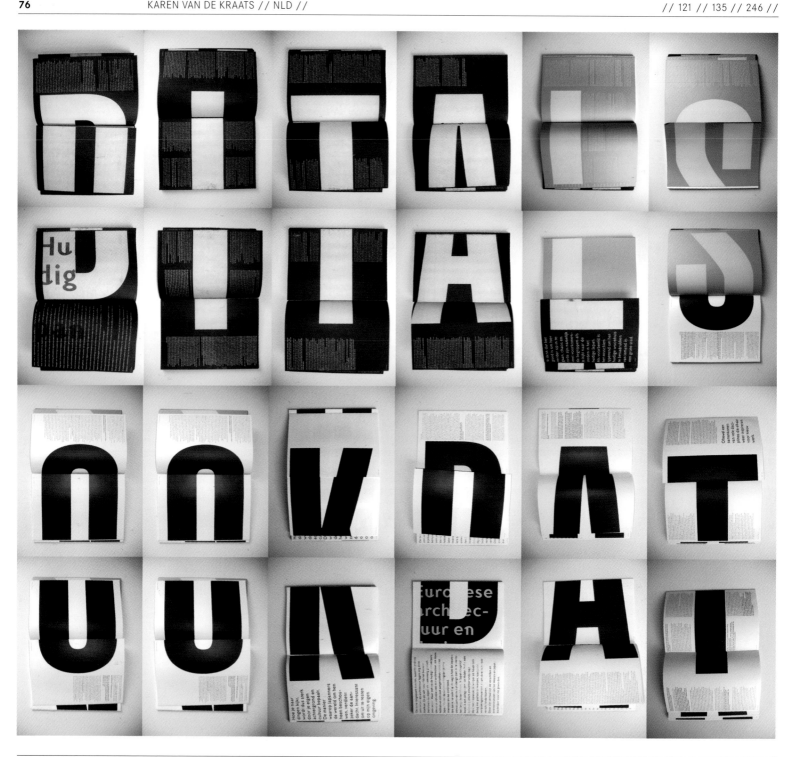

Dit als ook dat // 2001 //

The Dutch designer Karen van de Kraats wrote and designed her book *Dit als ook dat* as part of their B.A. at the Arnhem Academy of Art and Design in the year 2003. The topic of the book is Japanese architecture and its traditional context. The title sentence, "This as well as that" is a Japanese phrase, according to which all things can co-exist, which Karen van de Kraats understands to be both a cultural as well as visual possibility. Inspired by Japanese traditions, the designer reduced her book to the colors black, white and grey, and produced the book as a kind of "architecture within the book." Moreover, the entire book was created on a photocopying machine that could print white instead of black ink.

Karen van de Kraats // The Netherlands // www.karenvandekraats.com //

Although I can't tell any single project that I would call my favourite, I can say that I am generally really happy with the projects I initiated myself. I learned a lot of being photographer, editor, writer, translator and designer at the same time. After this I realized how much work it is to start your own publishing company or publish a book. But you get a lot of fun out of it!
I am working in three different studios at the moment and am always surrounded by other nice young designers. On my desktop you will usually find my laptop, my personalized WACOM tablet, an extra screen if there is any, a bottle of water, some pencils, my mobile phone, my MOLESKINE agenda 2006 and some empty sheets to draw on. On my laptop desktop there is a really nice picture of huge amounts of old paper cubes.
Good print design shows time.
If I was asked to give advice to students of graphic design, I would say, Don't glue yourself to your computer! Look further!
My motto? Kill your darlings!
Here are the 5 Things I am crazy about: Antoine / Graphic Design / Rain on a hot summer day / Lots of music / A good talk with friends.

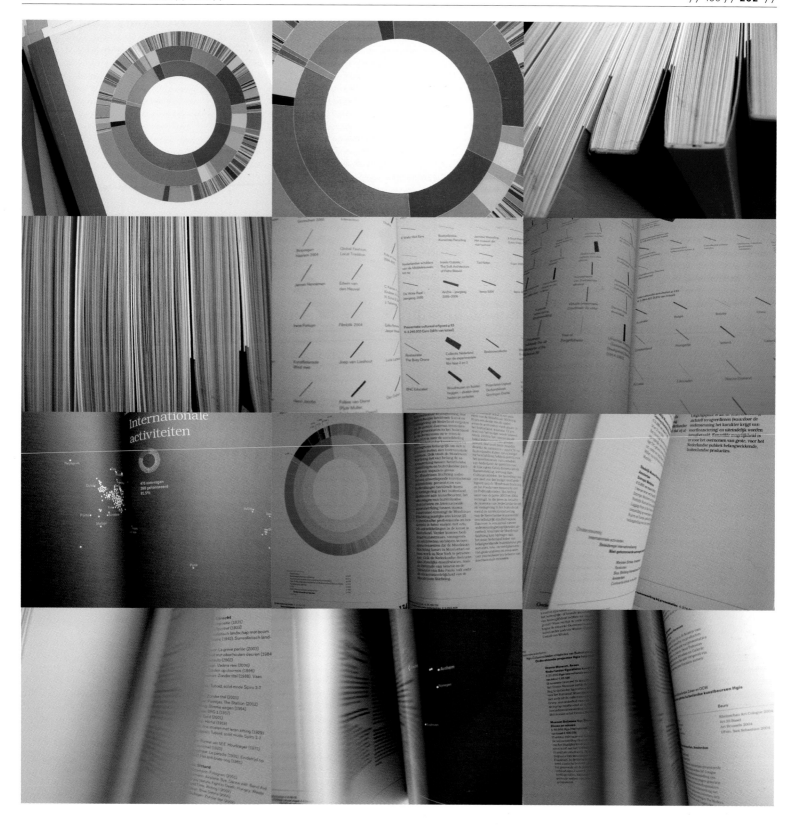

Mondriaan Foundation // 2005 //

The Mondriaan Foundation supports visual arts, design and the cultural heritage of the Netherlands by granting financial support to institutions, companies and authorities—both national and international. The variety of the requested projects is clear in the report, which describes more than one thousand support measures per year. The 2004 annual report, designed by the Dutch design firm Lust, reflects this variety in an explosion of colors: every page is printed on a different color paper.

The order of the colors is random and unique to each copy of the report. There are eight different colors for the cover and more than twenty different colors for the inside pages. Throughout the book, Lust separates different levels of information by a specific typographical system crafted for this purpose. A special three-ring pie chart shows exactly what the Foundation spent on each project.

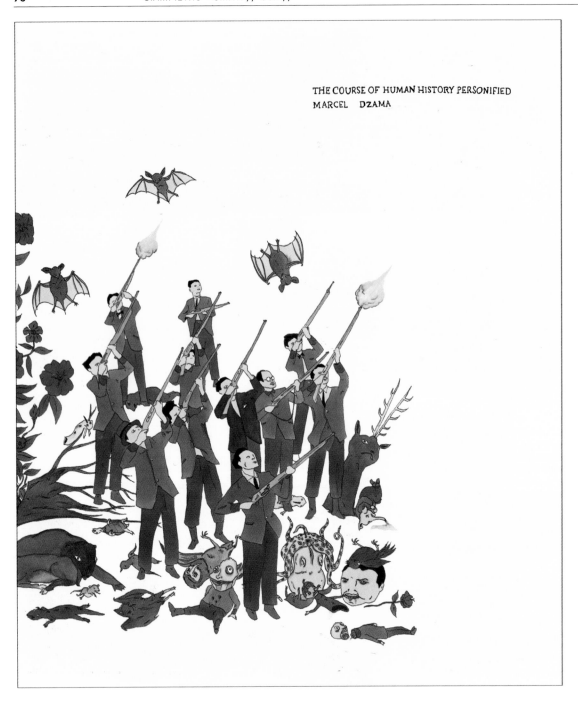

THE COURSE OF HUMAN HISTORY PERSONIFIED
MARCEL DZAMA

The Course of Human History Personified: Marcel Dzama // 2006 //

Rob Giampietro and Kevin Smith of the New York-based design firm Giampietro + Smith designed the catalog to Marcel Dzamas's exhibition "The Course of Human History Personified" in close co-operation with the artist himself. For Marcel Dzama, the exhibition in David Zwirner's Gallery in New York was his biggest show to date, and for the catalog, he had a very particular kind of binding in mind: basically a softcover book in a hardcover binding with a nine-panel foldout. Giampietro + Smith tried many different possible solutions until they found one with which they were completely satisfied.

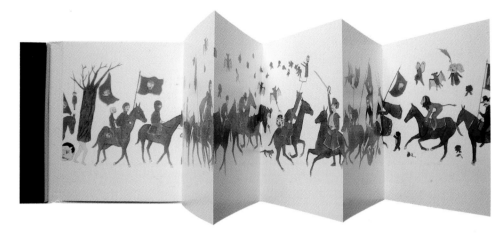

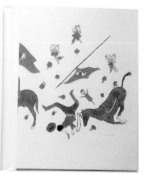
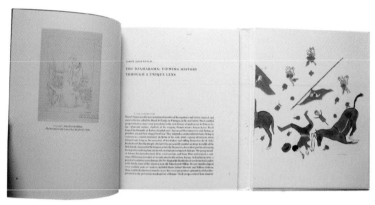

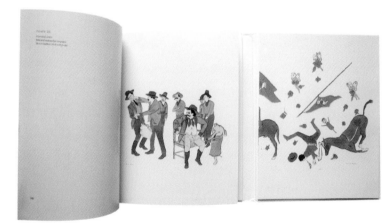
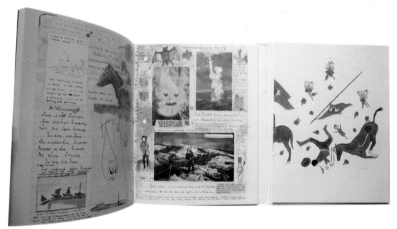

Giampietro + Smith // Rob Giampietro, Kevin Smith // New York, United States // www.studio-gs.com //

As for early influences, we were both huge lovers of comic books when we were younger. We learned how stories got told through words and visuals coming together. As we went on, we were really influenced by learning about fine art and the history of art. Drawing is so important. Being able to take pictures is so important. Artists like Sol LeWitt and John Baldessari really blow us away. And we're influenced by great writers, particularly those who write eloquently about visual things, like Lawrence Weschler.

Talking about work we have done so far, two projects that always stand out are *Topic Magazine* and our work on the NYC2012 Olympic Bid. One is a really really small struggling downtown magazine that can barely publish. The other was this huge project that was seen by millions of New Yorkers. But what makes us happy is that we learned a lot from both of them. We've learned so much about the economics of magazines and how to engage a reader with *Topic*. And we've learned a lot about the value of simplicity from the NYC2012 Olympic Bid.

We believe design is a tool for learning, for designers and for the audiences they seek to engage, and we're always holding our projects up to that standard: What did we learn by doing this? And who did we teach?

As for quality in print design, it kind of boils down to the essentials: good typography and good printing. As a designer, you have to love the details. The biggest skill a student of graphic design can learn is how to set good type. After that, it's about learning what all artists need to know. How to have the discipline to keep working, when to know if something is finished, how to know if something is good or not good. From a skills perspective, it's not about the technology. The technology is no good if you don't know what you want to do with it.

Five things we are crazy about?

Mylo, *Destroy Rock & Roll* / Fedra Serif / Dot Dot Dot / 195 Chrystie Street / Café Habana

Made magazine //

With its hardcover and 250+ page thickness, *Made* magazine is more of a book than a magazine. In 2001, it was founded by Artistic Director Raif Adelberg in Vancouver as an independent bookazine with the goal of being something between living room discussion and group exhibition of artists from the various industries of design, fashion, music and art. Together with Mark Gainor, Cathee Scrivano, Michelle Evers and others, six completely different *Made* magazines have since been produced.

Made Magazine // Mark Gainor // Vancouver, Canada // www.mademag.com //

Of all my work, I am happiest with *Made* magazine, because it requires the most human interaction. I feel very fortunate that in my role at *Made* I am able to interact with some of the most interesting and talented people in the world. For example, the piece on the French catacombs in *Made* #19 came to be through a series of human introductions -- a friend introduced me to a friend who introduced me to a friend, etc. This continued until I was in a situation where I was able to go to Paris and meet with Alex and spend time in the catacombs.

This human interaction and activity happens in some degree with everything. This inspires me. My job as a designer is to display this inspiration/perspiration on paper, and I fail miserably. Nothing comes close to showing the reality of the situations. This is my aggravation but also one of my greatest joys, to live a life that is so rich that I can not begin to comprehend it.

Do I have a motto? Walk around the planet earth making money having fun.

My advice to students of graphic design is: Drop out, cash in your student loans and go outside. There are already enough students, critics and cheerleaders in this world. We need more participants.

Five things I am crazy about:

new Kicks with no socks / laughing / new friends / old friends / my wife, Gina.

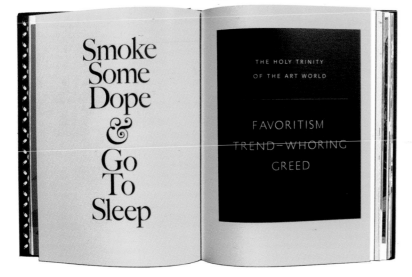

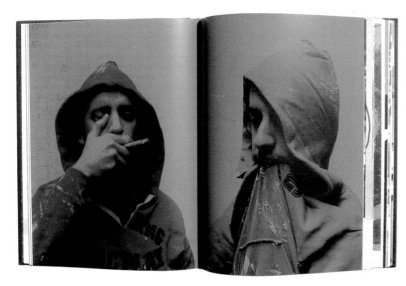

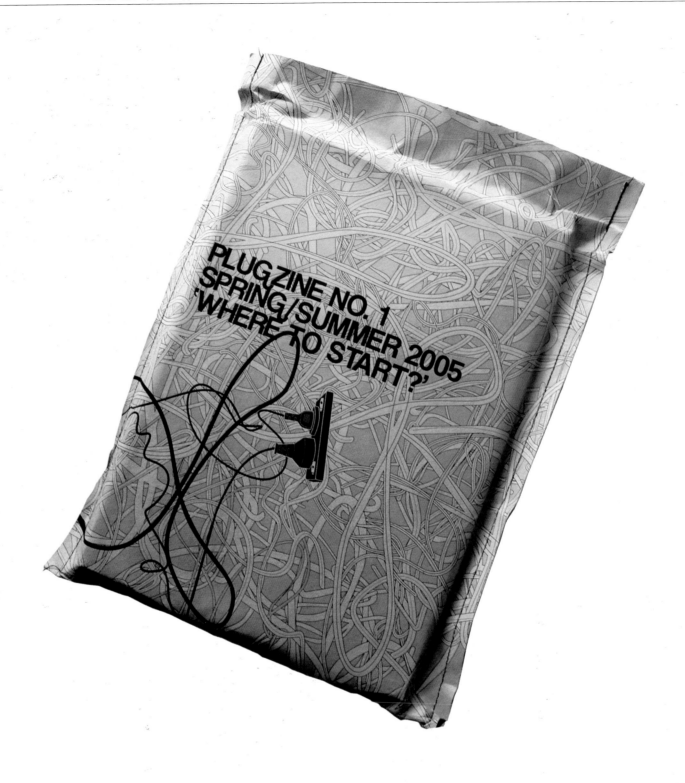

Plugzine No. 1 // 2005 //

Plugzine is a book about current visual culture, jointly published by Joyn:Design and the interdisciplinary Chinese designer Qian Qian. However, the designation "book" describes the first edition, limited to 2,000 copies insufficiently, since in addition to the high-quality, 300-page book, Plugzine No. 1 has stickers, bookmarks, pushpins and posters. Under the Plugzine No. 1 title, "Where to Start," twenty internationally renowned visual artists present their most recent works in bilingual interviews and with numerous illustrations. It is probably the first such publication to be written, designed and published completely in China.

Qian Qian // Missouri, United States // www.q2design.com //

My name is Qian Qian. I'm a graphic designer from China, now living in Springfield, Missouri, with my wife and two cats. I do graphic design and illustration for print, motion and Web. When I started out doing design years ago, the works and attitudes of the Designers Republic definitively gave me the biggest influence.

I think, quality comes from a well-considered balance between content and design, plus good choice of paper and good printing, of course.

I work at home, which is a common apartment. Nothing special. A motto? No, I don't have one. Maybe will have one sometimes later.

What inspires me? Good design, art and music; travel; friends; my cats. What aggravates me? Dishonesty. Nightmare: School examinations!

Any advice I could give to students of graphic design: Work hard and keep the amateurism. Have fun from your work.

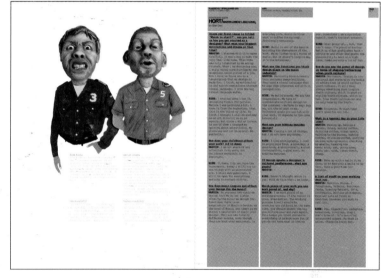

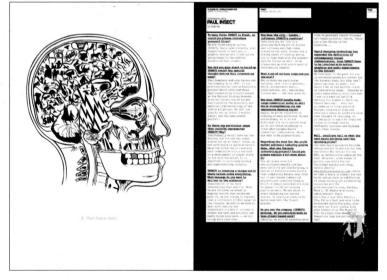

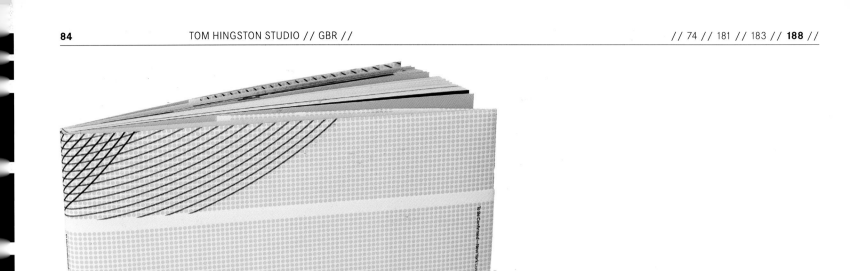

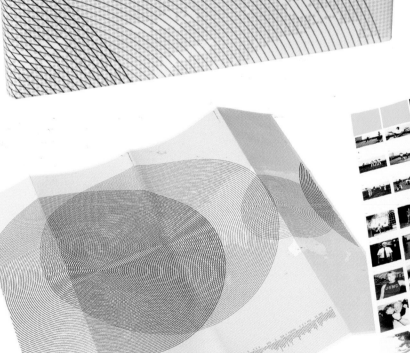

Name
Birthplace
New Zealand
Lives
London England
Works
London England
Company

Name
Birrs Wong
Birthplace
Malaysia
Lives
London England
Works
London England
Company

Name
Birthplace
England
Lives
London England
Works
London England
Company

To Be Confirmed //

"To Be Confirmed" is an alternative fashion trade show, which pursues the goal of showing progressive, non-commercialized fashion, thereby giving a forum to small brands and start-ups next to the large names. A concept of this trade show is to forgo the usual high-gloss chic of the industry and, instead, to show the fashion in a young and relaxed environment, that is targeted to the true audience of fashion rather than the money-purses focused on by the major designers. Invitations and posters, as well as a book for this event, were designed by the London-based Tom Hingston Studio from 2001 to 2005.

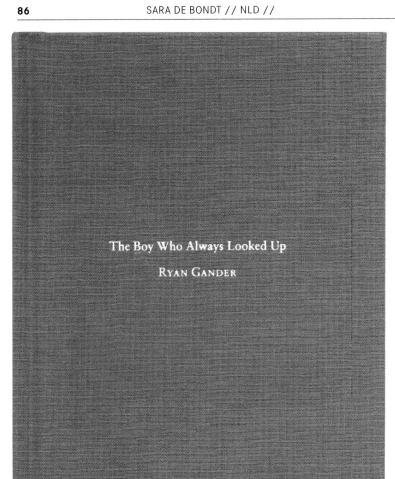

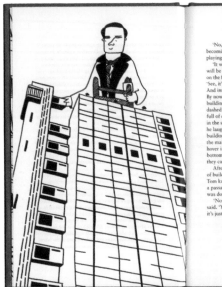

The Boy Who Always Looked Up // 2004 //

On the occasion of his 2004 exhibition "An Incomplete History of Ideas" in Manchester, the British photo, video and object artist Ryan Gander published the book *The Boy Who Always Looked Up*. The book recounts the circumstances that led to the death of the architect Erno Goldfinger from the perspective of a child, and in the typical style of a children's book. Layout and illustrations by the designer Sara De Bondt follow this stylistic model of a children's book for adults.

Sara De Bondt // London, United Kingdom // www.saradebondt.com //

I believe careful consideration of every detail makes good design. I want my work to be honest and try to do it bettery every time. Good works are those that don't need explaining.
Inspiration can be found in everything around me. Many things come to mind when I think about early influences: Wolf Erlbruch, Fiep Westendorp, Marcel Broodthaers, Paul Elliman, Richard Hollis, flags from Ghana, books designed by LeCorbusier, Antoine de St. Exupéry, my dad's gardening book, road signs in Belgium, Joseph and Anni Albers, Erno Goldfinger's house, the BHV basement in Rue Rivoli in Paris, de Slegte, the Alhambra, Jonathan Monk, Fischli and Weiss, Bruno Munari, Piet Zwart.
My advice to students? Don't listen to what your tutors say.

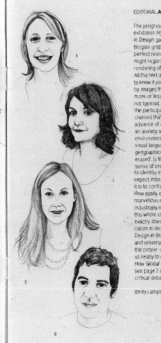

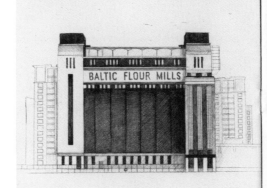

The British Council organizes global teamwork between England and other countries within the areas of art and culture as well as education and English as a foreign language. In September 2005, the Department for Design and Architecture published a newsletter, which was completely illustrated by hand by the London-based graphic designer Sara De Bondt, including all images and text. The sixteen-pages are printed in a single color on newspaper.

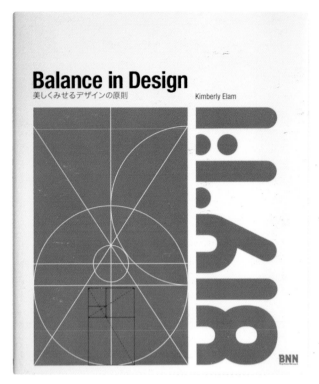

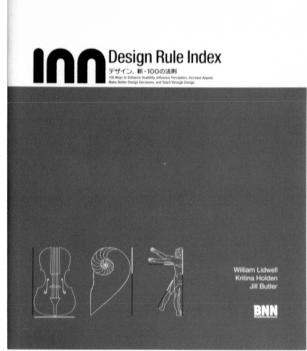

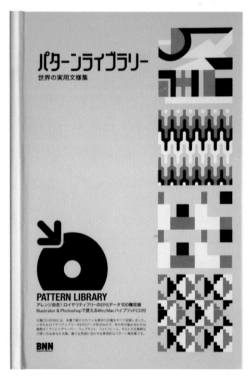

Balance in Design // 2005 // *Design Rule Index* // 2004 // *Pattern Library* // 2005 // *Shade Architecture* // 2005 // *Destination* // 2003 //

Within the Japanese design team Power Graphixx is Masahito Hanzawa, born in 1975, and one of the specialists for printed media. The selection above primarily shows covers for publications that appeared at BNN, a publishing house in Tokyo, that specializes in design books.

Power Graphixxs // Masahito Hanzawa, Hiroyuki Nagatake, Yoshiyuki Komatsu, Junya Saito // Tokyo, Japan // www.power-graphixx.com //

The Japanese design firm Power Graphixx was founded in 1996 by Masahito Hanzawa, Hiroyuki Nagatake, Yoshiyuki Komatsu and Junya Saito. Although all of them received their university diplomas in architecture, they first distinguished themselves primarily with logo and flyer design. After winning a competition for the design of a new visual identity for a Japanese music TV channel, they were extremely successful in expanding their product range to motion graphics, animation and film. Today the versatile team produces all kinds of print and logo designs, title sequences for films, event and music videos and even furniture design. While Hiroyuki Nagatake is mainly responsible for product and furniture design and Yoshiyuki Komatsu is in charge of motion graphics and film, most of the print design goes to Masahito Hanzawa and Junya Saito.

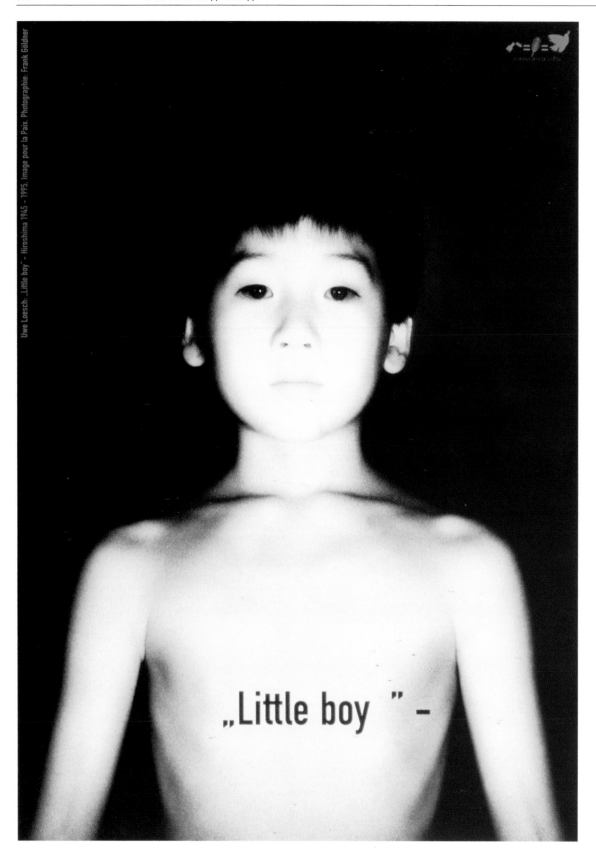

Uwe Loesch: „Little boy" – Hiroshima 1945 – 1995. Image pour la Paix. Photographie: Frank Goldner

Little boy // _Geschichte als Argument_ // _www.scheisse.de_ // _Faire le beaux_ // _Vogelfrei_ // _Istanbul bye bye!_ //

Uwe Loesch's posters communicate with extreme efficiency: only few visual elements entangle the viewer in levels of importance. Often the parts of the poster build upon themselves in the head of the viewer to a pulsating whole. Typography provides content that goes beyond the literal meaning of the printed message, creating a tense relationship with the image in which typography becomes the im-

age itself. In the first example, the prize-winning poster that recalls the 50th anniversary of the bombing of Hiroshima, Loesch writes the code name for the bomb, "Little Boy" on the iconic, tender photo of an Asian boy. From the reciprocal effect of writing and image, the poster derives its dizzying strength. During such pointed reduction, even a blank character in the typography has meaning. An example in

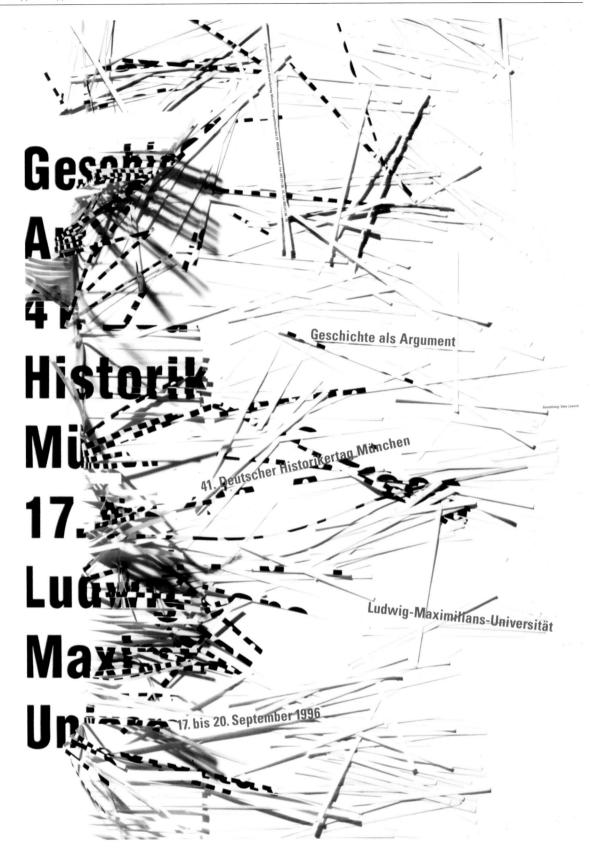

which typography becomes the image itself can be found in the poster created for the German Historian's Conference of 1996. The slogan of the conference, "History as Argument," is almost unrecognizable after being devoured by a shredder. A poster which becomes a part of the discussion of the conference.

Uwe Loesch // Düsseldorf, Germany // www.uweloesch.de //

More than 30 individual exhibitions and 100 group exhibitions, and the awarding of nearly all international design prizes prove that Uwe Loesch is one the most important current poster designers worldwide. Born in Dresden in 1943, Uwe Loesch has been working for publishing houses, companies and social and cultural organizations from his own design firm in Düsseldorf since 1968. By the beginning of the 1980s, his posters were receiving international acclaim. His pointed, content-driven images cannot be pigeon holed ina specific style, but instead anticipate numerous trends decades ahead, such as the treatment of the sharp and the obscure, the evaluation of typography as a multilayered experiential element, unconventional formats such as a poster that can be cut up into a book and much more. Internationally renowned museums like the MoMA in New York collect and show his works in their permanent exhibitions.

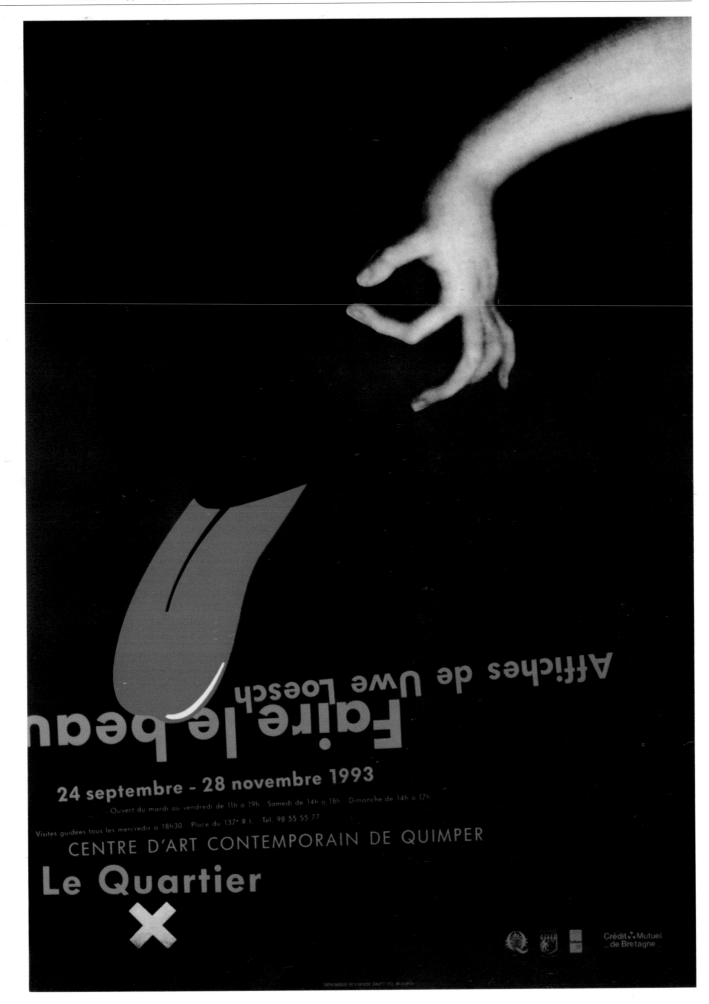

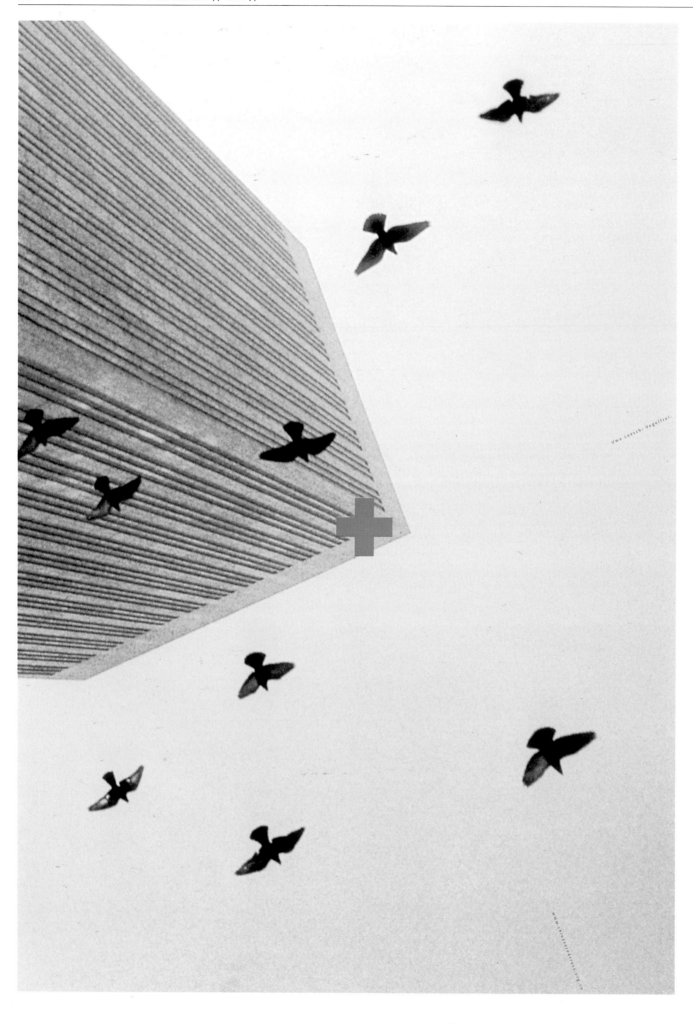

Uwe Loesch: Vogelfrei.

www.chinesecontext.org.cn

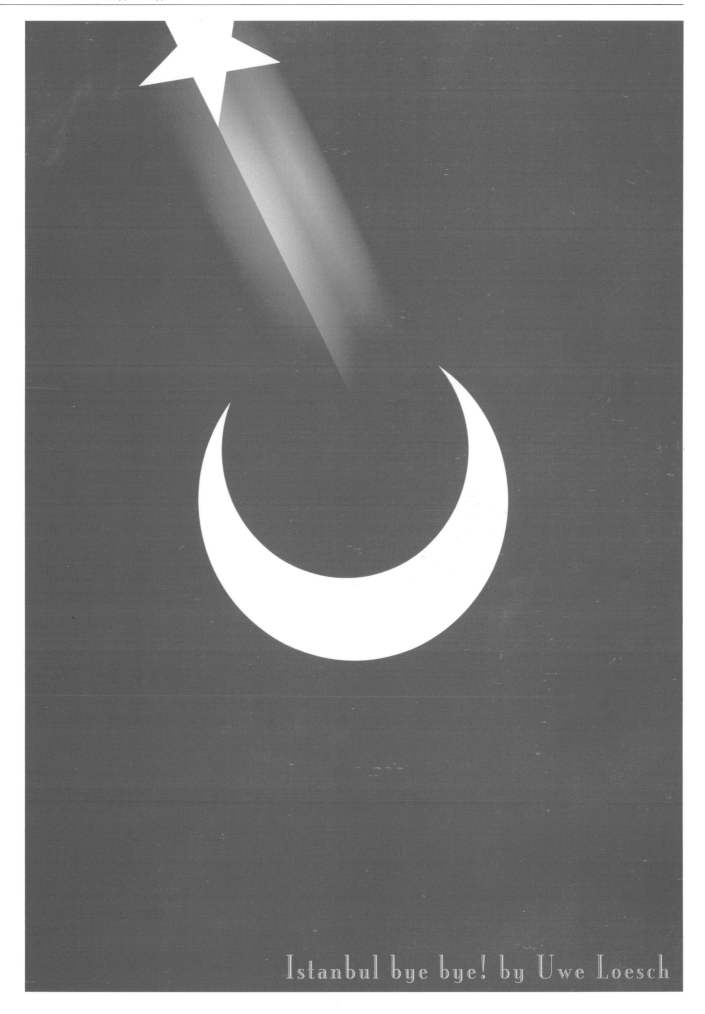

Istanbul bye bye! by Uwe Loesch

Beck: Sea Change // 2002 //

For the "Sea Change" tour of the singer/songwriter and multi-instrumentalist Beck, the Paris-based designer Laurent Fétis of Paris designed the tour poster into an idiosyncratic combination of photographs, illustrations and typographies that recall the psychedelic aesthetic of the 1960s and 1970s. The poster was printed in a limited edition of 2,000 copies.

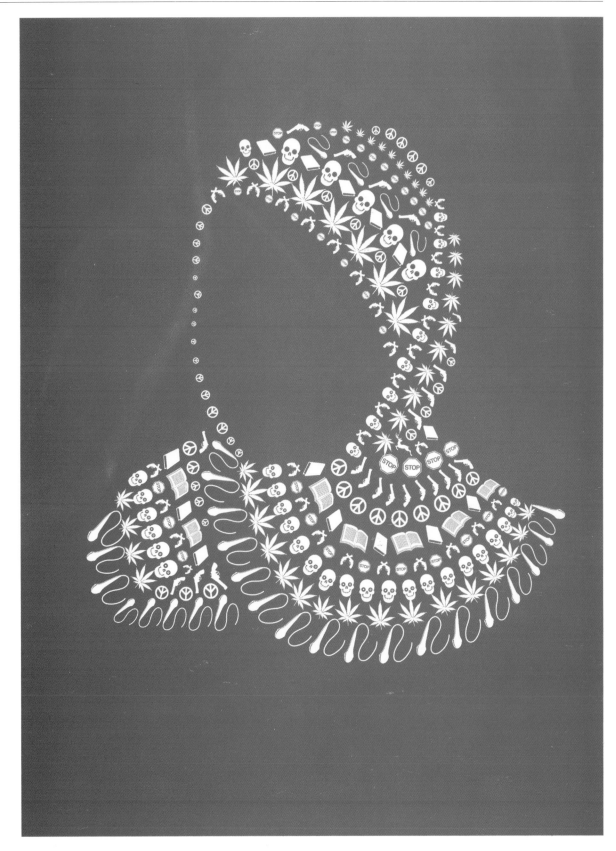

Volksbuurtmuseum: Buitenspel // 2003 //

The Dutch design studio NLXL designed the printed media for *Buitenspel*, a theater production by the Volksbuurtmuseum based upon interviews of thirty young people from "De schilderswijk", a multicultural residential area in The Hague. In the inter-

views the young people express their views on their expectations of the future. Under professional direction, the same young people brought distilled excerpts from the interviews to the stage.

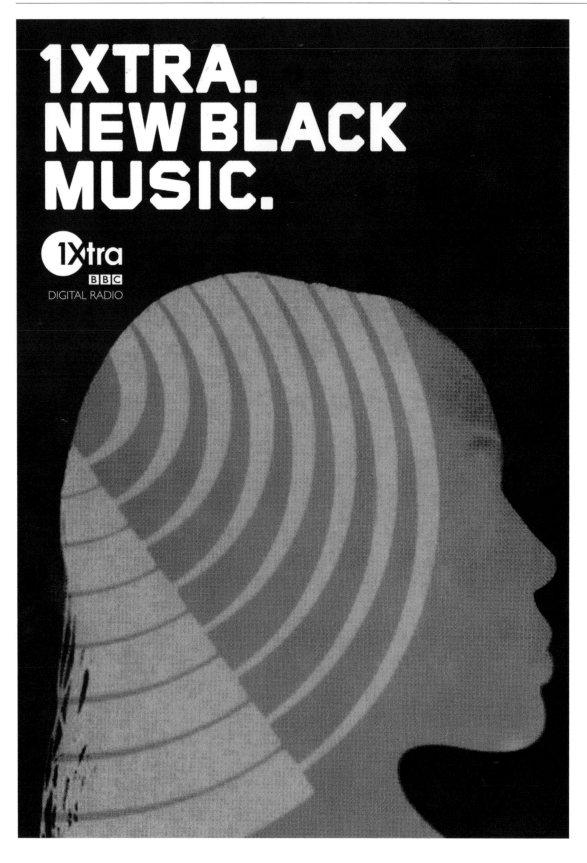

1Xtra //

The London-based design firm Blue Source developed a completely new visual identity for 1Xtra, a digital radio transmitter of the BBC that focuses primarily on current black music for a predominantly young audience.

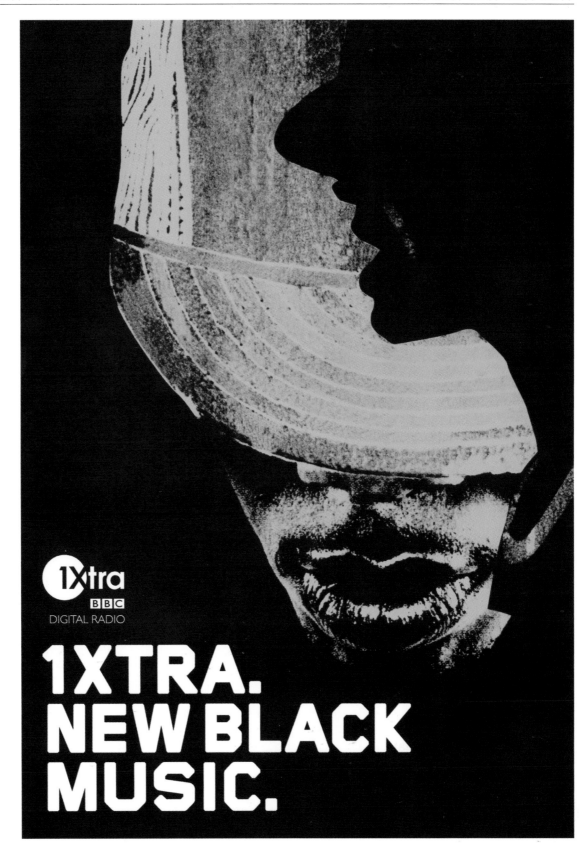

Filmstad presenteert

**tischePoë,
menteleExperi
en zinnigeKunst film**

 *film*FESTIVAL

18 & 19 november

vrijdag 14.00 - 01.00 uur
zaterdag 12.00 - 01.00 uur

Filmhuis Den Haag

www.filmstad.org

ontwerp: www.studioduel.nl | still: GONAH-E MARYAM van Parisa Shahandeh

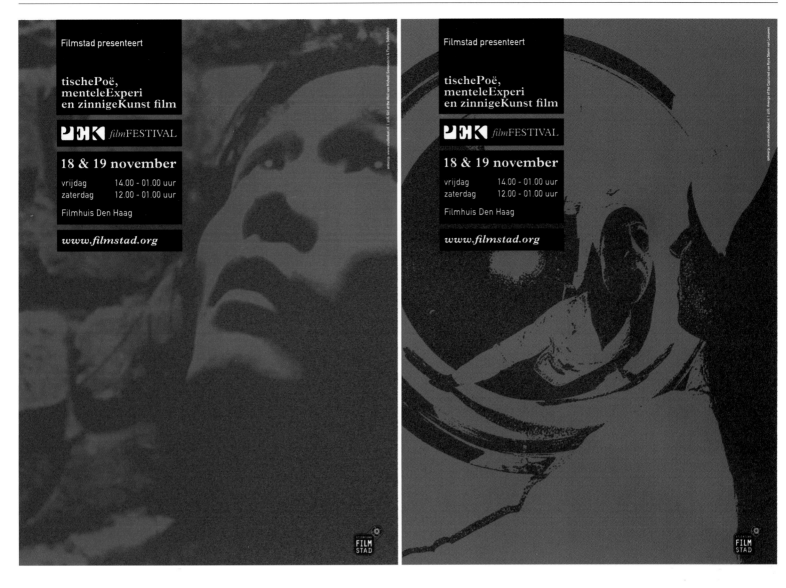

PEK Film Festival // 2006 //

In film all colors are created from the combination of three colors: red, green and blue. By means of various large portions of these three basic ingredients, the entire light spectrum can be represented. This knowledge forms the design concept that the that the graphic design firm Duel created for the advertising media for the contemporary PEK Film Festival in The Hague. For example, the contents of the program publication are placed on full-format monochrome background images that reflect the color tones of the light spectrum: starting with red on the title page to green in the center of the publication to blue at the end. The posters follow the same concept: each of the three posters is reduced to one of the three basic colors.

Duel // Hederik van der Kolk & Bas de Koning // The Hague, Netherlands // www.studioduel.nl //

While still studying at the Academy of Fine Arts in Arnhem, we were hired to design a bookcover for an upcoming new version of a Dutch Youth Bible. Our cooperation turned out to be so fruitful that after finishing this assignment we decided to work together under the name Duel.

Duel is mainly concerned with graphic design, but we are interested in everything that concerns visuals. Our activities are very wide-ranging. Up until now we did flyers, posters, brochures, corporate identities, book design, annual reports, websites, video performances and much more.

In particular, we are very content with the line of prints we are producing for Workspace. Every print we designed for this annually returning event represents a new attempt to capture the three -dimensionality of the exhibit hall in one two-dimensional image.

We have a weak spot for designers that know how to redefine themselves. Dare to make mistakes. Avoid the mainstream. It's good to know the outlines of the field you are placed in and then leave them far behind.

Our desktops consist of mainly computers and a bunch of mess. Often, the latter tends to fully cover the desk surface. We also have a sort of conference/relaxing/inspiration room. It houses a large table, a (filled) refrigerator, many books, and lots of magazines.

What's my nightmare? To wake up one day and find out all was but a dream, to find your colleagues are wearing ties and drinking coffee from plastic cups at a nine-to-five office job.

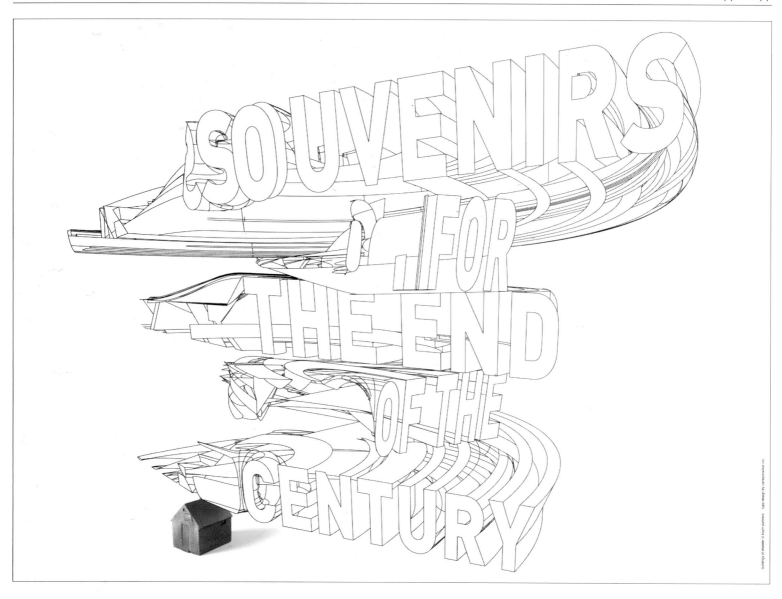

Souvenirs for the End of the Century //

The Boym Design Studio in New York created the catalog *Souvenirs for the End of the Century* and commissioned a cover by colleagues at the agency Karlssonwilker Inc. The latter worked feverishly on a 3-D title, which was to look "broken" some-how. The solution came in the form of a coincidental error in the software, which Karlssonwilker was able to use for the project.

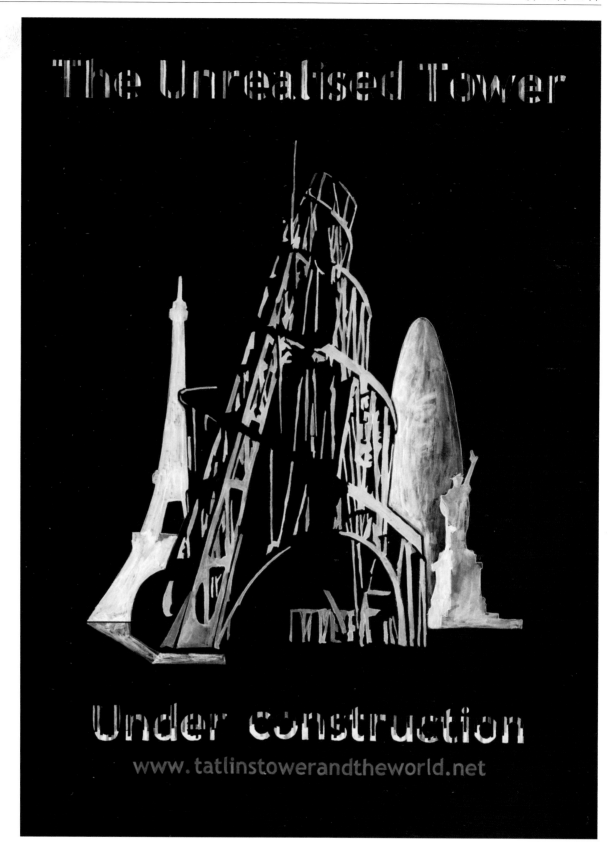

Tatlin's Tower // 2005 //

Tatlin's Tower is considered the Atlantis of Russian Constructivism: a never con-
structed utopia, created in the 1920s by Vladimir Tatlin based upon purely aesthetic
criteria and referring to the reconciliation of all peoples by its visual reference to
the tower of Babel. In addition, the tower is considered structurally unrealizable.
Despite this, or because of this, the English artist group Henry VIII's Wives took on
the building of the legendary architectural structure, although in numerous, dis-
jointed individual parts, scattered all over the world. In 2005, with a poster cam-
paign in the context of its Platform for Art program, the London subway drew the
attention to the artist group's initiative. The two designs by the graphic designer,
Sara De Bondt were subsequently included by Henry VIII's Wives in the exhibition
"PoPulism," which was shown in renowned museums in Amsterdam, Oslo, Vilnius
and Frankfurt.

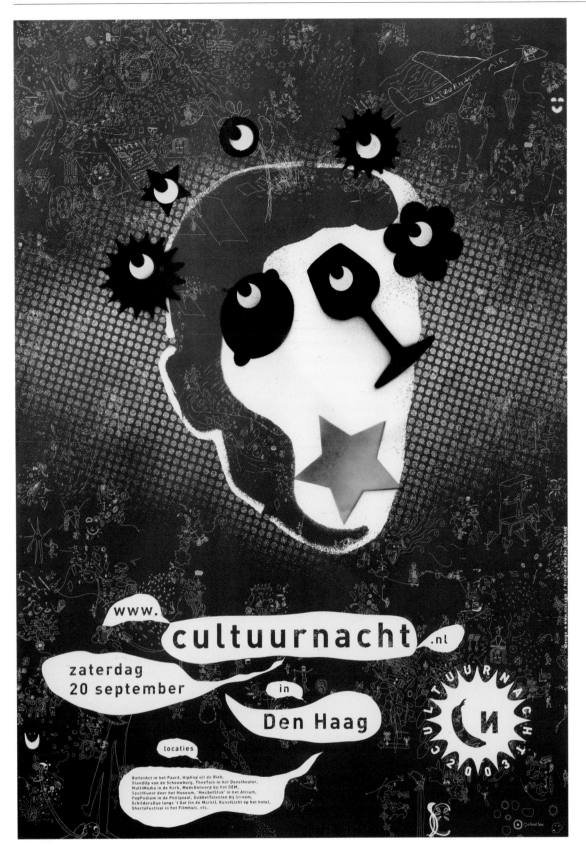

CultuurNacht // 2003 //

CultuurNacht is an annual festival in The Hague that seeks to draw primarily a young audience to the city's museums, theaters, dance and concert venues. The Dutch design studio NLXL is responsible for the entire visual communication of the festival. A specialty are the promotional posters for the year 2003: the posters were initially printed in one single color. Afterwards each individual one was handpainted using a spraycan. Thanks to this time-consuming graffiti procedure, each poster of this year is unique.

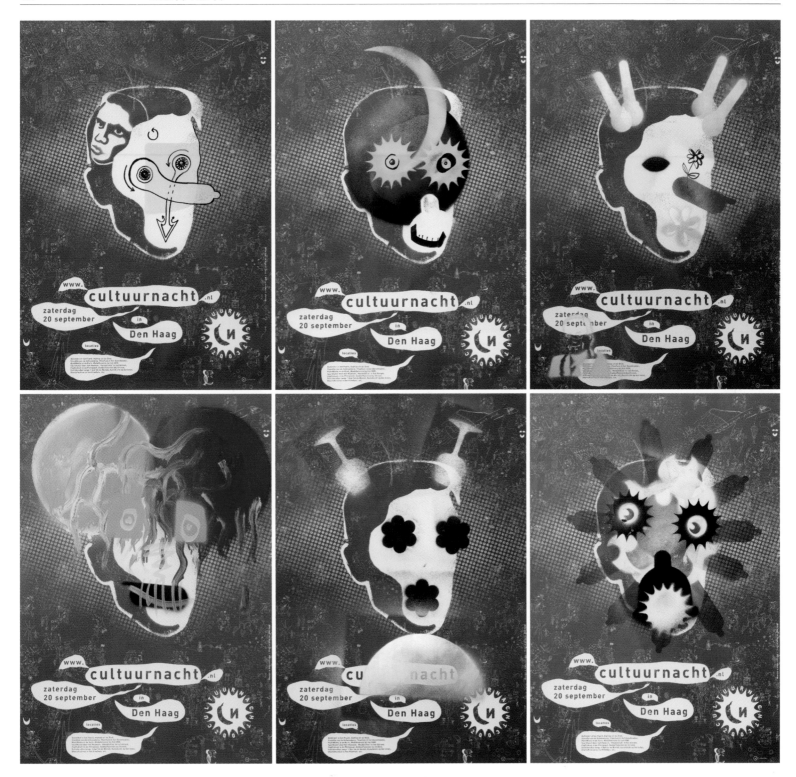

NLXL // Bob van Dijk, Oscar Smeulders, Joost Roozekrans // The Hague, Netherlands // www.nlxl.com //

We work in a big open space, a former art galley with only windows as a roof. We are all sharing the same workspace, so everybody knows everything of each other. There are two big speakers and a couple of iPods. We like to listen to loud music while we work. It is a mixture of system and chaos. In total there are 8 people working at NLXL.
Bob: At the moment, my desk is clean, but normally it is full of everything. I am a collector. I have a big collection of stuffed birds at the studio and a collection of artificial limbs. Wait till you come to my house for what you see, ha, ha, ha. I am a curious person, want to know everything and am interested in a lot of things.
Oscar: As for my desktop, I like to photograph and change my desktop photo often. Other than that, there are about sixty documents and folders. A bit messy.
Joost: I am an organized man. There is mainly work in progress on my desk and a few things that need to be archived.

Do we have a motto for work?
Bob: My motto is, that I don't want to feel like I am working. I want to play and to invent.
Oscar: My motto is simple: Have fun in work. Fun in things we design and fun in designing.
Joost: Be curious!
As in any design, we believe it is a strong idea that makes for quality in print design.
What guidelines or advice would we give to students of graphic design?
Bob, Oscar: No guidelines, just do it! Stay happy and surprise yourself!
Joost: Only study what you really want to study. That goes for every education, I guess.

Kong // 2006 //

Kong is a dedicated young gallery in Mexico City that produces, displays and sells everything that can highlight design, from toys to design books to T-shirts. On the occasion of their opening in May 2006, Kong gave thirty renowned international designers the commission to design posters that would have the marvelous epon-ymous gallery as a theme. The Australian graphic design firm Rinzen made a contribution by designing an illustration with their typical visual efficiency, in which a minimum of elements makes a great impression.

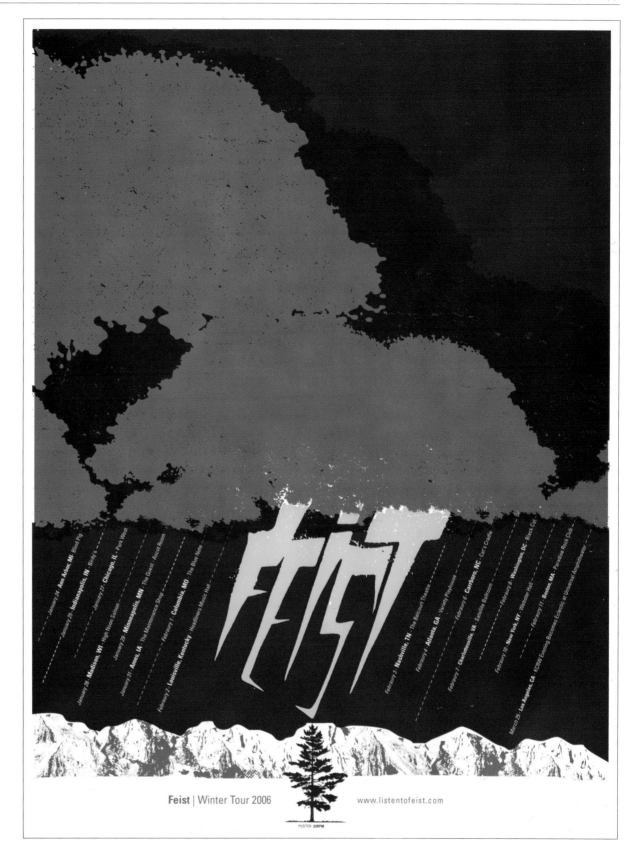

Feist | Winter Tour 2006 www.listentofeist.com

POSTER: 33RPM

Feist // 2006 //

Andrio Abero, a young designer in his own studio, 33rpm, in Seattle, USA, stepped into the international spotlight and out of the shadow of local prominence after receiving numerous prizes such as the Young Guns Award of the Art Director's Club. His speciality is posters, particularly for music festivals and bands. Although completely computerized, his poster designs often give the impression of handcrafted work, not least because of Abero's enthusiasm for traditional screen-printing technology. In this context, his preference for solid color surfaces, clear forms and a reduced color palette is noticeable. He usually tries to use as little text as possible, which he includes in simple fonts as a part of the image.

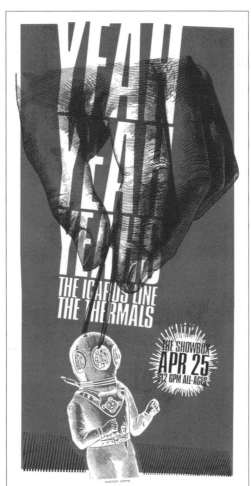

Pedro the Lion // *Catpower* // *Yeah Yeah Yeah* // *U.S.E.* //

33rpm // Andrio Abero // Seattle, United States // www.33rpmdesign.com //

My first exposure to the aesthetic I'm influenced by was when I lived near Portland, Oregon. I listened to and saw a lot of indie rock from there. I also saw a lot of posters by Mike King, but not knowing who he was at the time. The music I bought also had a lot of crazy design. I was also heavily influenced by the Built to Spill covers by Tae Won Yu. Moving up to Seattle I came upon the work of Jeff Kleinsmith, and enjoyed his expert use of negative space, typography, bold imagery and color.

Two works I remember as especially satisfying to make were "Primrosa" and "Drew Victor," both among the first posters I screen-printed. It was really exciting working with my hands, which eventually changed the way I thought about my design process.

My desktop? I'm a purist and I don't like clutter, so I keep my desktop at default setting and shortcuts to current project folders. Pretty boring huh? I just recently moved

into a new studio, which I share with four other designers, so it's pretty lively here. It's located in an old noodle factory that burned down twenty years ago and got renovated by a group of artists. We're on the corner of the building. It's flanked by two twenty-foot windows with a concrete floor. It's very industrial. Directly behind me is a piece of linoleum for breakdancing. I don't have much in the way of stuff; a computer table, drawing table, a large flat-file and some bookshelves.

My motto? I don't have one. Should I?

What aggravates me? Clients that ask you to make insert objects a little bigger!

And here are my top five:

eating good thai food / laughing uncontrollably / good weather / Apple products / friends and family.

Ratiaudio Empir //

"Ratiaudio Empir" is a multimedia performance project of the Dutch Sonido Gris, in which Remco van Bladel and Freek Lomme reduce rock music in abstracted form to four basic archetypical ingredients: percussion, bass, guitar and song. They achieve this by means of randomly selected viewers who use headphones to listen to a piece of music and indicate the respective "basic ingredient" by means of loud or soft playing of diskings of the spoken word "Drum," "Bass," "Guitar" and "Sing." The audience then hears a collage of the spoken words as an abstraction of the original rock excerpt. Analogous to the four basic ingredients, Remco van Bladel developed four typographic posters, which visualize the collage-like concept of the performance.

Sonido Gris // Remco van Bladel // Amsterdam, Netherlands // www.sonidogris.com //

People like Raymond Pettibon, Ed Fella, Karel Martens, *Purple Magazine* and Sonic Youth are some of my early influences. Today I draw inspiration mostly from contemporary art and avant-garde music. I work both at home and at Solar Initiative, which is based in an old sixteenth-century warehouse near Amsterdam's central station. It's a beautiful loft space with huge wooden beams.
Sonido Gris is a band and a small collective working on music and sound, video and

graphic design. When it comes to print design, what I consider quality is when design skills are mixed with original binding, choice of paper and inks.
Do I have a motto for work? Not really. Just be passionate, always try to learn more. I am aggravated by people who have no passions in life.
My worst nightmare? Becoming blind, I guess.
What advice would I give to students of graphic design? I think, the same things

Roger Willems (ROMA) taught me: Focus on your own qualities and learn to enjoy
to design and to initiate your own projects.
Here are my current top five:
Susanne / Making music, both solo and with Sonido Gris / screen-printing /
cutting paper type / listening to Tortoise while biking trough Amsterdam.

LAB is a think tank founded by Adam Pendleton. It began with his query into what really was a contemporary artist. How does a contemporary artist reach their largest audience in this global culture? How can they be the most effective? How can they make the world better?

LAB exists as an evolving answer to those questions. The transformation of an artistic practice into a think tank. A think tank that produces independent projects as part of its daily practice, and collaborates with persons invested in the cultural sector. A platform for a mapping of a mindset, which extends the notions of how a contemporary attitude towards art reaches into the world of design and branding, and how this contemporary attitude can be politically involved, revolutionary, and culturally engaged.

Pendleton approaches all of his work as projects where the conceptual means and motives behind his practice are questioned and reestablished each time. All projects are defined and influenced by the gradual development of central ideas, research, and an examination of the work as a sort of useable product.

LAB

lab launches history. history launches lab. the concept is simple. based on a fundamental understanding of what is serial. what could be serial and changing it. yet, trying to create the specifics of any potentially stock image and using those established characteristics for something a little soulful. a little dry. a little redundant. beat skipping and breaking. the image as the riff. the beat or rhythm of the riff the repetition. a perpetual claim to the right to space. to advertise. and maybe betray a past I know, but only through the present, and things are different. this is history.

so the most basic components communicate something different. the accessible or the inaccessible. the intellect which is the punk-rock. the unschooled, un-academic. layout and execution all made to bare through a good idea.

if an image loses its backbone when it's well-made it will find something else to support it. the spectator or the crowd. some things have to be made quickly to matter. history. in the urban environment. history. in the urban context. history. in the best way to live on earth. it could swell under a city and then take it over. what's the product? what's it got to give?

the abstract is covered by text. dates. more abstract overlays like grooves. grooves like tracks. what is representative is hard to read. the questions begin before the answers stop repeating. i come from all over. it comes from all over.

a hard earned guarded identity. the brand that burns. quiet like the wrong thing. the right thing. history. a change everyday. a proposal. a platform. our new structure.

LAB Posters //

When the New York-based graphic design firm Project Projects received the order to design two posters to communicate the founding of an artistic Think tank under the leadership of the conceptual artist Adam Pendleton, this Think tank did not even exist yet. In a certain way the poster was able to contribute to shaping the project. The designers of Project Projects let themselves be inspired by their concept of late corporate modernism.

Project Projects // Prem Krishnamurthy // New York, United States // www.projectprojects.com

We work in a small studio within an artists' collective in New York's Financial District. Our focus is on print, environmental, and interactive design projects, mostly for clients in the cultural sector, but we also produce a range of independent projects, like lectures, publications and events.
In our opinion, it is attention to detail, materials, and concept that make good print design. We are happiest with projects that allow us the highest level of involvement from conceptualization through execution.

Do we have a motto? No. Advice to students? Work all the time forever! A nightmare? Nuclear annihilation; alternately, nuclear destruction followed by the slow devolution of the species.
Five things we are crazy about?
Muriel Cooper / Hawkwind / HfG Ulm / F for Fake (Orson Welles's documentary about the nature of art —editor's note) / K. P. Wechselmann.

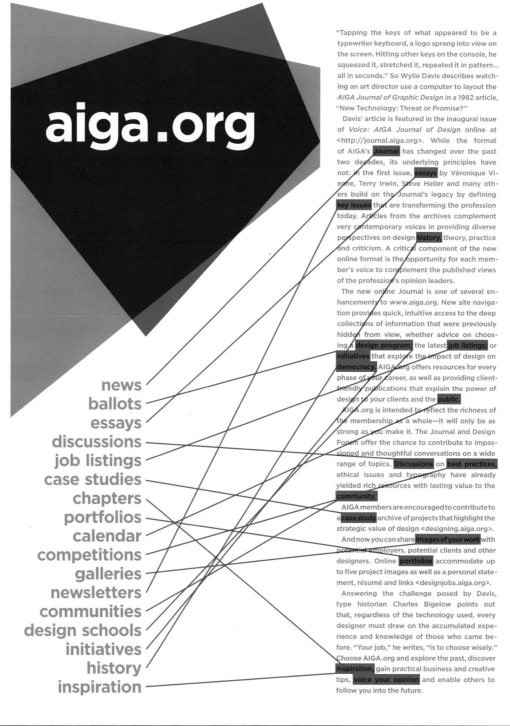

"Tapping the keys of what appeared to be a typewriter keyboard, a logo sprang into view on the screen. Hitting other keys on the console, he squeezed it, stretched it, repeated it in pattern... all in seconds." So Wylie Davis describes watching an art director use a computer to layout the *AIGA Journal of Graphic Design* in a 1982 article, "New Technology: Threat or Promise?"

Davis' article is featured in the inaugural issue of *Voice: AIGA Journal of Design* online at <http://journal.aiga.org>. While the format of AIGA's Journal has changed over the past two decades, its underlying principles have not: in the first issue, essays by Véronique Vienne, Terry Irwin, Steve Heller and many others build on the Journal's legacy by defining key issues that are transforming the profession today. Articles from the archives complement very contemporary voices in providing diverse perspectives on design history, theory, practice and criticism. A critical component of the new online format is the opportunity for each member's voice to complement the published views of the profession's opinion leaders.

The new online Journal is one of several enhancements to www.aiga.org. New site navigation provides quick, intuitive access to the deep collections of information that were previously hidden from view, whether advice on choosing a design program; the latest job listings; or initiatives that explore the impact of design on democracy. AIGA.org offers resources for every phase of your career, as well as providing client-friendly publications that explain the power of design to your clients and the public.

AIGA.org is intended to reflect the richness of the membership as a whole—it will only be as strong as you make it. The Journal and Design Forum offer the chance to contribute to impassioned and thoughtful conversations on a wide range of topics. Discussions on best practices, ethical issues and typography have already yielded rich resources with lasting value to the community.

AIGA members are encouraged to contribute to a case study archive of projects that highlight the strategic value of design <designing.aiga.org>.

And now you can share images of your work with potential employers, potential clients and other designers. Online portfolios accommodate up to five project images as well as a personal statement, résumé and links <designjobs.aiga.org>.

Answering the challenge posed by Davis, type historian Charles Bigelow points out that, regardless of the technology used, every designer must draw on the accumulated experience and knowledge of those who came before. "Your job," he writes, "is to choose wisely." Choose AIGA.org and explore the past, discover inspiration, gain practical business and creative tips, voice your opinion and enable others to follow you into the future.

news
ballots
essays
discussions
job listings
case studies
chapters
portfolios
calendar
competitions
galleries
newsletters
communities
design schools
initiatives
history
inspiration

AIGA //

When designers create print media for AIGA, they are speaking to their peers since AIGA stands for American Institute of Graphic Arts. Rob Giampietro and Kevin Smith of Giampietro + Smith in New York had complete freedom when designing a poster for AIGA's new website and decided to draw up-on historical poster design. They created visible parallels between current Web design and the works of Josef Müller-Brocmanns, the prominent theoretician and practician of the Swiss school.

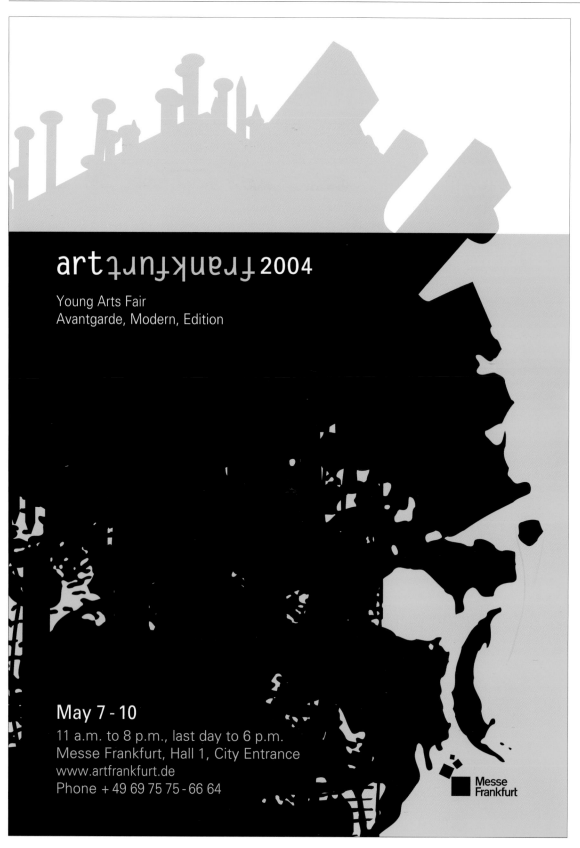

As a trade show for youthful art, every year "Art Frankfurt" wants to provide a representative overview of current trends in the international art market. The Frankfurt-based design firm Surface received the commission in 1994 to design a new identity for the trade show and developed a concept to visualize the fair as a showroom and traderoom for various types of art. They used exhibits from various participating artists and galleries, deconstructed them into smaller image excerpts and combined them into collages for new image modules. These modules were joined in ever-changing ways to the various printed media. By staying true to this method, the Surface design team could always showcase new perspectives at the art fair which were still connected to one another by means of a recognizable visual logic.

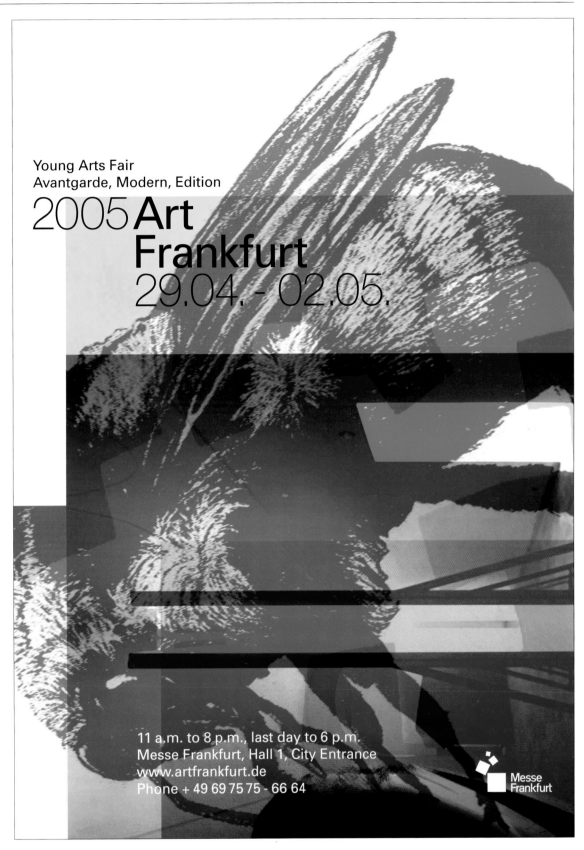

Young Arts Fair
Avantgarde, Modern, Edition
2005 Art
Frankfurt
29.04. - 02.05.

11 a.m. to 8 p.m., last day to 6 p.m.
Messe Frankfurt, Hall 1, City Entrance
www.artfrankfurt.de
Phone + 49 69 75 75 - 66 64

Messe Frankfurt

Surface // Markus Weisbeck // Frankfurt and Berlin, Germany // www.surface.de //

Surface, founded in 1997 with offices in Frankfurt and Berlin, creates texts and images for all imaginable media. From flyers to complex corporate identities, their work is always strongly conceptual in nature: they translate contents into visual and editorial communication, and distance themselves explicitly from classical advertising. The office has a clear affinity for art, not only in their clientele, which includes Art Frankfurt, the Forsythe Company and the Frankfurt Art Association, but also by means of numerous artist co-operations and free projects with so-called "emerging artists." In the year 2000, Surface also created the audio art label Whatness, a kind of audio gallery, which provides a forum for the co-operation of musicians and visual artists.

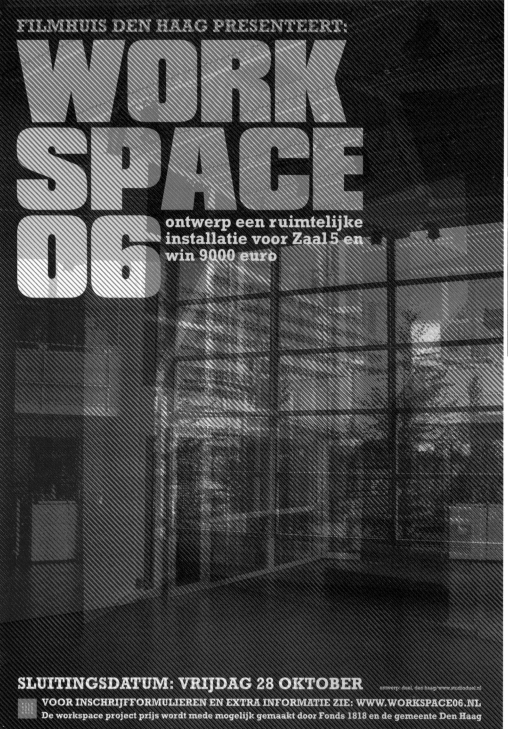

FILMHUIS DEN HAAG PRESENTEERT:

WORK SPACE 06

ontwerp een ruimtelijke installatie voor Zaal 5 en win 9000 euro

SLUITINGSDATUM: VRIJDAG 28 OKTOBER

ontwerp: duel, den haag/www.studioduel.nl

VOOR INSCHRIJFFORMULIEREN EN EXTRA INFORMATIE ZIE: WWW.WORKSPACE06.NL
De workspace project prijs wordt mede mogelijk gemaakt door Fonds 1818 en de gemeente Den Haag

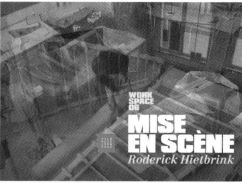

WORK SPACE 06
MISE EN SCÈNE
Roderick Hietbrink

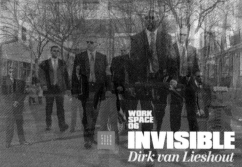

WORK SPACE 06
INVISIBLE
Dirk van Lieshout

Workspace 06 //

The Workspace competition at The Hague Filmhuis is about space: Film producers, designers and artists are challenged to create space installations in the modern Hall 5 of the Filmhuis. The representation of three-dimensional area on two-dimensional media such as print and screen also inspires the designers of Duel studio in their work for the festival. For the poster in the year 2006, they overlapped four screened photos of various corners of the exhibition hall: each of the images is printed in one of the four basic colors: cyan, magenta, yellow and black. Taken as a whole, the entire exhibition space is represented on the poster. For a flyer for the same event, the color cyan was replaced by metallic blue. If one holds the flyer against the light, the colors change and the two-dimensional "space perception" changes.

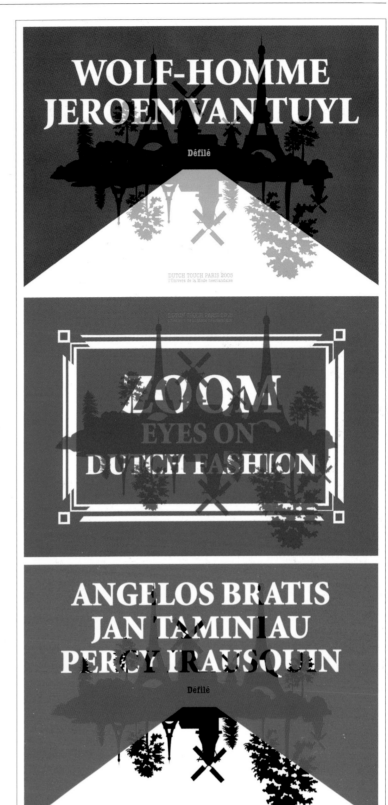

Dutch Touch Paris 2005 //

In 2005, the Dutch Fashion Foundation DFF presented young Dutch fashion designers in Paris and assigned the graphic designer Karen van de Kraats the design of invitation postcards for this "Dutch Touch" presentation. Karen van de Kraats had to integrate DFF's already-existing corporate identity into her designs. She put the titles of the exhibitions in semitransparent levels over the DFF logo and developed a series of illustrations into different combinations of the national colors of the Netherlands.

Vrijheidsfestival Den Haag // 2006 //

The "Vrijheidsfestival Den Haag" ("Freedom Festival") founded in The Hague in 2005 wanted to celebrate freedom and make us aware it is a lasting responsibility for each and everyone of us. It wanted to mark the occasion with a colorful, multifac-eted street festival with music, dance and cultural events. To accomplish this, the design studio NLXL from The Hague developed a comprehensive visual identity for the festival, which is shown in all print media from business cards to posters.

18-22 augustus 2004
www.grachtenfestival.nl

ontwerp: thonik

Grachtenfestival // 2004 //

Each year at the "Grachtenfestival" in Amsterdam the city's canals give the name for a series of concerts and events in one of the most popular events of the city. With their typical predilection for reduction to the essential, the designers of the Amsterdam-based agency Thonik developed a powerful typography for the festival's advertising banners and made these a starting point of the various print media of the festival.

なぜ彼らはそこに向かうのか？

写真家・小林キユウが自らも遍路道を旅しつつ、
そこで出会った若者32人ひとりひとりの
リアルでオリジナルな姿を美しい写真とインタビュー、
そしてエッセイで活写　1700円＋税　河出書房新社

Route88
小林キユウ
四国遍路青春巡礼

Route 88 //

The poster "Route 88" draws upon a book by the Japanese photographer Kiyu Kobayashi and was designed by the designer Tetsuji Ban, currently living in Tokyo.

Bang! Design // Tetsuji Ban // Tokyo, Japan // www.bang-design.com //

My early influences? Shohaku Soga, Yuichi Takahash, Ryusei Kishida. What do I consider quality in print design? Originality! What inspires me? My daughter. What aggravates me? Earthquake! What is my worst nightmare? Earthquake!

What guidelines and advice would I give to students of graphic design? Do not flatter it! A designer is a service provider.

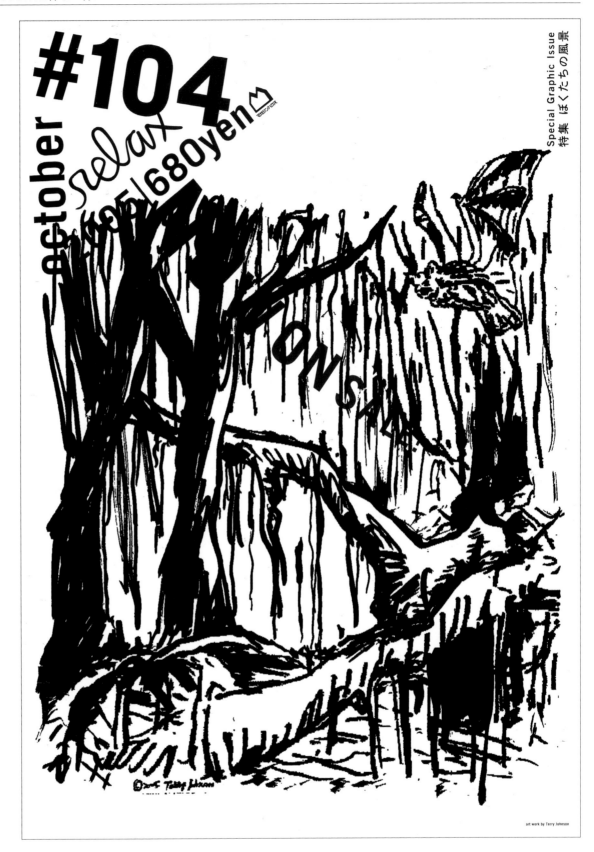

Relax // 2005 //

For the design of a poster for the Japanese culture magazine, *Relax*, Tetsuji Ban of the Japanese graphic design firm Bang! drew inspiration from the works of traditional Japanese masters. The overall poster is designed by hand and was also the cover of the *Relax* magazine in October 2005, a "Special Graphic Issue" which was completely planned, edited and designed by Tetsuji Ban.

hyperréalistes
en france
du 09/10/05 au 01/11/05
barraya, bodin, bowen, bricq

vernissage le jeudi 6 octobre à partir de 17h

galerie
art contemporain jacob 1
catherine et andré hug
9, rue de l'échaudé
75006 paris
métro // st germain des prés
ou mabillon

Les Hyperréalistes //2005 // 2006 // *Mise au point* // 2006 //

The posters of the Parisian "Catherine and André Hug Art Gallery" are created by Paris-based graphic designer Xavier Encinas in the firm Rumbero Design. Encina's predilection for strong typography often influences the design. The fold-out poster for the informational brochure for the photography exhibition "Mise au Point" was included in limited edition with a camera.

Rumbero Design // Xavier Encinas // Paris, France // www.rumbero-design.com //

Quality in print design? A good use of typography, a rigor on managing the layout and of course the "wow" effect. You know.

I think I don't have specific influences like Bauhaus or the Swiss School. Of course, like any other graphic designer I have my mentors: Michael C. Place, Cassandre, Experimental Jet Set, 123Buero.

One of my main clients is a little Parisian modern art gallery. They let me do what I want for every exhibition flyer. My favorite works are both works for "Les Hyperréal-istes en France." It was a great pleasure to work on a pure, typographical view. My motto? Have fun!

Advice to students? Don't know. I never went to a graphic design school. Went to business school. I know, it's a shame.

Five things I am crazy about?

My girlfriend / Michael C. Place / London / jazz trumpeters / typography.

n8 museumnacht // 2002 // 2003 // 2004 //2005 //

n8–the onomatopoetic translation of the Dutch word for "night" in a typography of only two characters–is the title of the Amsterdam-based museum night. In addition, this pointed reduction of the name is also an example for the clear image vocabulary and economy of means in which the design firm Thonik designed the posters for this museum night.

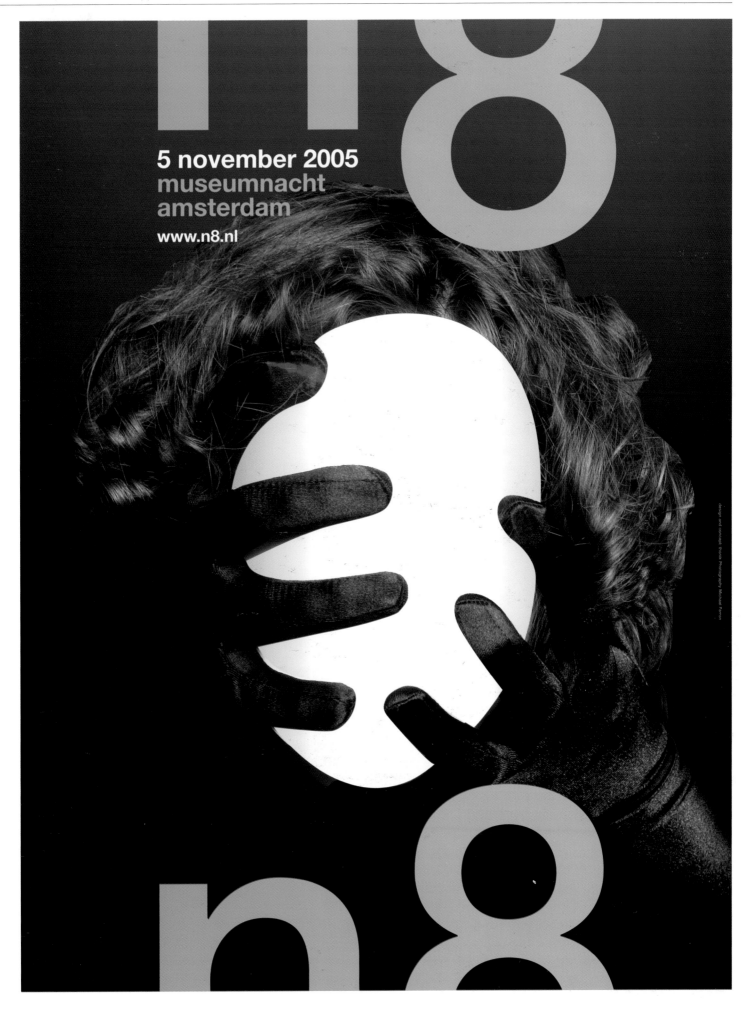

5 november 2005
museumnacht
amsterdam

www.n8.nl

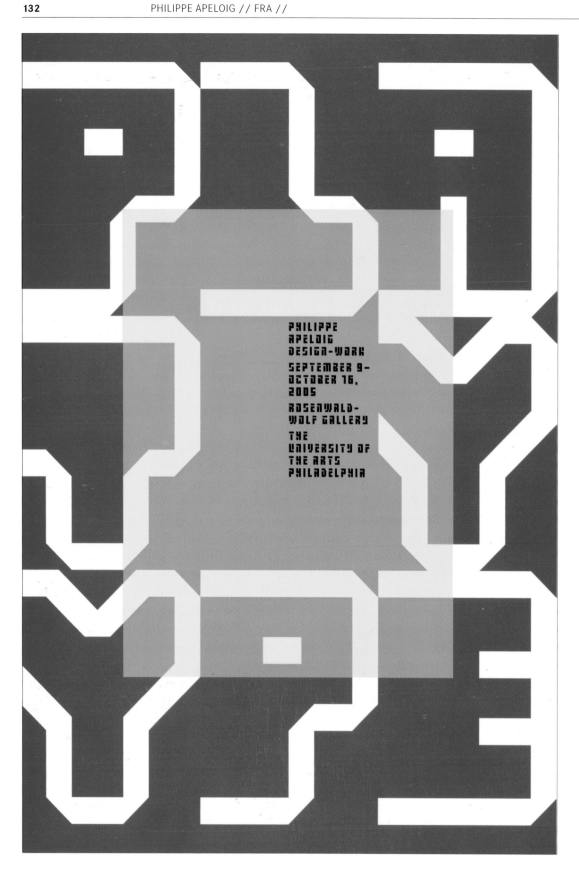

Play Type // 2005 //

"Play Type" is the title of an exhibition of works by the French graphic designer Philippe Apeloig in Philadelphia, USA, for which he designed the poster himself. The title is a reference to the French film Play Times by Jacques Tati and refers to the playful experimentation in the joy of typography enjoyed by the expert Apeloig, who succeeds again and again in transcending the communicative value of writing by treating the letters as an abstract image vocabulary.

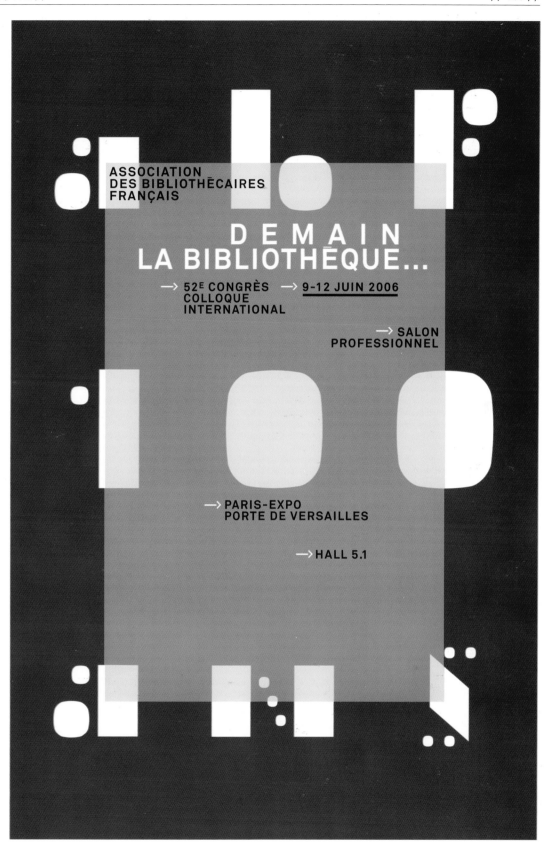

ABF // 2006 //

On the occasion of its 100th anniversary, the Association for French Librarians (ABF) gave Philipe Appeloig an order for a new visual identity. The French designer and typography specialist allowed himself to be guided in his design by the knowledge that, on the one hand, libraries are facing major changes based upon the digitalization of the media world and, on the other hand, they maintain their function as a location for study and dialog. He developed the typography of the poster in a visual vocabulary of an abstract floor plan in which the graphic elements recall symbols for tables, chairs and shelves. At the same time, it recalls the reduced stringency of the character forms of computer language.

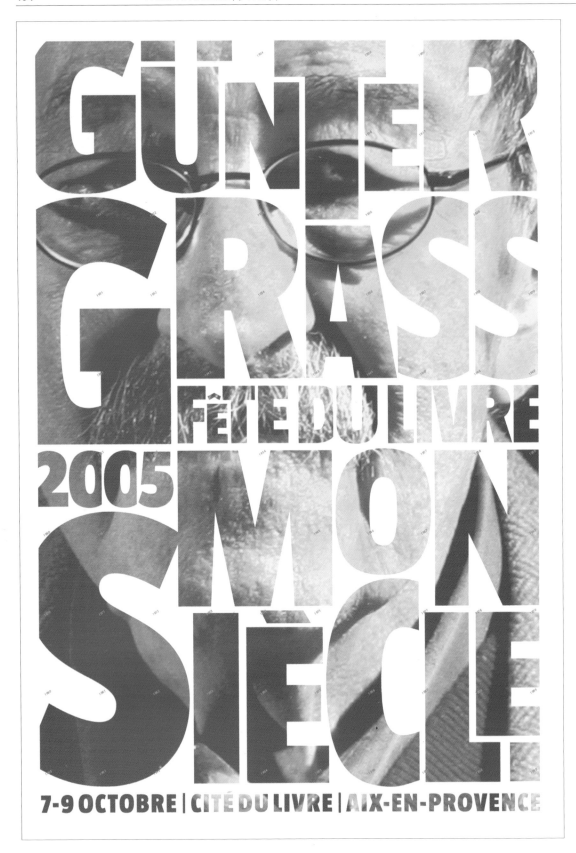

Günther Grass: My Century // 2005 //

Philippe Apeloig's poster for the literature festival "Fête du livre," focuses on guest of honor Günther Grass and his book *My Century*: a work that portrays, in 100 chapters, German history of the twentieth-century. Apeloig drew inspiration from the grand style and dense of prose of Günther Grass and expressed these features in the typography, which fills the entire space of the poster. The portrait of the artist is clearly visible through the letters and merges with his work. The size of the poster and the design of typography give Günther Grass grandeur and authority, and reflect his place in German literature as well as the title of his book. An additional reference to the book are the year numbers from 1990 to 1999 that Philippe Apeloig distributes in small numbers over the poster.

FASHION INSTITUTE ARNHEM PRESENTS GENERATION 7

ANGELA.AN TOINE.CAT ALINA.CAT TA.KATHRI N.MIESZKO. SHOKO.TUL AY. INVITE . YOU!!!

FlAgen // 2005 //

"Light" was the slogan of the seventh year at the Fashion of Institute Arnhem. The Dutch designer Karen van de Kraats knew that the showroom for the final meeting was to be decorated with mirror balls and also used this idea for the design of the invitation to that meeting. She set the typography of the invitation as a transparent mask over the photo of a mirror ball, thereby creating an abstract translation of the topic of light.

Bitte vormerken: 05/07/2001

Thurm & Dinges Planungsgesellschaft mbH

Wir wollen mit Ihnen feiern, und zwar am 5. Juli 2001, ab 17 Uhr
im Marmorsaal, Weißenburgpark, Stuttgart. Was genau es zu feiern gibt
und ein detailliertes Programm inklusive Einladung werden wir Ihnen
im Mai zukommen lassen. Bis dahin...

D

Thurm & Dinges
Planungsgesellschaft mbH
Friedrichstraße 10
70174 Stuttgart
Telefon (0711) 2 28 71-0
Telefax (0711) 2 28 71-49
Email info@thurm-dinges.com
www.thurm-dinges.com

Thurm & Gindes // 2001 //

In its design of an invitation to the 30th anniversary of the German engineering firm Thurm & Dinges, the graphic designers of the agency Brighten the Corners were guided by thoughts of the passage of time as well as the development from chaos to order. Instead of offering the usual DIN-length invitation in print, they designed two full-size posters, which were sent to the guests in a delayed manner. While the first A1 poster communicated only the date to the recipients, the second one communicated the event and place of the celebration. The numbers, which lie upon one another in a random manner, are sorted in the second poster to form a stack of increasing year numbers.

1971 – 2001

Thurm & Dinges Planungsgesellschaft mbh

Wir laden Sie herzlich ein, unser 30-jähriges Firmenjubiläum mit uns zu feiern
und würden uns freuen, Sie am Donnerstag, den 05. Juli 2001, um 17.00 Uhr,
im Marmorsaal im Weißenburgpark in Stuttgart begrüßen zu dürfen.

Lassen Sie sich von unserem Programm überraschen und genießen Sie einen
abwechslungsreichen Abend mit geistigen und kulinarischen Genüssen.

Bitte geben Sie uns bis zum 15. Juni 2001 mit beiliegendem Telefax-Formular
oder telefonisch Bescheid.

D

Thurm & Dinges
Planungsgesellschaft mbh
Friedrichstraße 10
70174 Stuttgart
Telefon (0711) 2 28 71-0
Telefax (0711) 2 28 71-49
Email info@thurm-dinges.com

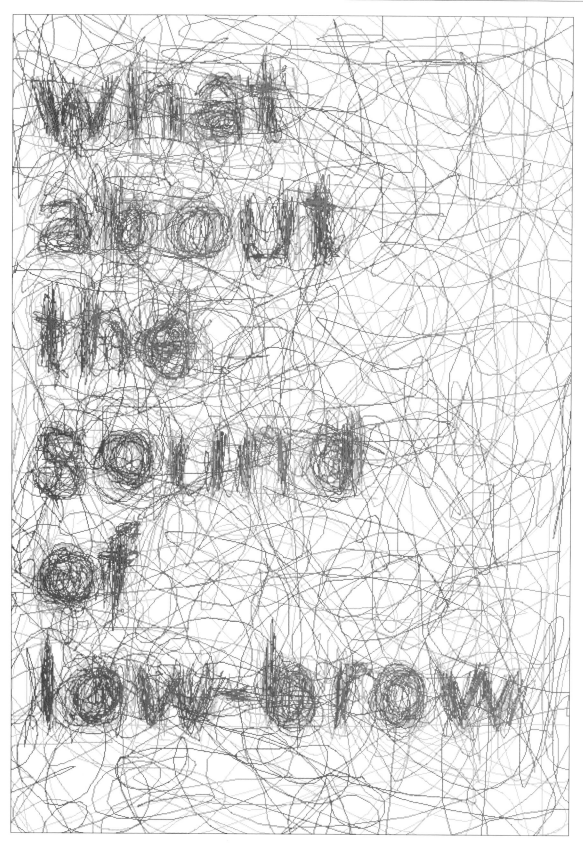

LOOS Festival // 1999- 2003 //

The LOOS Foundation, founded in 1982 by composer and multi-instrumentalist, Peter J. A. Bergen, is dedicated, in various ways, to new music that uses multimedia to integrate current technology, live electronic, digital composition and performance. Foundation events include the LOOS Festival for which the graphic design firm Lust, based in The Hague, has already designed several posters. Lust always uses the idea of a large-pixel typography, which is clearly developed as a computer-generated accumulation of fine lines and, in so doing, reflects the festival's affinity to software and computer-generated music.

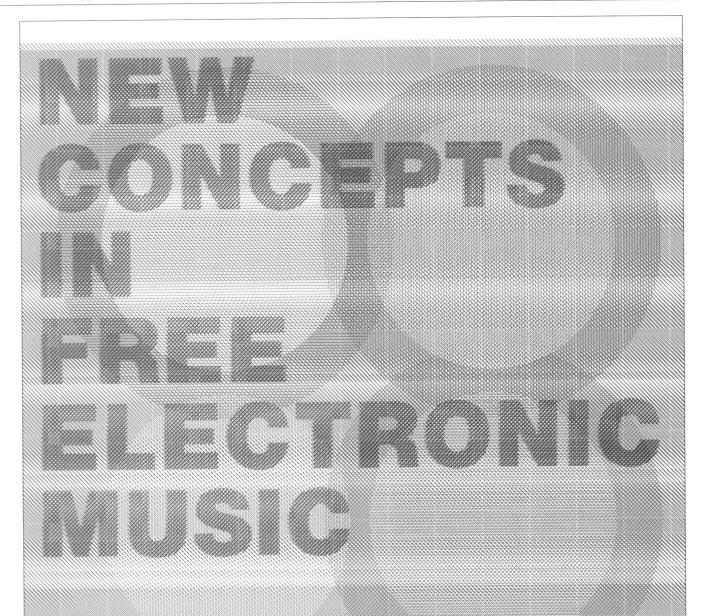

NEW CONCEPTS IN FREE ELECTRONIC MUSIC

LOOS 20 YEARS
7 FEB 03
KORZO THEATER
DEN HAAG

E-RAX (D, NL)	Felix Klopotek (D)	Bart Visser (NL)	Pita (A) / Tina Franks (A)	**7 February 2003** **Doors open: 20.00**
Electronic Music: Thomas Lehn Gert Jan Prins Peter van Bergen	Lecture: 'Directions In International Free Electronic Music'	Performance LOOS Ensemble (NL) New works	Powerbook + Live Images	**Korzo Theater** **Prinsestraat 42, Den Haag** **Reservations & information** **070 363 7540**
Live Image: Petra Dolleman				

www.loosensemble.nl A LOOS Foundation Production

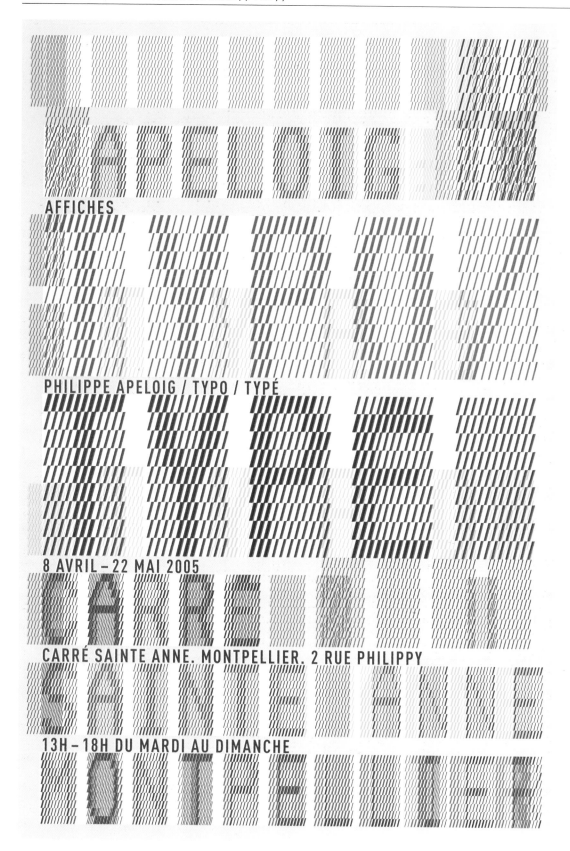

APELOIG

AFFICHES

PHILIPPE APELOIG / TYPO / TYPÉ

8 AVRIL – 22 MAI 2005

CARRÉ SAINTE ANNE. MONTPELLIER. 2 RUE PHILIPPY

13H – 18H DU MARDI AU DIMANCHE

Philippe Apeloig // Paris, France // www.apeloig.com //

Most of the posters are displayed in the streets, in the urban landscape. The inspiration for each design comes from a careful understanding of the subject matter of the poster. For the literature festival, I started the reflection by reading Günther Grass's book and trying to be informed about the country that it is about. I find most of my inspiration in the art field and the culture.

All the posters are silkscreen printing in large scale. I like to use the traditional inks that are opaque and rich in pigment. In that case the colors are extremely bright and powerful. The visual impact is strong. I also like to use transparency of certain parts of the poster to create a feeling of a three-dimensional space on a two-dimensional surface.

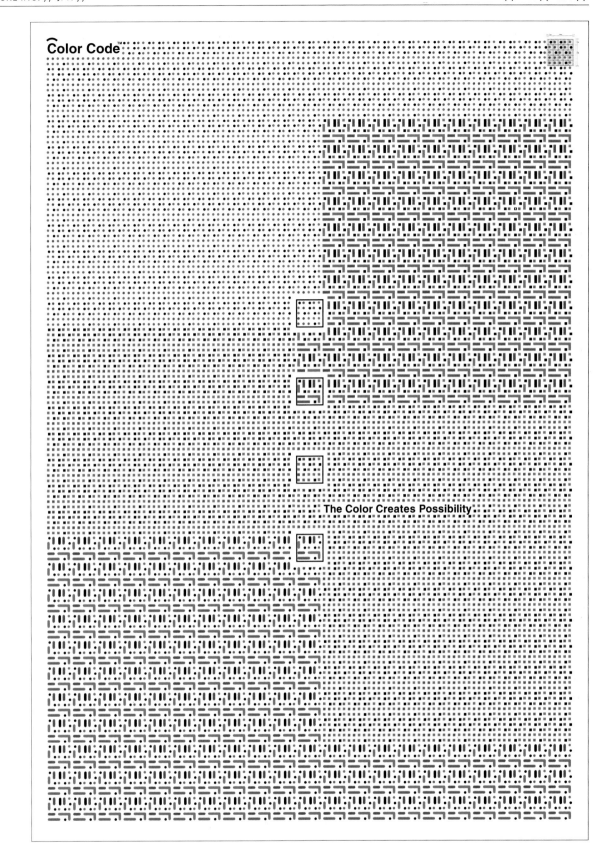

Inter Medium Institute: Color Code //

Shinnoske Sugisakis strength in designing appealing posters from abstract surfaces and geometric patterns is also shown in a poster for the exhibition of the Inter Medium Institute in Japan. The exhibition's topic of discussion is a new color code system, which allows Internet users to access websites by scanning a color code with their mobile phone.

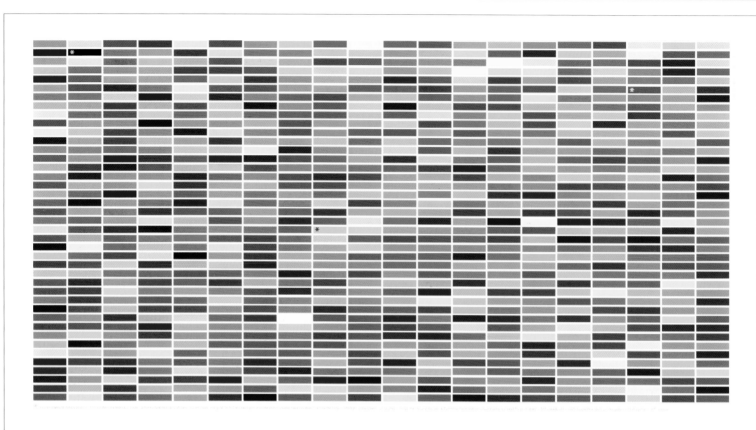

very german

DAAD Design Competition
DAAD London 1927–2002
email for further information and
entry forms: info@daad.org.uk

Very German // 2002 //

In the context of an extensive advertising campaign for German language instruction in England, this poster was developed, and refers to a creative competition on the topic of German clichés. The design office Brighten the Corners found an appropriate visual symbol for the cliché of Germans' love of order. For the poster, they had to define 820 individual colors. Included in the pattern are the official colors of the German national flag.

LES
TROMPES
L'OEIL

Our eyes are said to be windows to our very souls. But trickery is rife. Whether it be in art, love or knickers, do you know when your eyes are being deceived? Ron Beverage has a good hard look at the world of eyes, trompe l'oeil and internet porn hazards.

Surrealism
In art, the effect of creating a three dimensional perspective is often referred to as trompe l'oeil (for example, Edward Collier's *A Trompe l'Oeil of Newspapers, Letters and Writing Implements on a Wooden Board*). Other famous exponents include the moustachioed Catalan wrongcock Salvador Dali, whose famous sofa installation looked like Mae West's lips when viewed through the eye of a needle.

At home with trompe l'oeil
A quick look on the internet will reveal a wide plethora of trompe l'oeil mural painters, who specialise in transforming your home into a 3D smorgasbord of colour. For example, you could

have a scenic, dolphin-filled bay painted in an airing cupboard. Or, for your child's nursery, a happy woodland scene, with a wise-old owl standing in a tree wearing a mortarboard and reading a book of fairytales. With ten foot blood-drinking lizards devouring otters in the background.

The twenty yard rule
When you see an attractive member of the opposite sex approaching you down the road, withhold your judgement until they are at least within 20 yards of you. Trompe l'oeil will have you believe that a figure of beauteous splendour is approaching, when in fact on closer inspection it is a fanged hound.

Anna Sui's trompe l'oeil thong
Ladies, if your ass needs a trompe l'oeil, then this floral patterned thong will flatter to deceive.

Magic eye
In the nineties, many people were entranced by a new craze which involved staring at a

seemingly random set of patterns for a while, whereupon a secret image would appear. Newspapers like the Daily Mail would print these patterns every week. The rest of us had been receiving similar effects from strong drugs for years.

Miracle eyes
Via the wonders of modern technology, even if you're born half blind you can have near-perfect vision... without wearing glasses. Due to the miracles of laser eye surgery, a 5-minute operation can have your short-sightedness corrected, rendering those old beerbottles useless. Hallelujah! The catch? You have to have your eyeball sliced open and peeled back while you're fully awake. And you can smell the laser zapping your eye-meat.

PROTECT YOUR EYES!
Your peepers need protecting, whether it be from bacteria, dust, chemicals, ultra violet light, or the jabbing finger of a younger sibling.

• UVB rays can cause serious damage to the cornea, while UVA rays have been linked to cataracts. Whatever the science, you can avoid such risks by wearing sunglasses: it's very simple.

• Eyes should be examined every five years at least: not just for sight, but for early signs of glaucoma.

• Prolonged viewing of a computer screen can result in computer vision syndrome (CVS), especially when combined with prolonged and excessive masturbation.

• Sports are the biggest cause of eye injuries in the UK. Playing squash alone accounts for over 4000 incidences of injury per year.

One more point: if you find blindness gets in the way of pulling a blonde estate agent then why not try bribes such as offering your flat rent free or maybe dinner with the Blairs?

You may be eligible for a free eye test on the good old NHS – check www.nhsdirect.nhs.uk or ask at your local GP surgery for more details

For more information on eye conditions and eyecare charities, have a butchers at:

www.eyeuk.com. Hundreds of links to relevant eye-related sites

www.eyecare-information-service.org.uk/ steeleyecaretrust. Set up to raise awareness of all aspects of eyecare

For the next two weeks dontpanicmedia.com will be dedicated to the theme of the senses, with lots of articles, designs, images and links. Log on and contribute your musings or just check out what people are saying.

Poster designed by Patrick Duffy
www.utah.co.uk
www.fullmoonemptysportsbag.com

When Patrick Duffy received the order from the London-based design firm No Days Off to design a poster to advertise medical vision tests, he remembered images that had already fascinated him as a child: the Ishihara color test boards. The Japanese professor Dr. Shinobu Ishihara developed his test patterns in 1917 to diagnose color-blindness.

Theater Brava! //

The Japanese designer Shinnoske Sugisaki designed his logo for the multi-purpose theater "Brava!" as a visualization of the Italian meaning of the theater term: a rejoicing call for female actors. Correspondingly, his logo is a typographic showcase of joy and applause. The individual elements of the typologos are arranged, multiplied and changed as needed. As an example of the posters on display, the form vocabulary of the title was expanded to a full-size pattern.

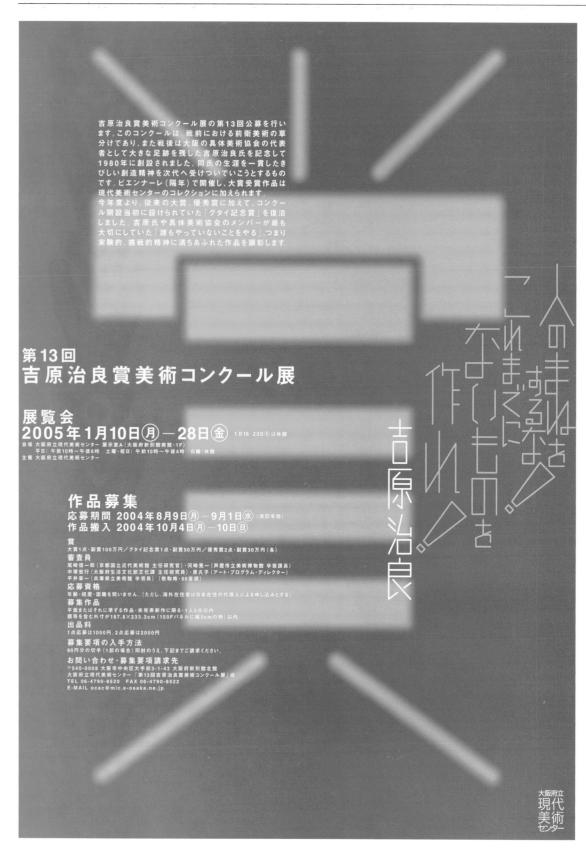

More than 3,000 Chinese ideograms are also used in Japanese, where they are pronounced differently. Their pictographic meaning, however, remains the same. In some of his posters, the Japanese designer Shinnoske Sugisaki showcases these pictograms spoken by 1.5 billion people in various languages as design-shaping visual elements. In this way, his posters for the Yoshihara Art Prize of the Osaka Contemporary Art Center are full-size variations of the same "kanji."

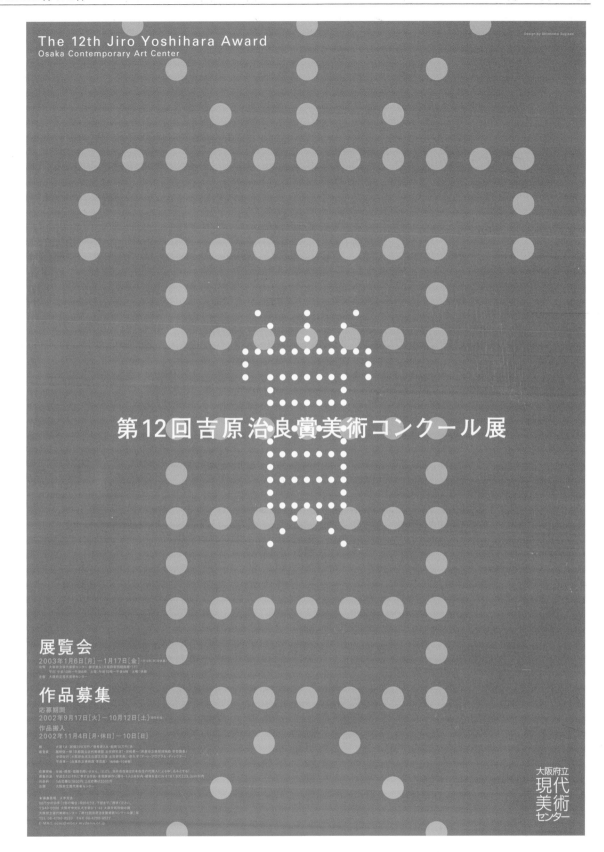

A325

A325 – W123

A325 – 1546

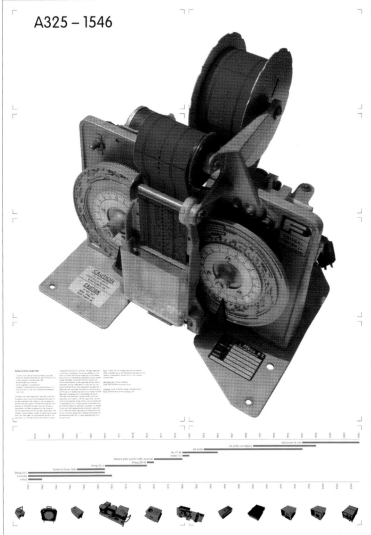

A325 // 2005 //

For a nine-part poster series about the road that connects the two Dutch cities Arnheim and Nijmegen, the graphic design team of the Dutch firm Catalog Tree concentrated on the translation of technical facts into visual form. While in some posters the source of the inspiration remains unintelligible–for instance in Poster 9, upon which the installation plan of a loop detection system is shown–other ideas are strongly encrypted. For example, the meandering serpentine form on Poster 8 is a translation of data regarding traffic volume at major intersections. For some of these graphic conversions, the Catalog Tree programmed its own graphic design software.

Catalog Tree // Daniel Gross, Joris Maltha // Arnhem, Netherlands // www.catalogtree.net //

Early influences?
Star Wars / Béla Bartók / stereo photography / Stanley Kubrick / Beach Boys / Early maps of the Dutch Land Registry Office / Rick Ringers / SINCLAIR ZX81 with additional 35 kilobyte of memory.
What we like in print design is imperfection as a design strategy, and attention to detail.
Our desk is a 7,2 m2 rectangle set up in the middle of the room. On top of it: an Olivetti coffee mug, a magnifying glass, paper samples, pushpins.

What aggravates us? A conference call using Skype.
What is our worst nightmare? Redesigning the Powerpoint template "communicating bad news."
Advice we would give to students of graphic design?
"Glattes Eis, ein Paradeis, für den der gut zu tanzen weiß." (Nietzsche)
Here are five things we are crazy about:
Ferrite Compact Cassette / 5 1/4-inch minifloppy / 3 1/2-inch microfloppy / syquest 24 cartridge / Permanent magnets.

A325

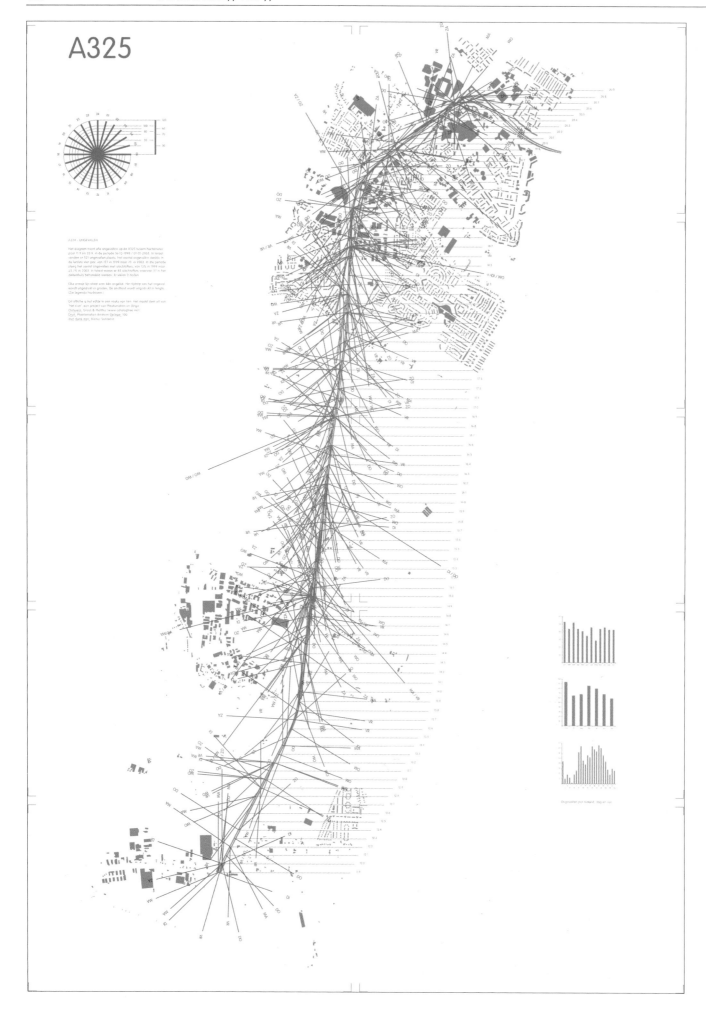

A325 – N325

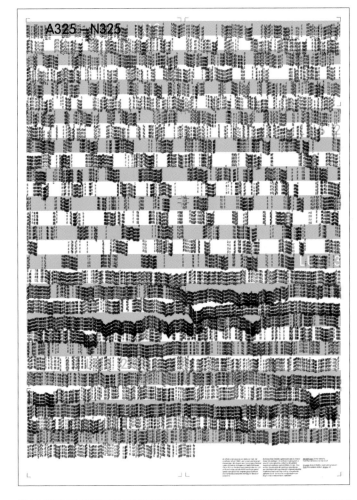

A325 – slot car

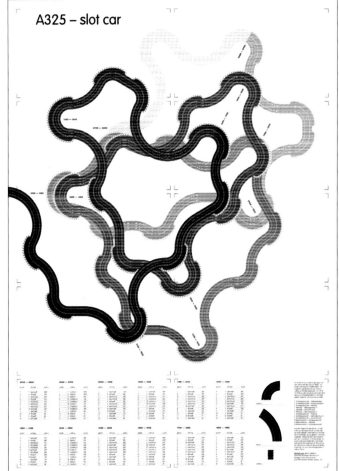

A325 1:14 000

A325 – DETECTIELUS

Mono Psychodelic-A // 2005 // *Print with Love* // 2004 //

"Print with Love" could be both the slogan and characterization of the London-based designer Michael C. Place and therefore served as the title of an exhibition of works by the trailblazing designer in Manchester's book gallery Magma. The event poster was appropriately designed by Michael C. Place himself, elegantly minimal in metal-lic bronze and fluorescent pink tones. A similarly independent stylistic vocabulary and colorful minimalism also characterize his poster for the 25th anniversary of the newspaper *Creative Review*, in whose Peer Poll, Michael C. Place was selected as one of the most influential designers of the year 2004.

glocal proportion

Glocal //

"Glocal" was the title of an international university symposium with events based on the topic of global networking and local identity in the fields of design and visual communication. The Japanese designer Shinnoske Sugisaki designed posters in which he transformed statistics about the countries and continents in question into geometric shapes that, in their analytical clarity, recall aesthetic diagrams.

Shinnoske Inc. // Shinnoske Sugisaki // Osaka, Japan // www.shinn.co.jp //

My early influences? Printing dots on a paper.
What does my working environment look like? Men at work
Do I have a motto for work?
I have my design check list: Essential? Concise? Progressive?
What inspires me? Finding.

What aggravates me? Phone ringing.
What is my nightmare? Typo!
What guidelines and advice would I give to students of graphic design?
Look at everything around you. Find design in everything around you.

Daniel Eatock // London, United Kingdom // www.eatock.com //

What inspires me?
Reading / Cooking / Cycling / Seeing / Discovering / Conversation / Art / Flávia / Sleep.

What aggrevates me?
Dropping Litter / Urban 4x4's / Blocked Cycle Lanes / Religion / Junk Email / Telemarketing / Smoking / Ignoring People / Perfume / Dumb Advertising / Drunk Driving / Copying Ideas / Objectification / Dumping Car Batteries / Free Pitches / Sugar in Coffee / Hitting.

Early influences?
Steven Wright (comedian) / Dan Forster (high school friend) / Nirvana (Seattle grunge band) / Ayrton Senna (F1 Driver)

I believe, qualities that make good print design are humbleness, appropriateness of material. Say YES to fun, function, and NO to seductive imagery and color!

If you want to know more, check out my manifesto at www.eatock.com

Postcard Back Compositions

1. Archetypal
2. Reflected
3. Opposite
4. Portrait
5. Big Message Small Address
6. Small Message Big Address
7. Disjointed

Daniel Eatock /1000
First Edition Published 2006
ISBN 0-9551194-1-3

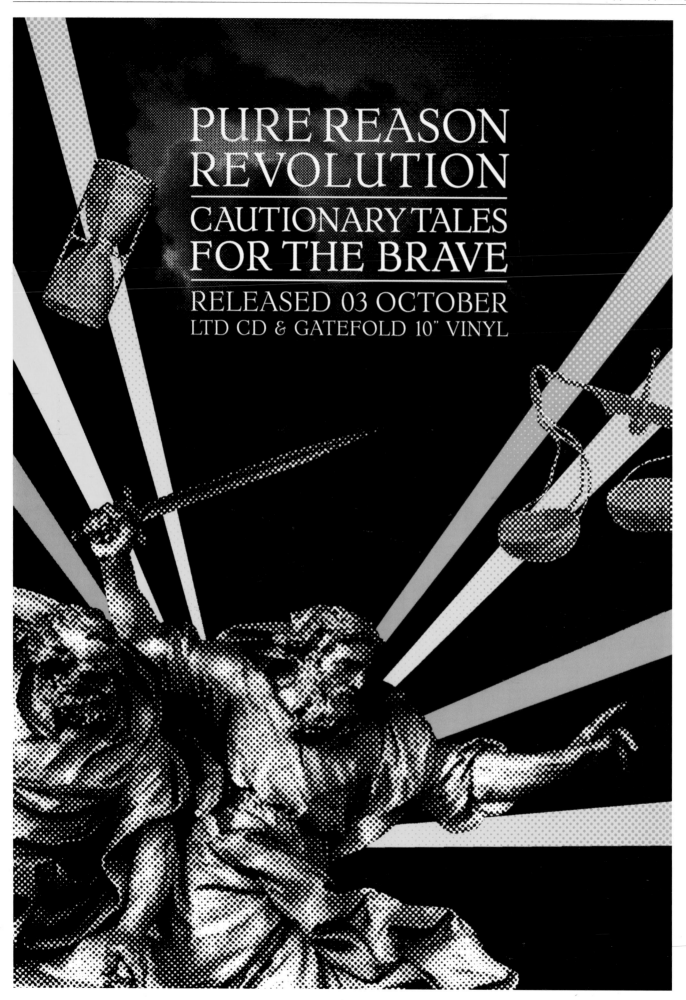

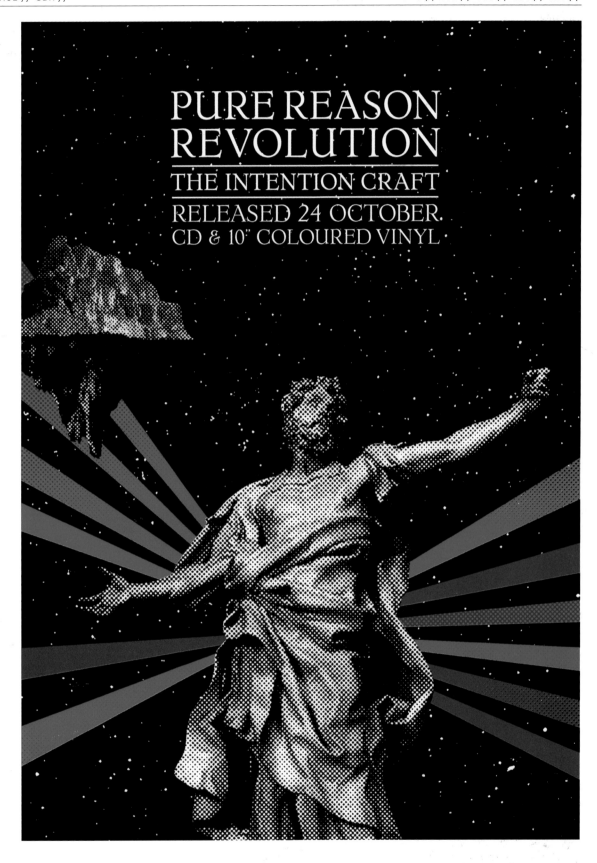

Pure Reason Revolution //

The music of the British rock bank Pure Reason Revolution showcases a strong affinity for pagan mythology and mysticism by means of abstract and associative texts. The London-based design firm Blue Source, drew inspiration from this for an album cover, for which it used images by a little-known underground artist named Jessen.

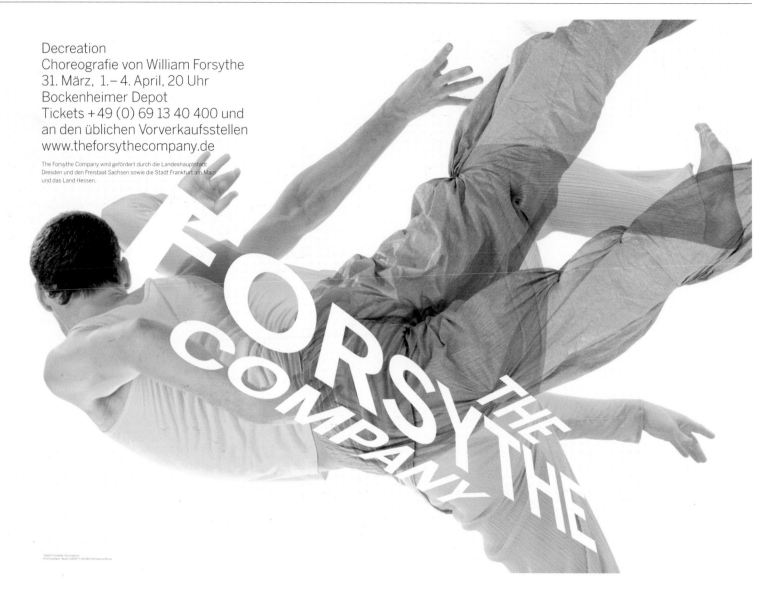

Decreation
Choreografie von William Forsythe
31. März, 1. – 4. April, 20 Uhr
Bockenheimer Depot
Tickets + 49 (0) 69 13 40 400 und
an den üblichen Vorverkaufsstellen
www.theforsythecompany.de

The Forsythe Company wird gefördert durch die Landeshauptstadt
Dresden und den Freistaat Sachsen sowie die Stadt Frankfurt am Main
und das Land Hessen.

The Forsythe Company // 2005-2006 //

The advertising media of the internationally renowned dance ensemble The Forsythe Company has been designed for years by Frankfurt design firm Surface. Markus Weisbeck's design team addresses the particular challenge of communicating powerful movement in three-dimensional space using two-dimensional posters and flyers by means of various design media: collage-like entangled dance photos create lightness and dynamism; the typography of the ensemble name is set as a kind spatial object in the multilevel image composition.

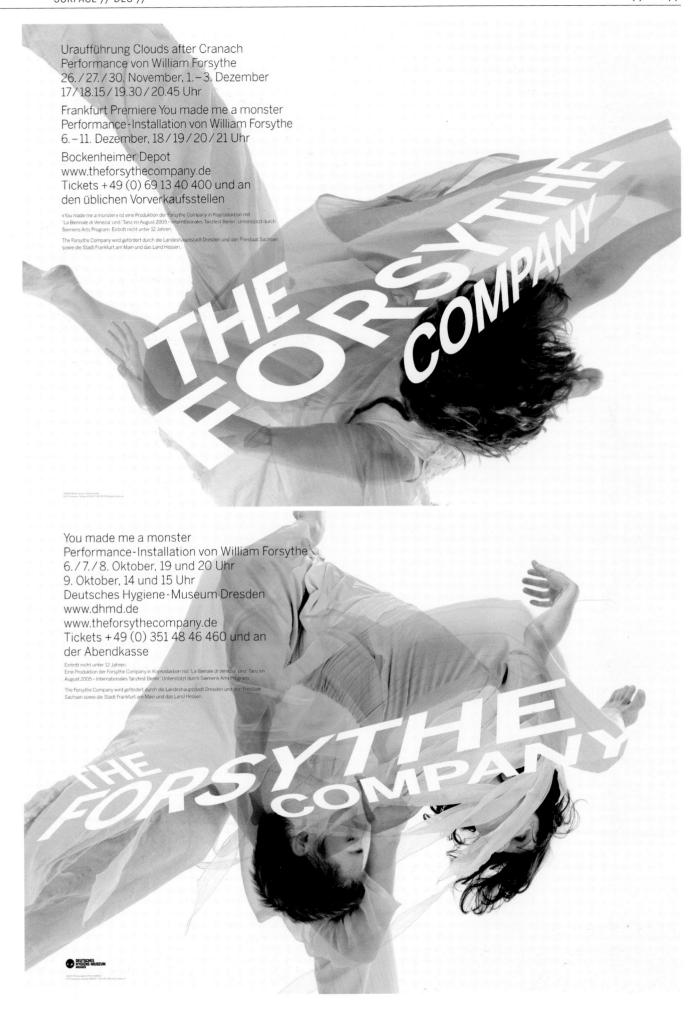

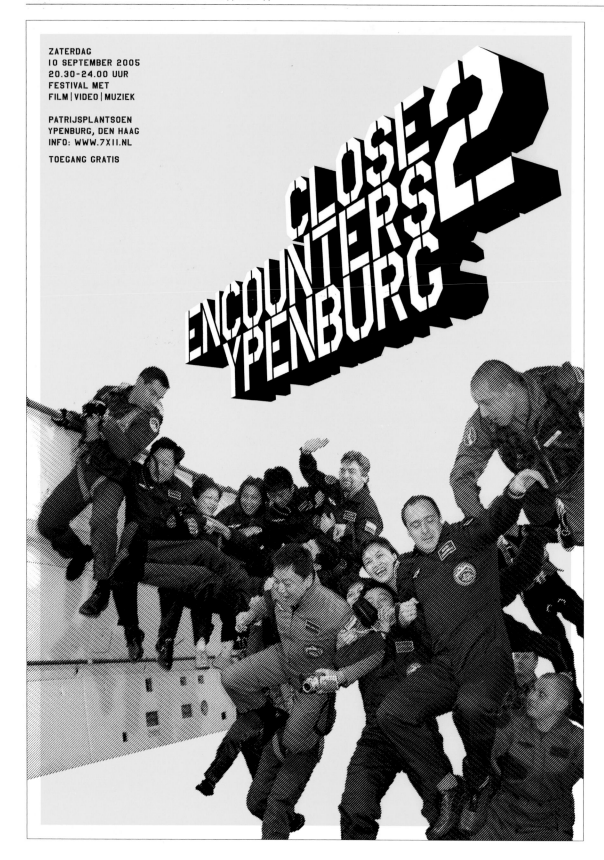

Close Encounters Ypenburg // 2005 //

The Dutch city Ypenburg was developed completely on the site of a former airport; the runways became roads and the air traffic control tower still stands today. In its printed media for the Close Encounters film festival, the graphic design firm Catalog Tree from Arnhem plays upon the unique character of the location.

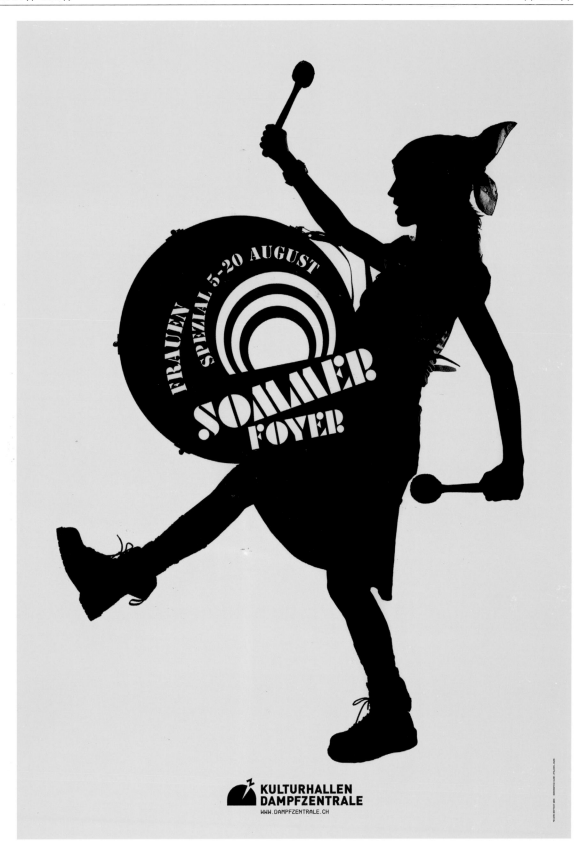

Sommer Foyer // 2005 //

The Dampfzentrale culture halls, a center for contemporary culture in Bern, gave the poster commission for "Sommer Foyer" 2005 to the Bern-based office Destruct. Marc Brunner, a founder of the internationally renowned firm, drew inspiration for the poster from the striking style of Russian revolution graphics, as well as his weakness for bass drums and trumpets, and photographed his girlfriend with a bass drum in front of her for the stamp-like translation of his idea in the signal colors yellow and black.

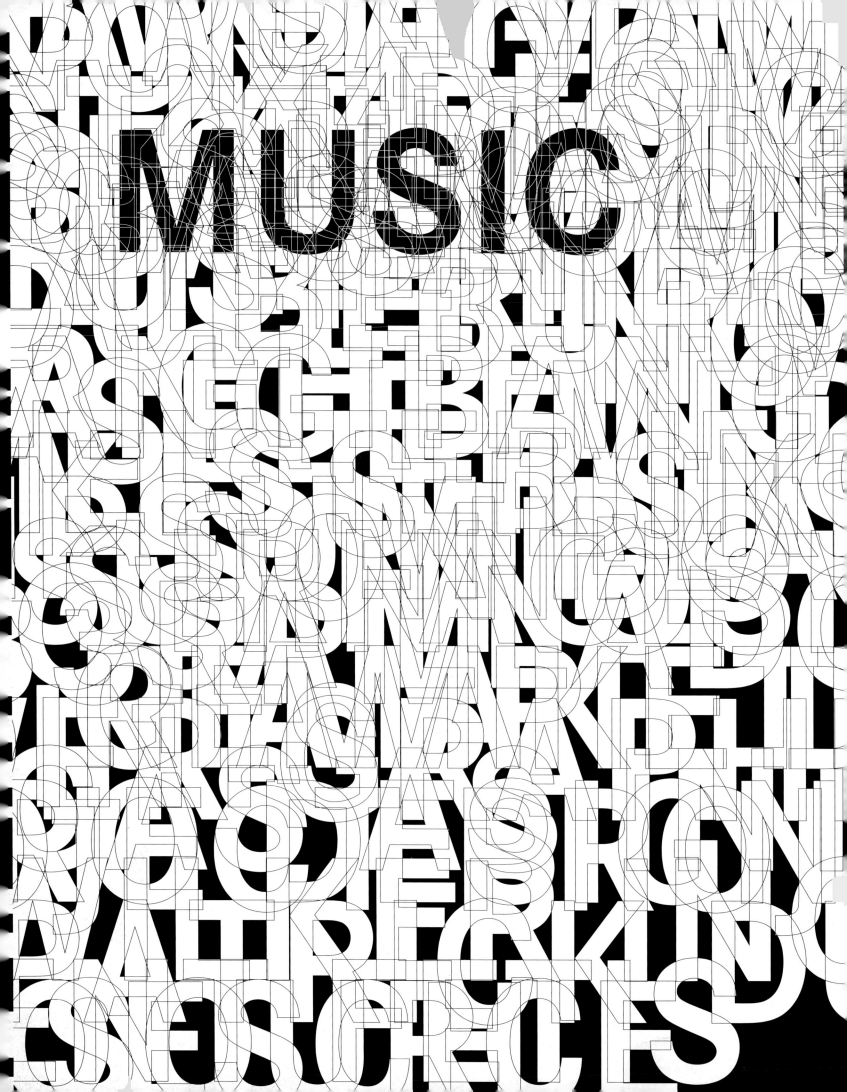

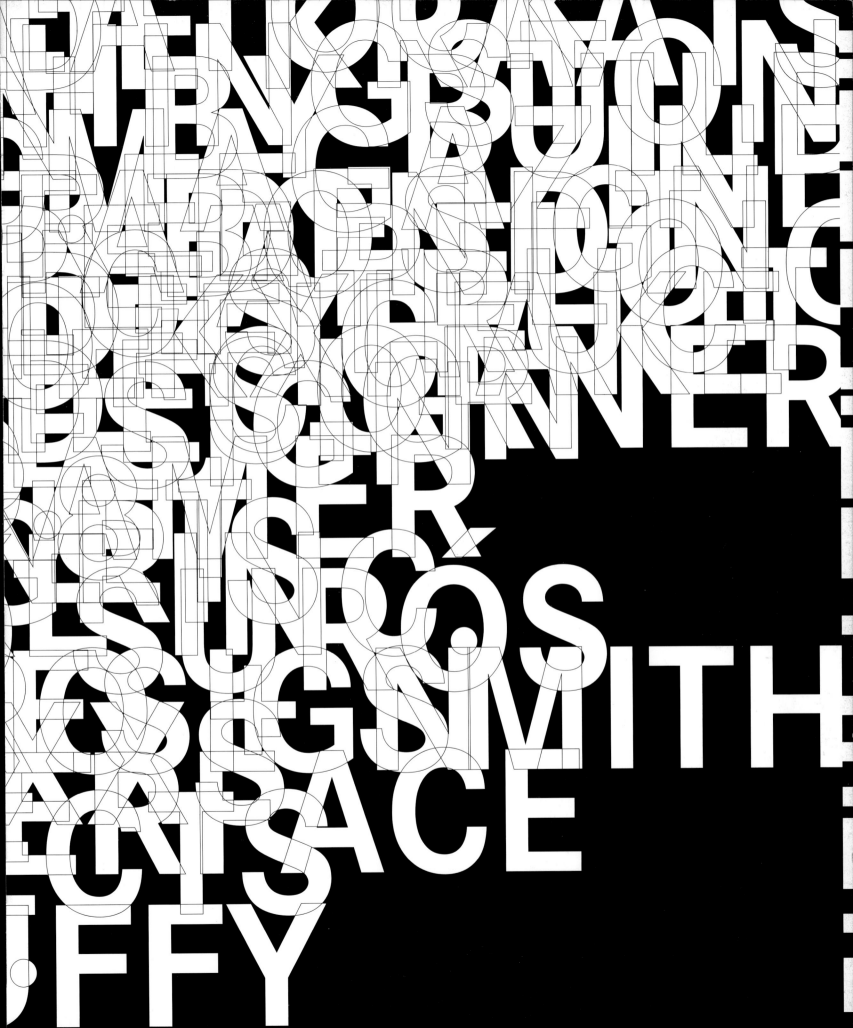

Ponyloaf // 2001-2006 //

Ponyloaf is an avant-garde rock band from Brisbane, Australia, with an affinity for pixilated grooves and electronic sounds, whose music retains warmth and playfulness, which differentiates the trio from Down Under from other electronic bands.

The design firm, Rinzen, also located in Brisbane captured these musical characteristics in their illustrations for the cover and booklet of the album, "Epic Travels."

Rinzen // Brisbane/Sydney, Australia // Berlin, Germany // www.rinzen.com //

Australian design collective Rinzen is best known for the collaborative and illustrative approach of its five members, having formed as a result of their RMX project in 2000. In addition to their own book published by Germany's Die Gestalten Verlag, Rinzen's work has appeared in numerous design and art books and in magazines

such as Nylon, Relax and Tokyo. Rinzen's large-scale artwork has been installed in Tokyo's Zero Gate, their posters and record covers exhibited at the Louvre in Paris and their visuals incorporated into the shows of electronic musicians such as Kid606.

Bob Marley & The Wailers
Africa Unite:
The Singles
Box Set

Bob Marley //

At the center of the widely distributed activities of the London-based creative team Blue Source lies the ability to find a coherent and inspired image vocabulary for the visualization of music. Long before drawing attention to themselves by means of original music videos, they designed successful album covers. A current example from this category is the cover design for a Bob Marley anniversary compilation.

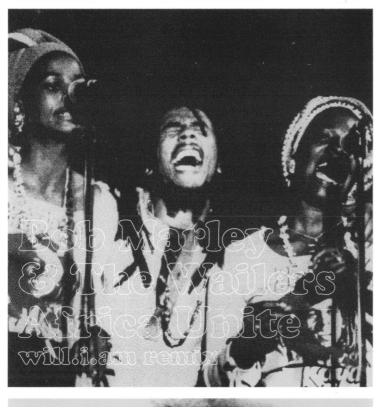

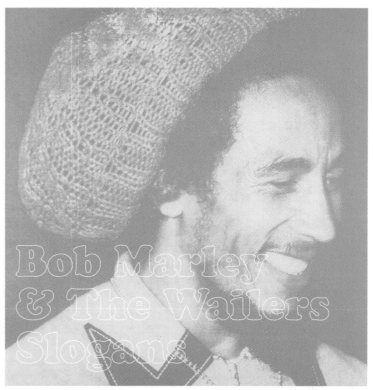

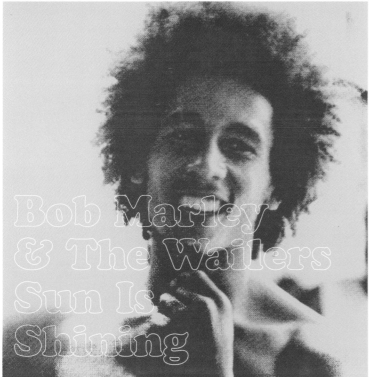

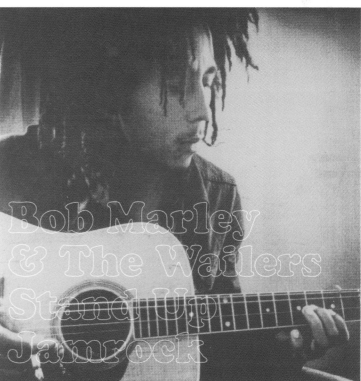

Blue Source // London, United Kingdom // www.bluesource.com //

Blue Source is a London-based creative team that does just as first-rate a job in the design market as it does in the production of video clips and short films. In the mid-1990s, Rob Leggatt and Leigh Marling began producing flyers and T-shirts for local record companies and night clubs they had befriended before growing into a prosperous design firm. Although these days they advise a broad range of customers—from a small delicatessen to a international companies—their work for all areas of the music industry remains central and have begun to produce music videos. They received numerous accolades in this field. Their design work is characterized by enormous versatility, which allows them to find creative solutions that address the matter conceptually aside from any stylistic restrictions.

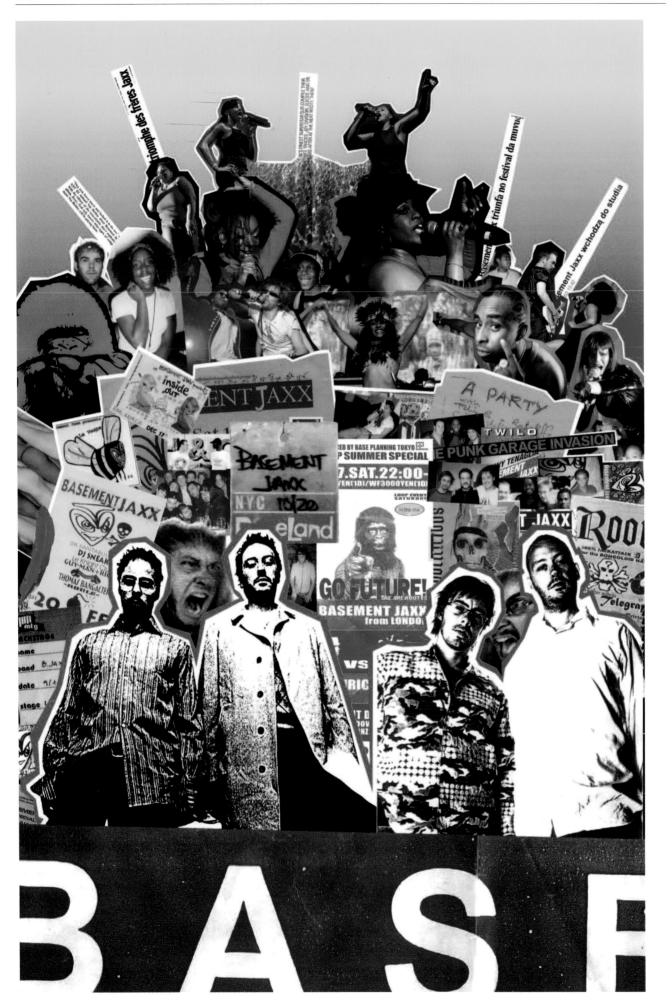

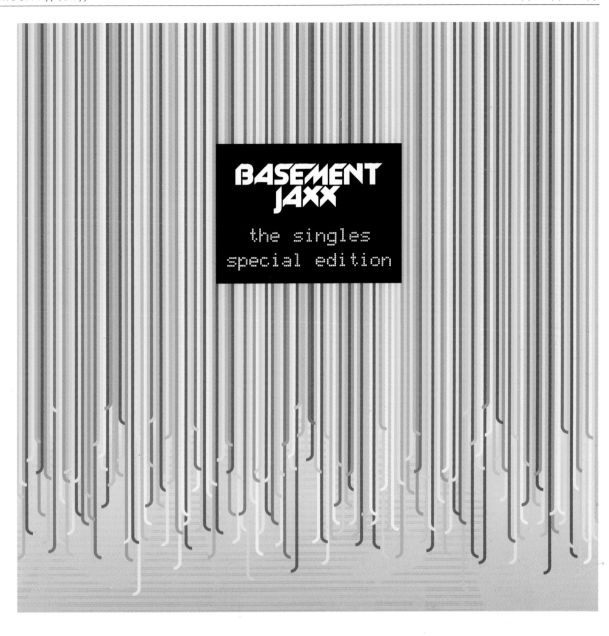

Basement Jaxx //

The sounding euphoria of the London-based Nu-House volume *Basement Jaxx* is reflected in the often multicolored, slightly shrill design of the cover. Also the CD and DVD sleeves by graphic designer Patrick Duffy followed this tradition, although in clearer and more strongly abstracted form than earlier covers of the band. The colorful strips are inspired by party streamers and reflect the carnival-like party atmosphere of the album's music.

Patrick Duffy // London, United Kingdom // www.nodaysoff.com // www.utan.co.uk //

In terms of graphic design, I don't really have any "early influences." I've been more influenced in my life by music than anything else and I've learned most of what I know by making mistakes along the way.
I'm rarely happy with any of my work for very long. That's why I always want to make the next job better.
I work in a small studio, mostly clean and free of distractions. On my desktop are –at the minute–my phone, pens, a bold letterpress 'X,' an Au Pairs CD, an old photo of my dad, my record player, The Stone Roses LP, my keys and my tax return (still blank).

A Motto? No Days Off. Inspiration? Bukowski. What aggravates me: bad grammar. My advice to students? Try and find your own voice, do your homework and stay away from my girlfriend.
Five things I am crazy about:
Anthrax, *Gang Of Four* / Delta 5, *Mind Your Own Business* / Nilsson, *Jump Into The Fire* / PIL, *Memories* / King Creosote, *Lavender Moon.*

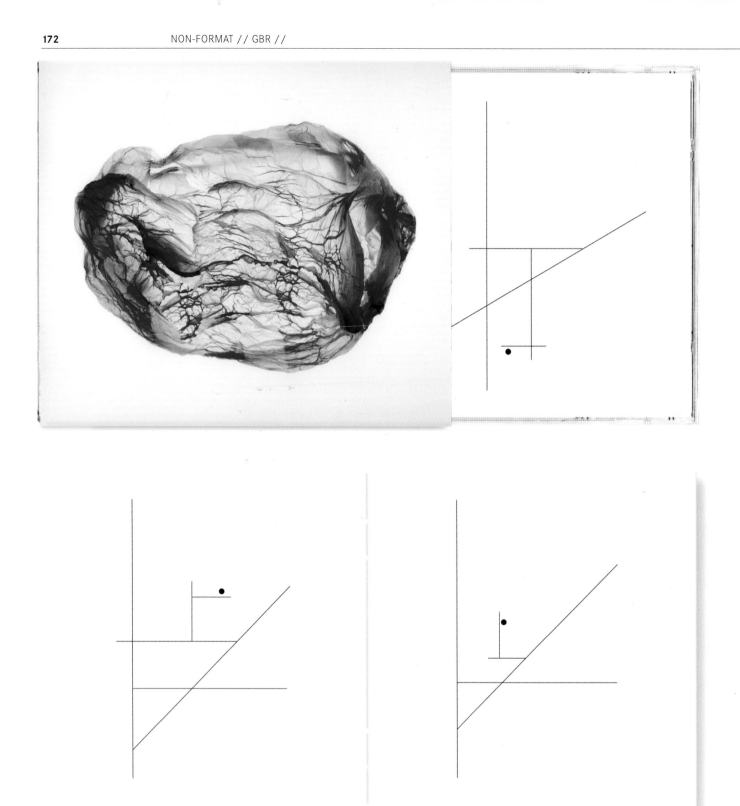

Susumu Yokota & Rothko // *Check The Water* // *Anoice* // *Theodore* //

Non-Format // Kjell Ekhorn, Jon Forss // London, United Kingdom // www.non-format.com //

In 1999, Kjell Ekhorn from Norway and Jon Forss from England discovered their common penchant for graphic design and first worked together under the name EkhornForss Ltd. Two years later, Tony Herrington, editor-in-chief of *The Wire* hired them for the complete visual reorganization of the renowned music magazine. For four years, they worked in the London office of the music publishing house and showed their eclectic style of decorative illustrations, stock photographs and modern typography in over 50 issues of the magazine. Although primarily known in design circles for their organic patterns and ornamentation, their illustrative and decorative elements, all of their projects are rooted in clear project analysis and defined by clear conceptual logic. In 2005, they left *The Wire* in order to be able to work more independently for various clients in the areas of music, art, fashion and advertising. In the meantime, using the name, Non-Format, they were honored with international awards and a monograph published by the Pyramid Verlag.

Lo Editions

1.2.3.

Bug Powder
Electric Sheep
Synthetic Pleasures

Lo Editions

4.5.6.

Strings & Things
Fluff & Nonsense
Bleeps & Bling

Lo Editions

9.10.11.

Mutant Jazz
Freaky Folk
Twisted Beats

Lo Editions

14.15.16.

Camera Obscura
Avant Garde
Art Brut

Lo Editions //

Illustrations and print design for the music industry are among the specialities of the London-based design firm Non-Format, which completely redesigned the visual identity of the music magazine *The Wire* and which received substantial acclaim in music and design circles. For years they have been considered among the most popular graphic designers for the Leaf Label and Lo Diskings when it's a question of CD covers and booklets. Their stylistic hallmarks include independent, often organically appearing illustrations, which are never an end unto themselves but are always conceptually connected to the music and contents of the CDs.

THIS POSTER ANNOUNCES A NEW BAND WITH A NEW SOUND:

HATTLER

NO EATS YES – TOUR THE BAND IS:

SANDIE WOLLASCH – VOCALS NKECHI MBAKWE – VOCALS

SEBASTIAN STUDNITZKY – TRUMPET OLI RUBOW – DRUMS

HELLMUT HATTLER – BASS

Hattler //

New York-resident designer Jan Wilker of the agency KarlssonWilker, is also from Ulm in Germany, just like the internationally renowned musician Hellmut Hattler. For his fellow countryman's CD, *No Eats Yes*, published by Universal in the year 2000, KarlssonWilker developed the CD sleeve, booklet, poster and website. For the CD sleeve, a sticker, covering up a photo of the musician, was to be used.

Since the machine was not able to place the sticker correctly, the packages hired ten students to place the stickers by hand. In addition to the regular release, a more complex printed Limited Edition was manufactured by the prestigious brand Harman/Kardon.

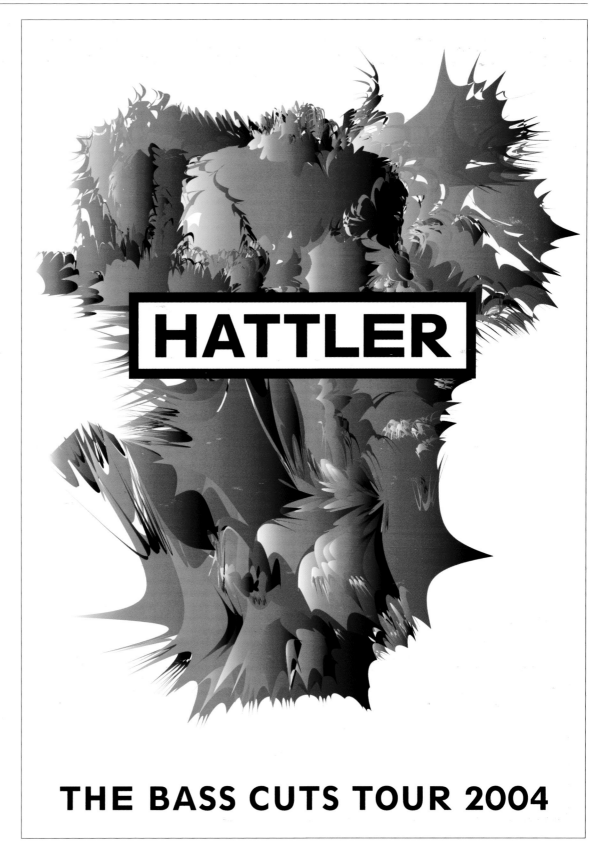

KarlssonWilker // Jan Wilker, Hjalti Karlsson // New York, United States // www.karlssonwilker.com //

As for early influences, I grew up in Ulm, Germany, mid-seventies, where the spirit of the Ulm school was still apparent to mid-nineties. What I consider quality in pint design? I don't know. The same as in any other design field. I don't care too much about paper, special high-end printing, specific paper stocks, etc. Of my own work, I am especially happy with the "end" poster for Boym's *Buildings of Disaster*, be-cause the type happened to be more of an accident than thought through–a small glitch in the 3-D software that we could use for this piece. What does my working environment look like? Nothing on the walls, bright, a bar with barstools, a big green plant, a foosball table. Do I have a motto for work? No. What inspires me? Every-thing. What aggravates me? Myself. What is my worst nightmare? That I die while answering this questionnaire. Advice to students? Learn, read and do things. And use your time as a student to truly experiment as much as you can.

Five things I am crazy about:

Life itself / the ocean / people (some) / alcohol / good food.

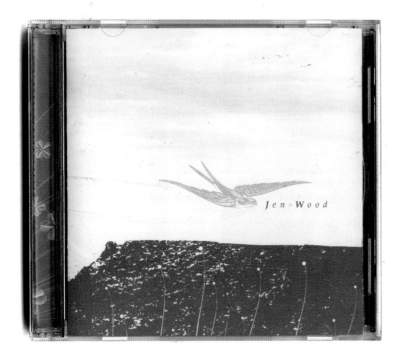

Jen Wood //

In the design of the cover and booklet for the Seattle-based singer Jen Wood's current CD, the penchant of fellow Seattle resident, designer Andrio Abero are clear: distinct, flat compositions, typography subordinated to the image design and, overall a design that shows Abero's connection to the silkscreen printing process. In the case of the Jen Wood CD, Andrio Abero also uses his own photographs. To integrate them in the color palette of the CD booklet, Abero transformed the color photos in monochromatic images.

Loyola Drive //

For the CD of the California band Loyola Drive, Studio Duel wanted to avoid the conventional format of a booklet in a plastic case and, instead, folded a sheet of wrapping paper around the CD in such a way as to create a covering and booklet in one. The paper, in the format of an A3 poster, was printed by silkscreen. The special touch: each individual issue was hand-produced by Studio Duel, including silkscreening, precise cut and folding.

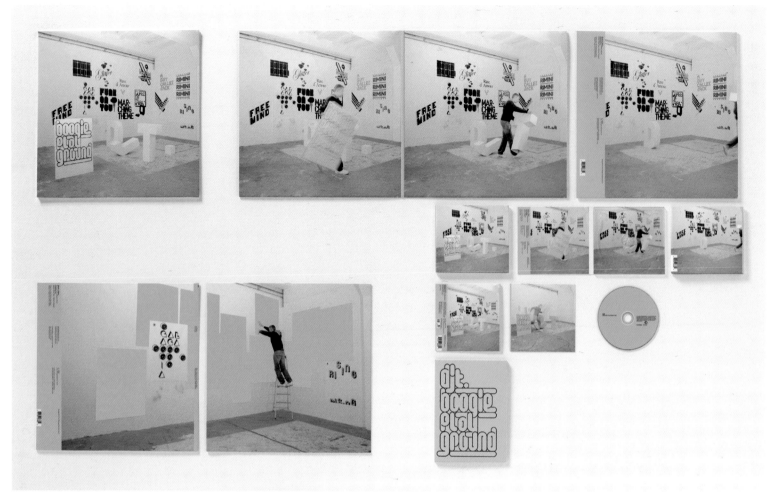

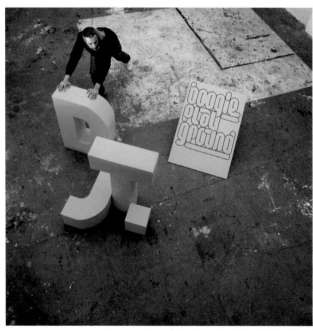

DJT //

The advertising media for the debut album *Boogie Playground* by the German DJT were designed by the graphic designer Martin Lorenz during his time at Eikes Grafischem Hort, and follow an unconventional concept: all relevant information and components required for the disk cover, poster, postcards and other advertising for the album were created by Martin Lorenz in a real space. For the different printed media, various photos of this installation were then made. Information that was not relevant in a certain connection was then covered by a full yellow surface over the black-and-white photo. Thus for a single edition, only one of the posters on the wall remains legible: the one with the title song of the album.

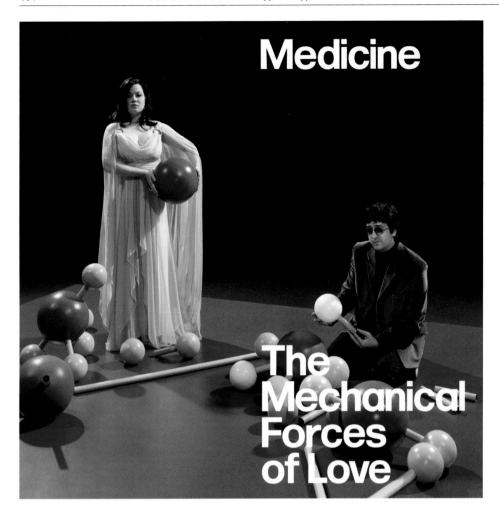

Medicine //

"Glitchy Beach Boys harmonies" is the description the British musician Brad Laner, alias Medicine, gives to his fourth album, *The Mechanical Aspects of Love*. In contrast to these stars of the 1960s, however, Laner creates his sounds completely electronically, spiking them with diagonal sound bytes and, in so doing, producing a type of sound microcosm in the laboratory. For the album cover, the London-based design company Tom Hingston Studio in collaboration with photographer Jonathan De Villiers have found the perfect image vocabulary.

PANDATONE

WHAT
HAS
NATURE
DONE
FOR
ME
RECENTLY

PRODUCED BY T. SIAS
VOCALS ON "TWO PIECE" BY MICHI OF MACDONALD DUCK ECLAIR
RECORDED IN NYC & TOKYO
MIXED & MASTERED BY PANDATONE AT THE RELATED OFFICES
IN ASSOCIATION WITH MUSIC RELATED RECORDS
DESIGNED BY STILETTO
PHOTOGRAPHED BY TOBIN YELLAND
FLOWERED BY SAIRA HUSSAIN

SPECIAL THANKS TO:
MICHI, TOYOMU, RYAN, EVERYONE AT STILETTO, TOBIN, STEPH,
MARXY, SHUGO, MIDORI, LEE, & EVERYONE AT EX.1

PANDATONE 2006 ©

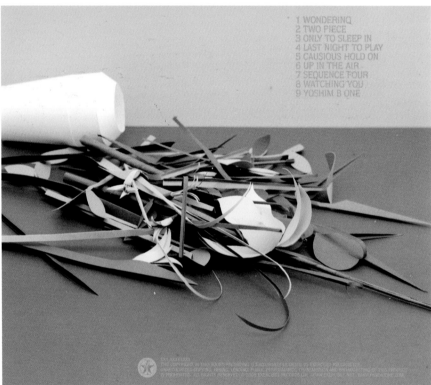

1 WONDERING
2 TWO PIECE
3 ONLY TO SLEEP IN
4 LAST NIGHT TO PLAY
5 CAUSIOUS HOLD ON
6 UP IN THE AIR
7 SEQUENCE FOUR
8 WATCHING YOU
9 YOSHIM B ONE

Pandatone //

To design the printed CD materials for the most recent album by the Electro-Art musician Trevor Sias, alias Pandatone, Stefanie Barsch and Julie Hirschfeld of the New York-based design firm Stiletto drew inspiration from the album's title: What Has Nature Done for Me Recently? All the flowers photographed for the cover were hand-made by the intern, Saira Hussain, which made the album's cover and booklet design an unusually time-consuming project.

Zoot Woman
Gem

Zoot Woman
Grey Day

Zoot Woman
Taken It All

Zoot Woman
Zoot Woman

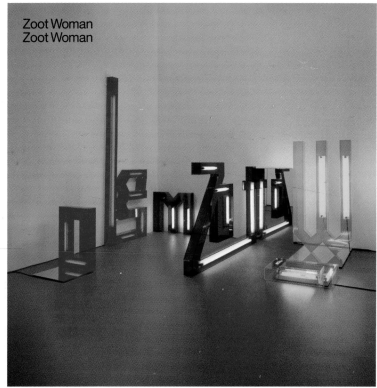

***Zoot Woman* //**

In its music style, the successful English band Zoot Woman gives new elegance and a fresh groove to the Electro-Pop sound of the 1980s. The cover design for their second album, which was published in 2003, is precisely rooted in this aesthetic of the 1980s, and the newness of the continued evolution. The London-based Tom Hingston Studio organized the typography of the volume name a three-dimensional light object in the typical 1980s neon look in front of walls and mirrors and photographed the installation for the cover of the album. For the single, Tom Hingston Studio executed this idea and also showed "Editions" of the overall installation on the covers. Photography by Anuschka Blommers and Niels Schumm.

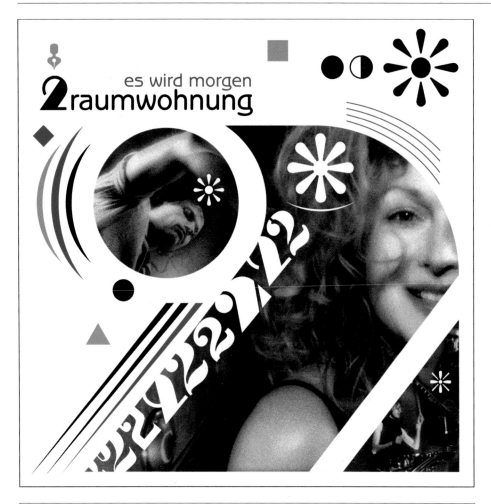

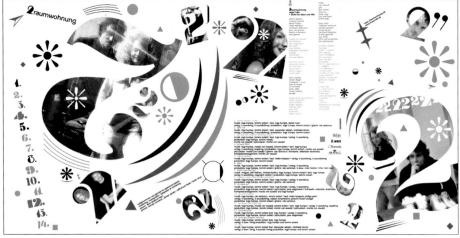

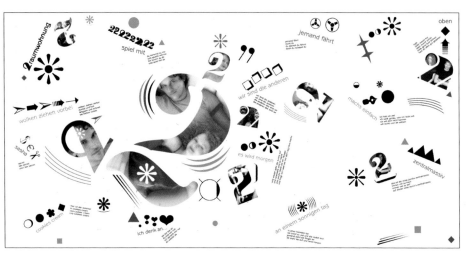

Zweiraumwohnung // 2004 //

In order not to omit any consumer in the difficult times of the crisis-laden music industry, the disk label of the Berlin-based band Zweiraumwohnung briefly created three variations of the CD *Es wird Morgen* for the various editions: Basic, Standard and Premium. Lorenz Gianfreda of the firm Destruct Bern thus developed a flexible design concept that could be realized in different connections. Depending upon the selected material and procedure, different priorities can be offered. The effort paid off: the sales figures earned the band a gold record.

Buro Destruct // Bern, Switzerland // www.burodestruct.net //

The Destruct firm is made up of a team of five creative people who supply the world with fresh designs, in particular with their own fonts and logos, from the small Swiss capital, Bern. Their fonts are worth their own website: www.typedifferent.com. The emphasis of their work lies in the area of print: record and CD covers, posters, flyers, books and extensive corporate identities. The renowned design publishing house Die Gestalten Verlag published not only books *by* but also two books *about* the firm Destruct, one in 1999 and one in 2003. Out of their preference for idiosyncratic logos, the Internet project Loslogos.org was created: a type of virtual protective reservation for threatened logos from around the world.

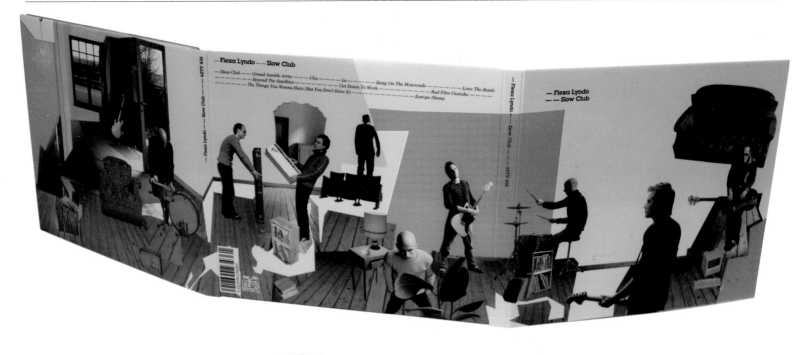

Flexa Lyndo //

For a cover for the Belgian indie-rock bank Flexa Lyndo, Pleaseletmedesign arranged photos of the musicians in such a way on the cover that the typography of the band name appears in the inside of the cover on the transferred silhouettes of the band-members. They express this concept by using a fluorescent special Pantone color that is printed in addition to the usual CMYK color spectrum.

Pleaseletmedesign //pierre&damien // Brussels, Belgium // www.pleaseletmedesign.com //

Our early influences? At first Rinzen, Buro Destruct, the Designers Republic, and then Experimental Jetset, Irma Boom, Mevis and van Deursen.
A motto? Here are the top three of our favorite mottos:
"If you make a work, book or newspaper, it has to be as pure as possible. A good designer is not afraid to be totally invisible in the final product." (Mark Manders)
"Say yes to fun and function, and no to seductive color and imagery." (Daniel Eatock)
"A compromise is not a solution, but a dialogue is always a good idea." (Happypets)
What do we consider quality in print design? Black type on white paper.

What guidelines and advice would you give to students of graphic design?
Talent = passion + patience.
What inspires us? Good ideas and hours of conversations with our friends.
What aggravates us? Graphic design without conscience is but the ruin of the soul.
What is our worst nightmare? Making graphic design that aggravates us.
Five things we are crazy about? We really would like to tell you we like philosophy, mathematics, playing cello, hiking.
But just like everyone else, we like movies, music, graphic design and girls.

The Experimental Tropic Blues Band //

The Experimental Tropic Blues Band plays a mixture of psychobilly, punk and blues, and when the graphic designer of the Belgian firm Pleaseletmedesign, received the order to design a disk cover for the band, they first researched all imaginable roots of pscyedelica and punk before designing a concept that brings the old influences forward into a more contemporary light. Their result required unusual methods: first they designed the typographic logo of the band, then printed it on 120 A4 sleeves in a total size of 6 x 2.5 meters and then transferred it to the ground of a storage space specifically prepared for it. The complete writing was then drawn afterward using Scotch tape. After three days of preparation, the band came to the photo shoot and also allowed themselves to be covered with Scotch tape.

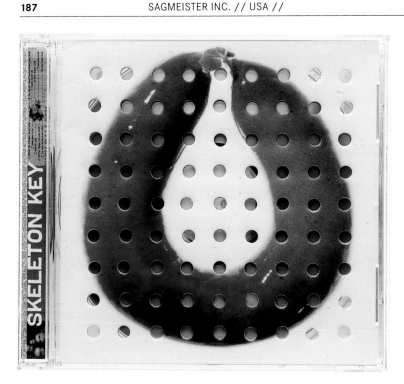

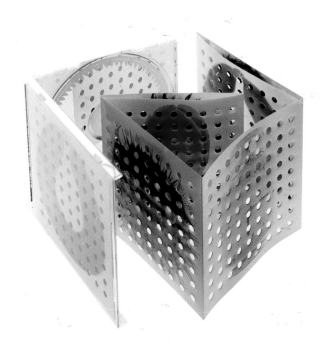

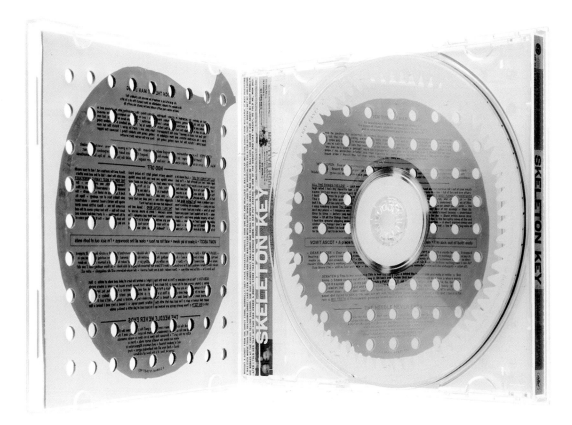

Skeleton Key // 1997 //

In 1994, the band, Skeleton Key was founded in the context of the legendary New York-based Knitting Factory. For the album *Fantastic Spikes Through Balloon* published in 1997, the New York design firm Sagmeister Inc. designed a booklet and CD cover in obvious reference to the title of the album: the graphic designers photographed various balloon-like objects, such as thick sausages, whoopee cushions and blowfish; printed them in the CD booklet and then perforated the paper. Since the band did not want people reading the printed lyrics while listening to the music, Stefan Sagmeister placed the letters in mirror writing so that they could only be read in their reflection of the CD.

Röyskopp //

Röyskopp is the cryptic name of the Norwegian electronic music duo of Svein Berge and Torbjorn Brundtland. The London-based design firm Tom Hingston Studio designed the album cover and booklet for their debut album, *Melody A.M.* Photography by Sølve Sundsbø.

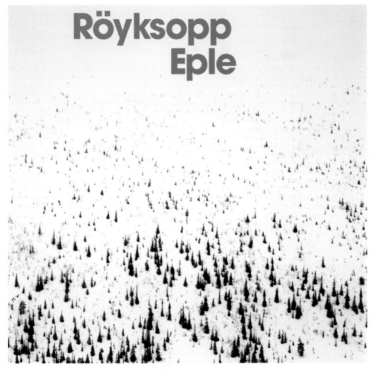

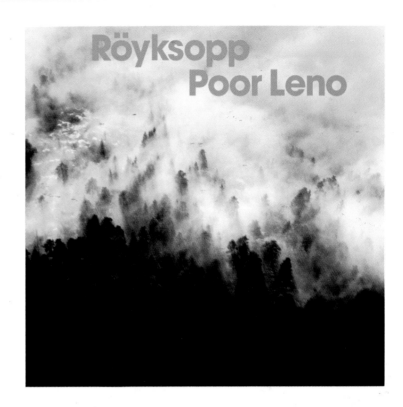

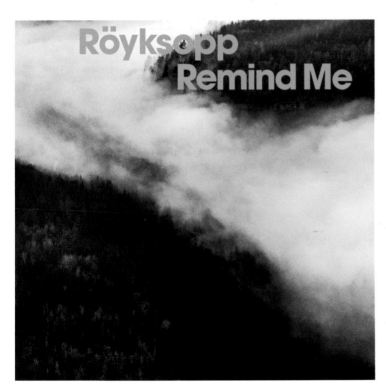

Tom Hingston Studio // Tom Hingston // London, United Kingdom // www.hingston.net //

Tom Hingston is an established graphic designer based in London. After graduating from Central Saint Martin's College of Art and Design in 1994, Hingston worked with graphic designer Neville Brody for three years. In 1997 he set up his own design company, Tom Hingston Studio. Based in London, THS comprises of four members; Tom Hingston, Danny Doyle, Manuela Wyss and Hannah Woodcock. The company works across a range of fields ranging from music, fashion and film to advertising, publishing and branding. Renowned for it's innovative and highly thoughtful approach to design, the studio has won numerous awards for it's art direction and design on a number of music projects. Clients and collaborators include Christian Dior, Mandarina Duck, Nike, Massive Attack, Nick Cave, Robbie Williams and The Rolling Stones.

Thought Universe - Mixed Messages.
TUC01.

Thought Universe - Mixed Messages.
TUC01.

Written and produced by Mark Pilkington. Thought Universe Records 2004.
© 2004 Thought Universe Music. Cat no: TUC01. Thanks to Justina, Noah, Mitzi, and Rio. Design/Photography by Build. designbybuild.com No unauthorised broadcast, copying, lending of this sound recording. All rights reserved.

Thought Universe // Heat Sensor // LE:01 // SD150V //

Already more than ten years ago, disk covers were one of the first successes of the London-based designer Michael C. Place, and by his own admission, today he can still spend a busy week working on a single CD sleeve. Current examples are work for Heat Sensor, Thought Universe, LE:01 and SD150V.

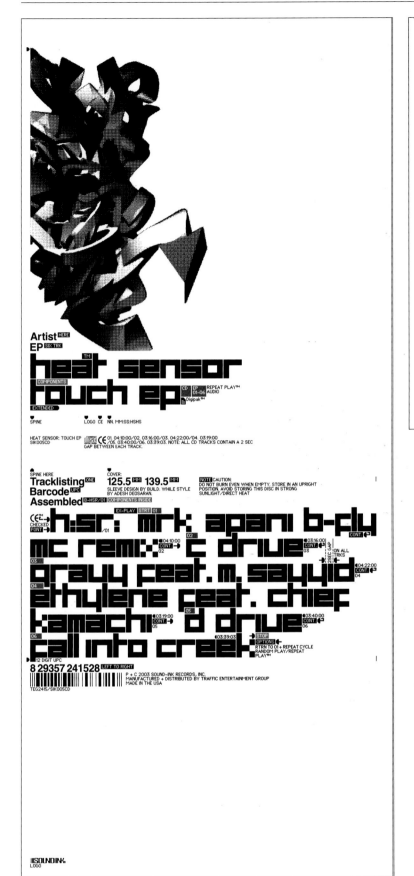

SD150V

SD150V

SD150V

SD150V

Design by Build // Michael C. Place // London, United Kingdom // www.designbybuild.com //

Michael C. Place founded Design by Build in the year 2001. Before he had studied design at Newcastle College Design, in Trevor Jackson's studio Bite It and subsequently had worked for almost ten years at "the Designer's Republic." Michael C. Place is a proven expert of the print trade, which he still practiced by hand, and though he has long moved on to other design areas, he still feels especially connected to print design. In addition he is a passionate and detail-oriented designer, who, by his own admission, does not like to make artistic compromises, which is also why he opened his own design firm. His creative determination has not only brought him prestigious clients such as Nike and Sony, but has also made him one of the most influential designers in the world.

Back to Black //

For its design of the Back to Black covers, the London-based design firm, Non-Format received the Non Member's Prize of the Tokyo Art Directors. The outer sleeve consists of stamped gold foil, an inner enclosure is printed in black ink on bible paper and folds out to poster size.

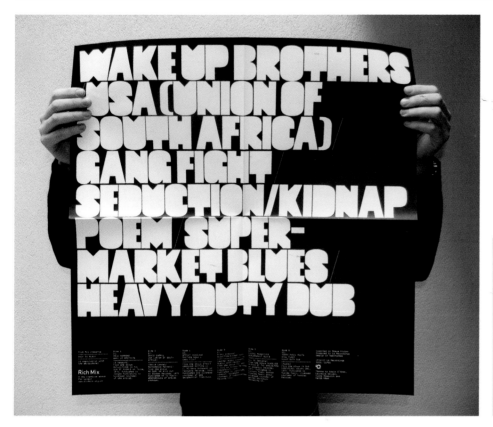

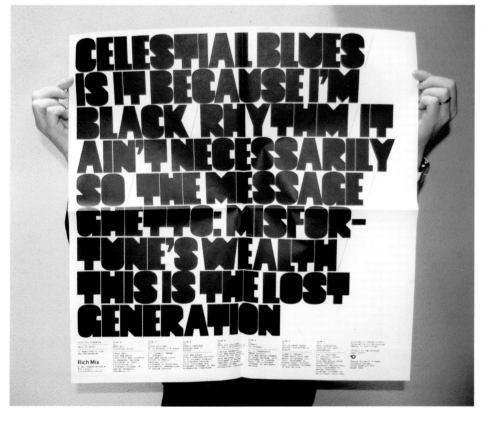

The Chap // Milky Globe //

The typographic illustration on the *Milky Globe* album cover is an example of the decorative organic forms and ornaments, for which the London-based graphic design team, Non-Format are famous. Likewise typical for the works of Kjell Ekhorn and Jon Forss are modernist writings such as on the disk cover The Chap.

FREQUENCY 4

NONSEXUEL

NEXL

KEH INC.

BBC
New Talent
Campaign Identity

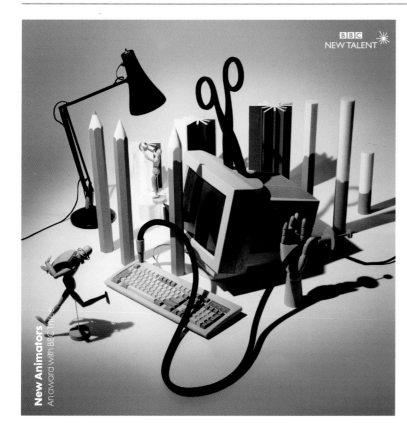

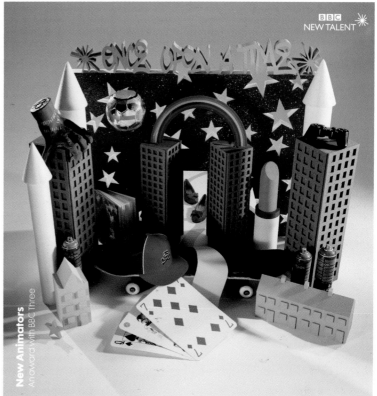

BBC New Talent Award //

The London-based design firm Blue Source developed the advertising campaign for the BBC New Talent Project with the renowned broadcast station by means of an open competitions for new media talents.

Vitra //

For an advertising campaign for the Swiss furniture company Vitra, the New York-based design firm, 2x4 developed stylized flower themes from photographs of furniture itself. Vitra is known for giving high-quality design to functional furniture; it is really the high aesthetic requirement that, in the eyes of many customers, differentiates Vitra's products from the furniture of other manufacturers. By freeing the furniture from its functional context and placing it in its own context as pure design object, the design firm 2x4 played skillfully with the self-image of the brand and the expectations of customers.

Hilliard //

The corporate identity that the London-based design firm Spin developed for the firm Hilliard is directly derived from the profile of the company: Hilliard deals with seasonal organic foods. Correspondingly, the corporate logo is made up of four stylized leaves, each of which represents a season. Included in the various print media that are designed in this identity image, there is also an adhesive strip with which the shopping bags of the customers are fastened: it has a different color depending upon the season and, in so doing, reminds the consumer of the current season.

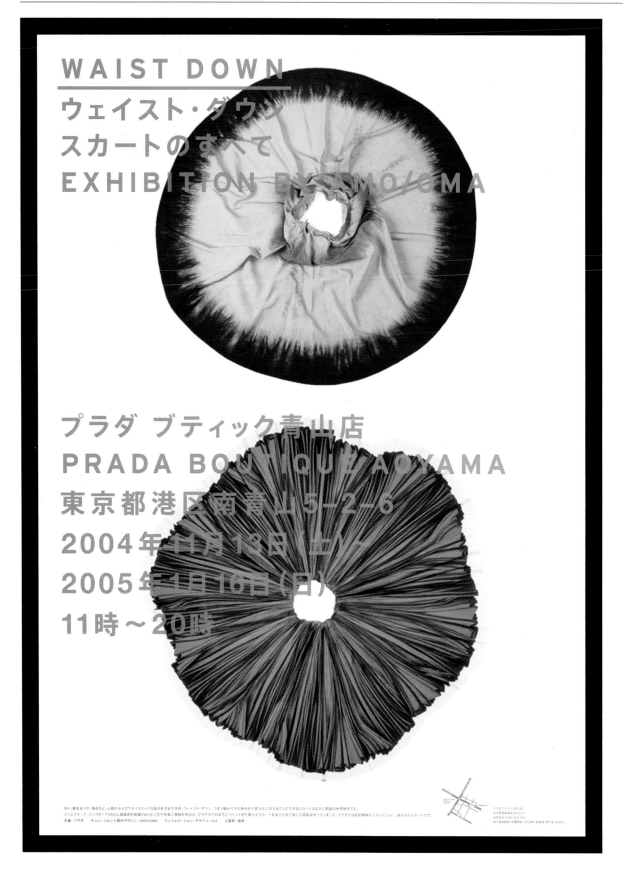

Waist Down //

In their exhibition "Waist Down," the Office for Metropolitan Architecture (OMA) and the New York-based design firm 2x4 featured skirts by the fashion brand Prada. First conceived for the Prada Tokyo Epicenter, the exhibition subsequently traveled to New York and Shanghai. The exhibition concept and the visual language of all the print media resulted in releasing the skirts from their context as articles of cloth-ing and showing them not on models but rather as independent design objects in a clear elegance, which they display like works of art in a gallery.

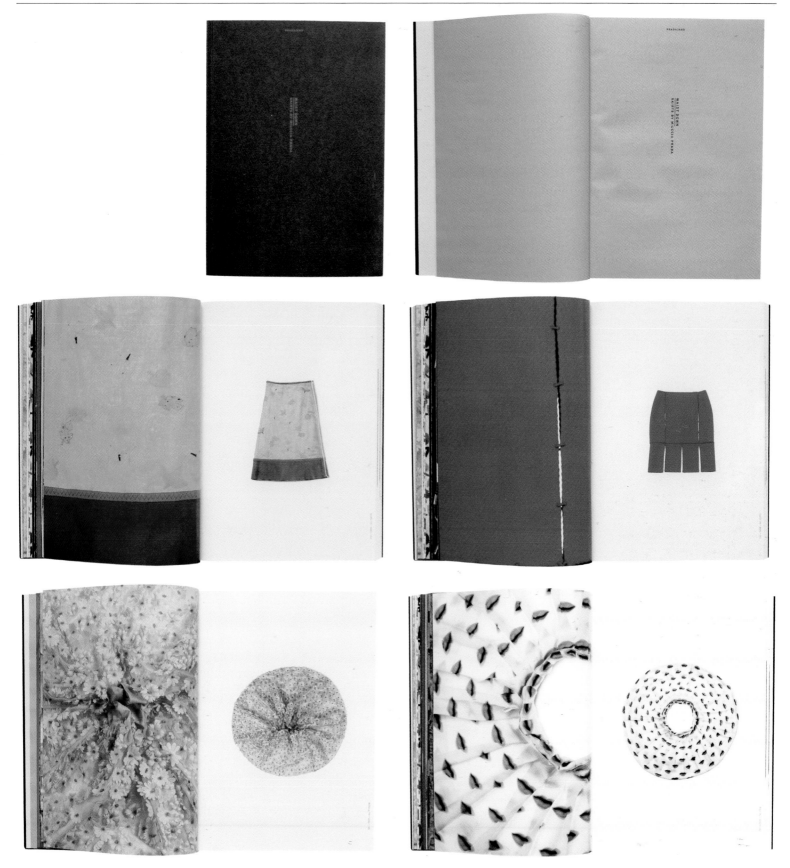

2x4 // Michael Rock, Susan Sellers, Georgianna Stout // New York, United States // www.2x4.org //

The New York-based design company 2x4 founded in 1994 by Michael Rock, Susan Sellers and Georgianna Stout, achieves its internationally celebrated design concepts by means of a nearly algorithmic design process based upon critical analysis and research. Their projects often show intellectual finesse and question established design concepts. The team of art directors, copywriters and designers never sacrifice their aesthetic philosophy to intellectual ambition. Instead, the projects, which they develop in all imaginable design areas from print to film for clients such as Prada, the Brooklyn Museum or the Swiss furniture manufacturer Vitra, are so convincing aesthetically that in 2005 the San Francisco Museum of Art dedicated an extensive single exhibition to them.

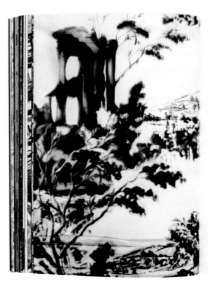

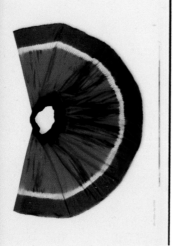

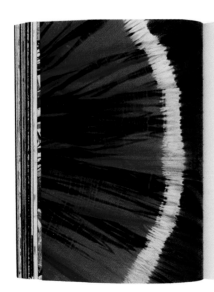

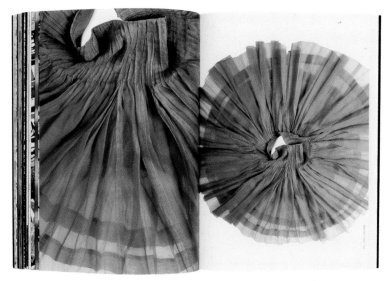

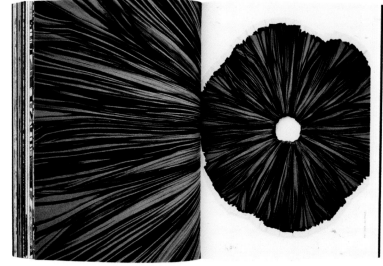

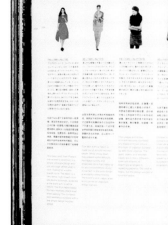

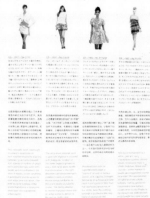

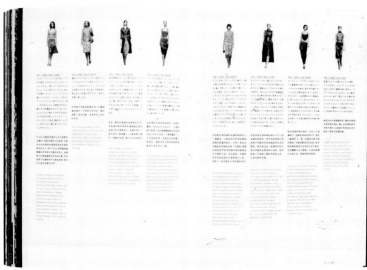

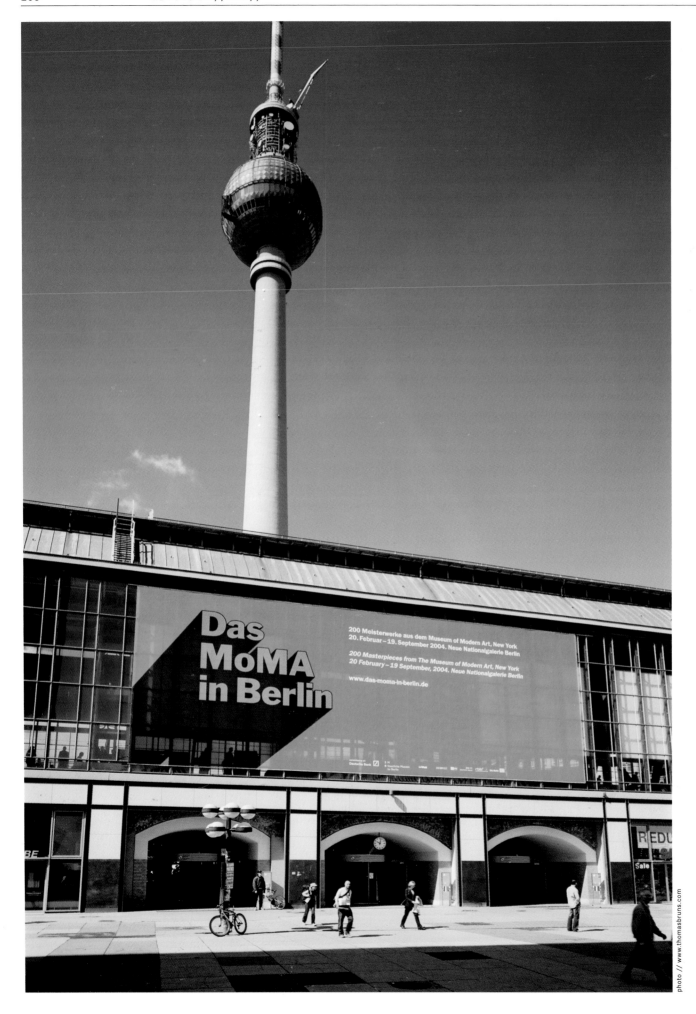

Das MoMA in Berlin // 2004 //

Even for Germany's cultural metropolis Berlin, the seven-month exclusive exhibition of New York's Museum of Modern Art (MoMA) was a special challenge, since to finance it at least 700,000 visitors had to be lured into the exhibition. For their comprehensive campaign, the Berlin-based branding agency MetaDesign developed a design concept that treated MoMA like a celebrity in Berlin. A few concise visual elements communicate brand values and guiding concepts. The flexible typographic logo appears monumental and includes spotlights or fanfares, as it would for the appearance of a celebrity. The house writing of the New York museum refers to the homeland of the exhibition and the colors of gold and pink highlight the exclusivity of the displayed masterpieces, as well as the American origin. In the end, more than 1.2 billion visitors where counted at the Nationalgalerie.

MetaDesign // Uli Mayer-Johanssen // Berlin, Germany // www.metadesign.de //

Design is a translation and guidance instrument for strategic corporate statements and, at the same time, a mirror of corporate values. It can therefore be an important tool of innovation and create great momentum in the company. –Uli Mayer-Johanssen, Chief Design Officer
Design is also a business, whose material use must be clearly recognizable to our clients. However, beyond this, design, good design, represents an aesthetic value, which–perhaps fortunately–cannot be expressed in concrete numbers as yet. It is a piece of quality of life. –Stefan Kirschke, Managing Director

Good Design is well thought-out and strategic. It has to function and its task must be fulfilled. But what constitutes excellent design? What is the difference between the good and the best? It's completely simple: enthusiasm, fun and a love for the topic. Design must entice, inspire, irritate, sometimes also shock. –Florian Dengler, Creative Director

Sammlung
Collection
Marta Herford

a a b c d e E F g h i j k l M N o p q r s t u v w x y z / !

Marta Herford //

In May 2005, with Marta Herford, the city of Herford, Germany opened an ambitious center of art, design and technology that is as interesting in contemporary art as it is in design, architecture, and all gray zones in between these poles. The symbiosis of three areas under one roof is unusual: first the museum with its own collection, second a convention center with representatives from the regional furniture industry and technical service providers, and third an event forum with spaces for cultural events and all types of events. The Amsterdam studio for visual communication Thonik devoted a color to each of these areas in their design for the corporate identity of Marta and connects them together by means of a strip of parallel stripes they reappears in all aspects of the corporate identity.

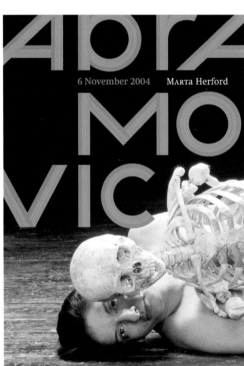

Thonik // Amsterdam, Netherlands // www.thonik.nl //

The Amsterdam-based Studio for Visual Communication Thonik is considered one of the most creative Dutch design firms, and receives corresponding international acclaim. Founded in the year 2000 by Thomas Widdershoven and Nikki Gonnissen, Thonik clearly belongs to the "conceptual school" and considers research, analysis and clear ideas as the focal point of its work, while it disdains trendy glamour as much as traditional forms and styles. They consider "lack of style" a compliment. Their visual clarity and precise content make them a model for young creative types in the Netherlands. They develop corporate identities for customers such as the City of Amsterdam, documenta XI or the Centraal Museum Utrecht. They design books, and are themselves the subject of the book Thonik, published in 2001 by BIS Publishers.

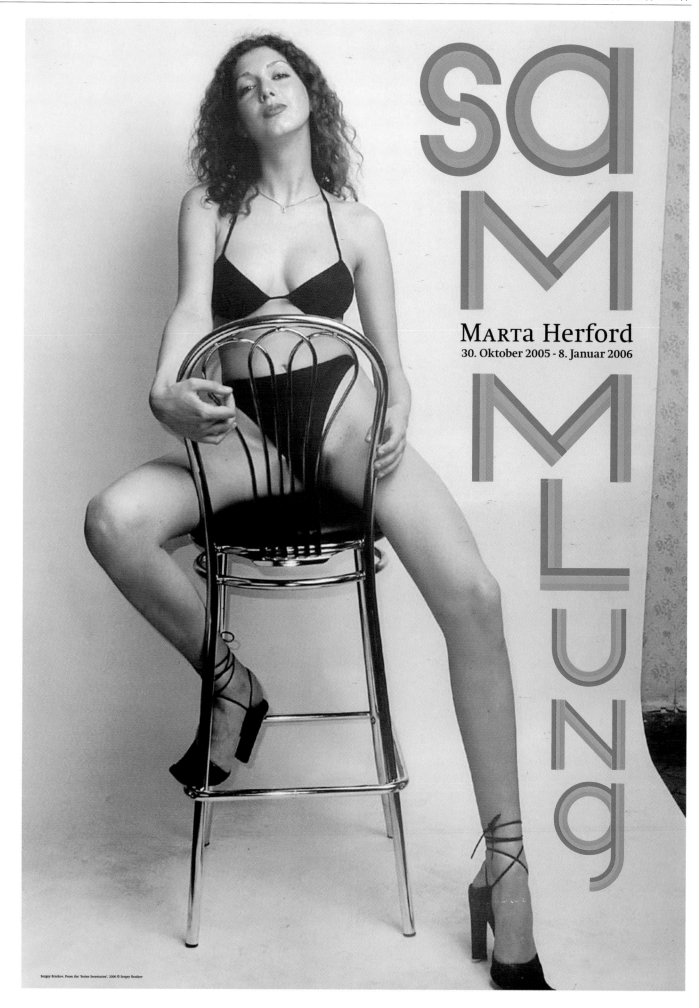

Sergey Bratkov, From the 'Series Secretaries', 2000 © Sergey Bratkov

***Brooklyn Museum* //**

The Brooklyn Museum wants to stimulate public family viewers to adopt a critical and independent view of classical and modern art. As one of the largest American art museums, it embodies authority and also wants people to question authority. The graphic design team of the New York-based firm 2x4 allowed solidity and competency to be as visible in the new visual identity of the museum as it did quirki-ness. In this way, the logo is, first of all, a kind modern seal, mutated then in ever-changing shapes. Each new variant is inspired by another form: a stamp, a flower, a water drop, a thought bubble. This variable system is applied to all visual elements of the museum.

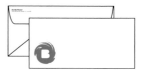

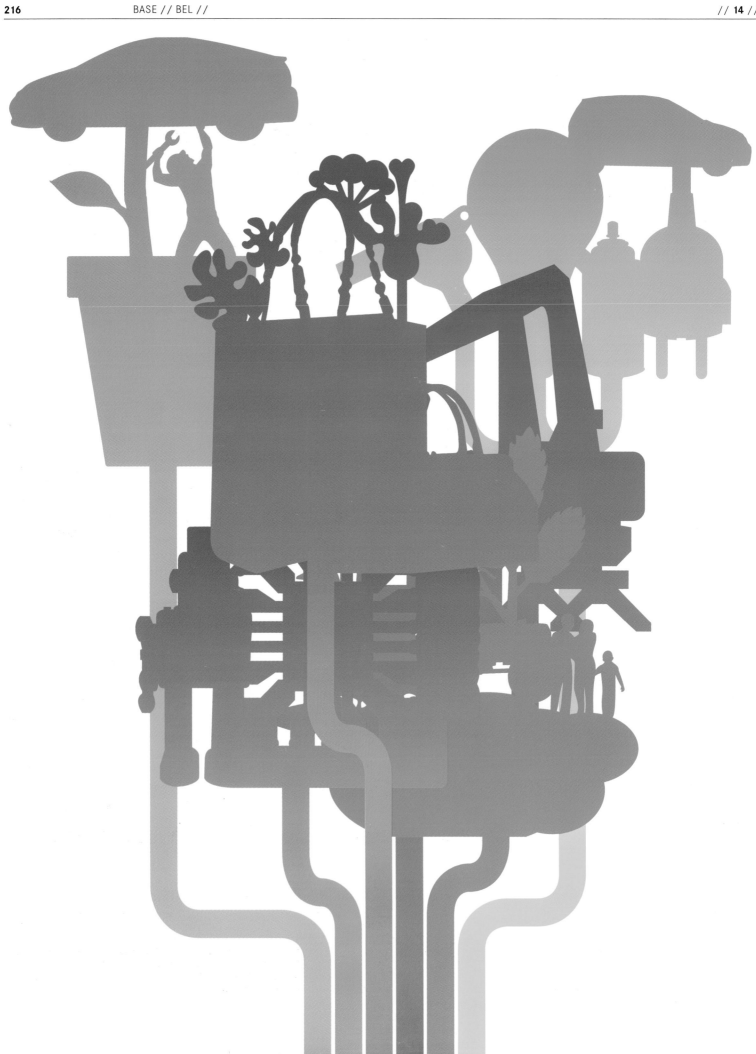

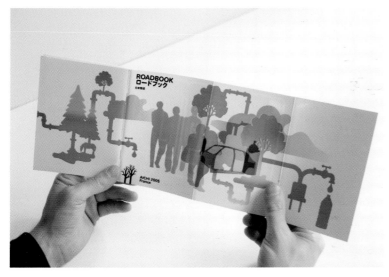

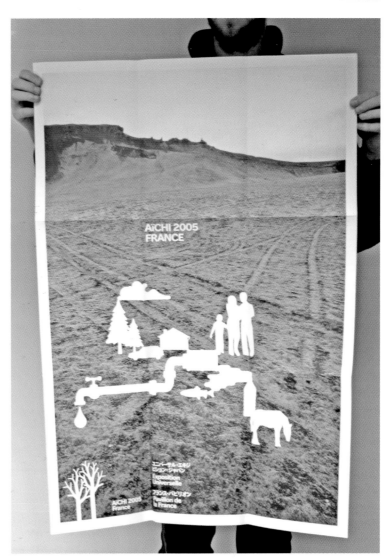

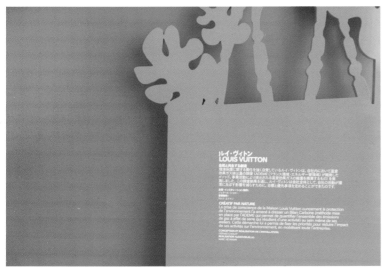

Aichi // 2005 //

In a competition to design the visual identity for the French Pavillion at Expo 2005 in Japan, the Belgian design firm Base triumphed over seven major French competitors. The topic of the Expo was sustainable development. For this, Base designed a repertoire of colorful pictoforms, which they connected in the logo to a collage, bringing together people, nature and technology in a happy, positive relationship.

In this way, Base Design used a universally understood image vocabulary to provide an image for the topic of sustainable development without the usual preachy or anxious tone, and provided the French Pavillon with an identity that radiates both zest for life and responsibility at the same time.

Moonlight // 2003 //

Moonlight Projects produces open-air cinema and music events for a young audi- ence in Melbourne, Sydney, Perth, Brisbane and Adelaide. They gave their corpo- rate identity assignment to the Australian design firm Rinzen, which designed an extensive campaign including postcards, posters, vehicle advertisement, billboards and advertisements, as well as an events magazine and a CD sleeve.

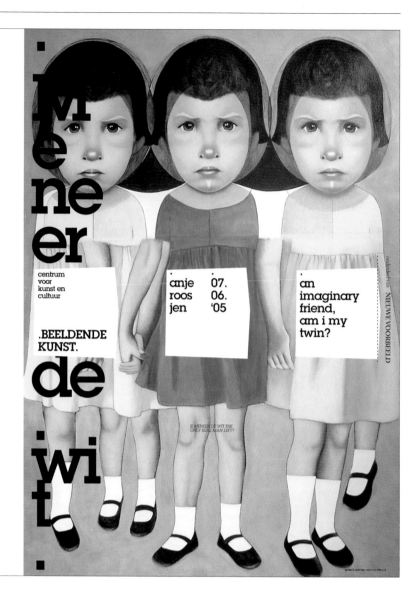

Meneer de Wit //

For Meneer de Witt, the Dutch graphic design firm No Office designed not only the print media shown here, but the entire visual corporate communication all the way to the name. They drew inspiration from film roles such as Charlie in *Charlie's Angels* or Stan in *Will and Grace*: people who remain influential in the background but are never seen by anyone: the viewer can only guess what they look like and what motivates them. The designers of No Office portray Meneer de Witt–in English "Mister White"–as a wealthy patron who provides the artists of this center with workspace and openness for art and culture. The entire visual language plays with this element of concealment and hidden image information.

No Office // Dikje Baker // Amsterdam, The Netherlands // www.no-office.nl //

We have very few things that influence us. As you know, that can help. We work below the city, below the subways. There's a whole world of tunnels and chambers that most people don't even know exists. There are no maps to where we are. It's a forgotten place. We love the smell of print in the morning. Not everything ends the way we think it should. But most things have a happy ending.

We had a nightmare. We dreamed we were a big office.
Advice to students? Trust us, it's paradise. Just keep your mind and suck in the experience. And if it hurts, it's probably worth it.
There's a big bowl of candy on our desktop, why don't you come and eat it?

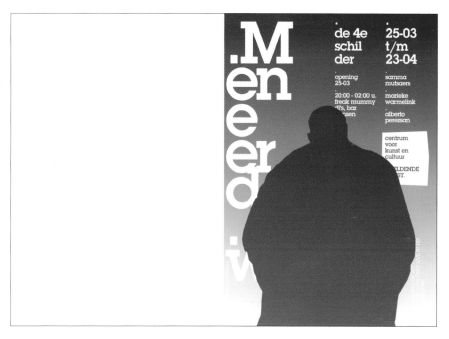

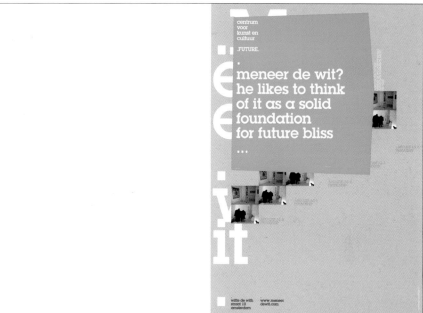

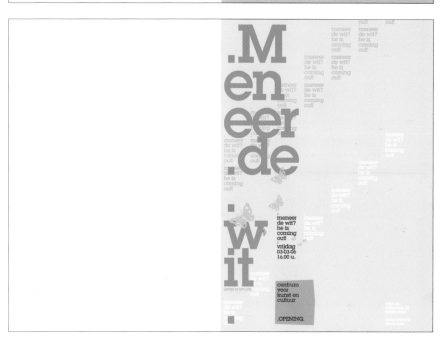

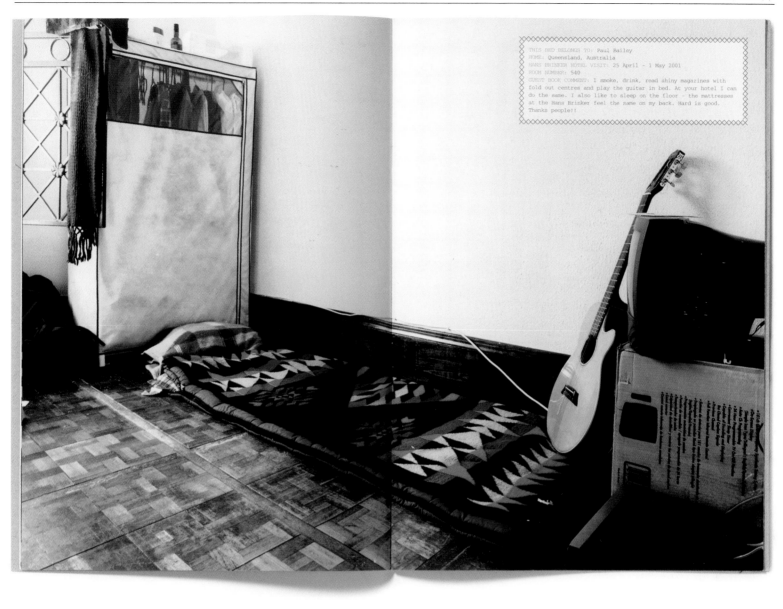

THIS BED BELONGS TO: Paul Bailey
HOME: Queensland, Australia
HANS BRINKER HOTEL VISIT: 25 April - 1 May 2001
ROOM NUMBER: 540
GUEST BOOK COMMENT: I smoke, drink, read shiny magazines with
fold out centres and play the guitar in bed. At your hotel I can
do the same. I also like to sleep on the floor - the mattresses
at the Hans Brinker feel the same on my back. Hard is good.
Thanks people!!

Hans Brinker Hotel // 2001-2005 //

The Hans Brinker Hotel was only one of many cheap hotels in Amsterdam until it achieved international acclaim and substantially increased turnover from the campaign by the advertising agency KesselsKramer. Instead of advertising the few advantages of the hotel, the advertising idea was to highlight all of the poor features of the hotel, thereby making it into a cult object over the years. Its success has gone so far that the Hans Brinker Hotel now sells pieces of its wallpaper as souvenirs. Curiously, not only the advertising for the wallpaper is by KesselsKramer but also the product itself. A special anecdote from the annals of the successful anti-campaign for the Hans Brinker Hotel was a TV commercial, which KesselsKramer produced for the "Just Like Home" campaign. Because of alleged obscene allusions the commercial was banned in England, which served to drastically increase the popularity of the hotel immediately.

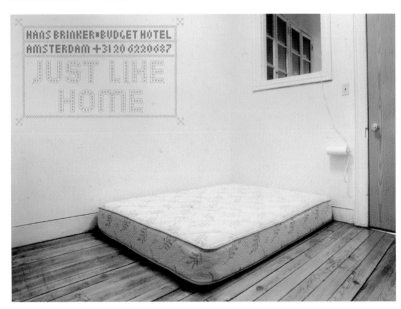

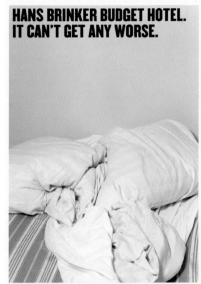
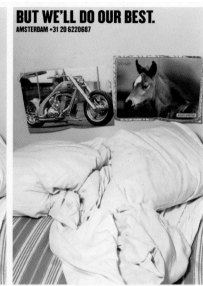

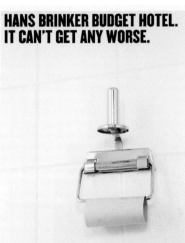
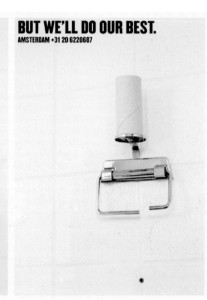

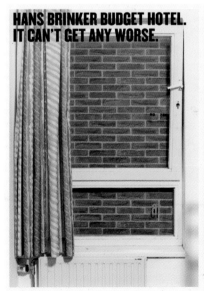
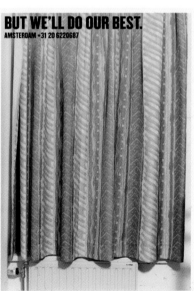

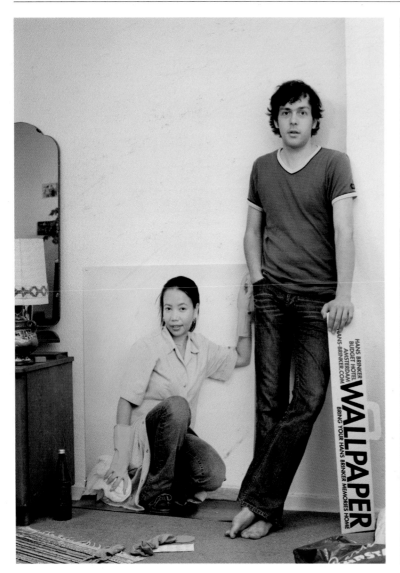

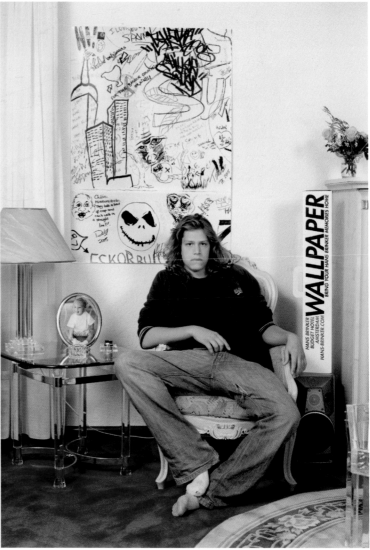

KesselsKramer // Johan Kramer & Erik Kessels // Amsterdam, Netherlands // www.kesselskramer.nl //

Our early influences are honest, straight-ahead ideas. One of our big heroes is George Lois. His work for *Esquire*, *The International Herald Tribune* and MTV is legendary. Lois always approaches a campaign idea with a strong concept. From this concept the idea spreads into appropriate mediums and increases the awareness.

Good print design expresses an idea that is clear and memorable. A smart person once said that people read and look at what interests them; sometimes it's a piece of communication.

We are especially happy with our work for the Hans Brinker Budget Hotel. The campaigns and actions have earned a lot of creative attention, but most importantly they are extremely effective. Our work for the Brinker won a gold EFFIE and the hotel is world-famous and well-loved for being the worst.

We work in a nineteenth-century church. We worked with a designer to create an interesting environment that is open, creative and makes us work hard to live up to expectations. Our motto? Be honest!

Our advice to students of graphic design is to listen to your common sense and don't try to show off with all the computer tricks available. Be clear and simple and interesting. You can do it. We believe in you!

Top 5: Family / Smart Nice People / Football / 2 Kilo / Bunnies.

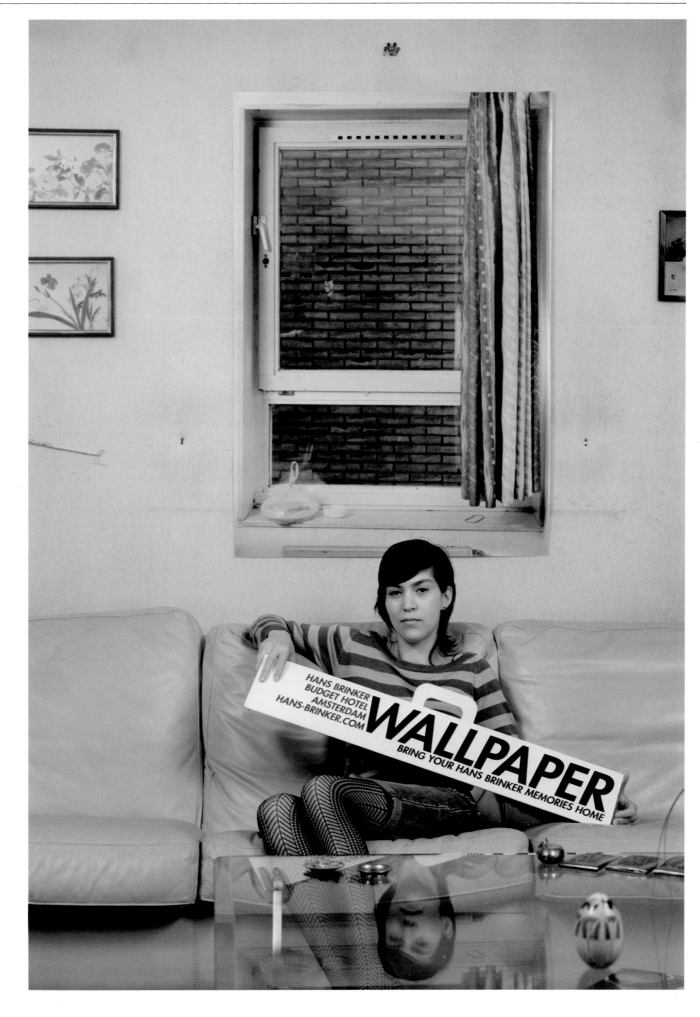

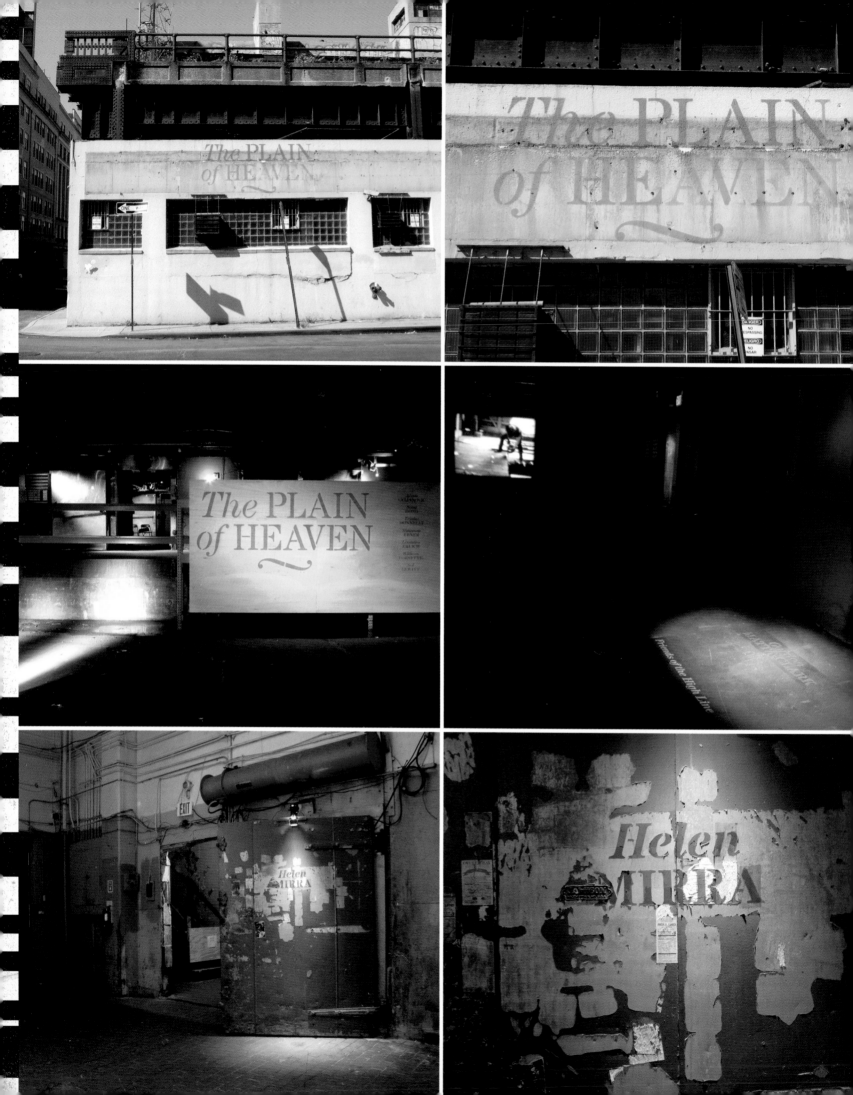

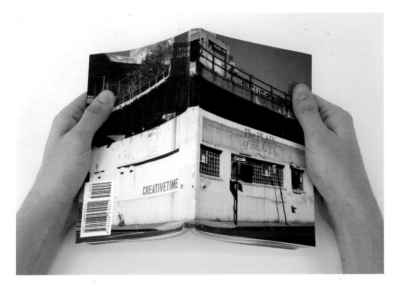

The Plain of Heaven //

In the autumn 2005 the group exhibition, "The Plain of Heaven" was held in a vacant meatpacking warehouse in Manhattan. The ambiance of an empty industry structure was particularly suitable, because the exhibition showed works that were inspired by an impressive industrial monument and its transformation over the course of time: the long-defunct "High Line" subway line in Manhattan. The New York design firm, Project Projects found plenty of inspiration in the topic and location of the exhibition to develop their advertising media. Since the storage hall was to be torn down shortly, the Project Projects team sprayed the exhibition graphics directly onto the outside and inside walls of the building. The stencil typeface was custom-developed for the exhibition. The show's catalog features the artists' work and curator's texts, and includes a hidden photographic narrative on the inside of its French-folded pages. In order to make this text completely legible, the book must also be destroyed.

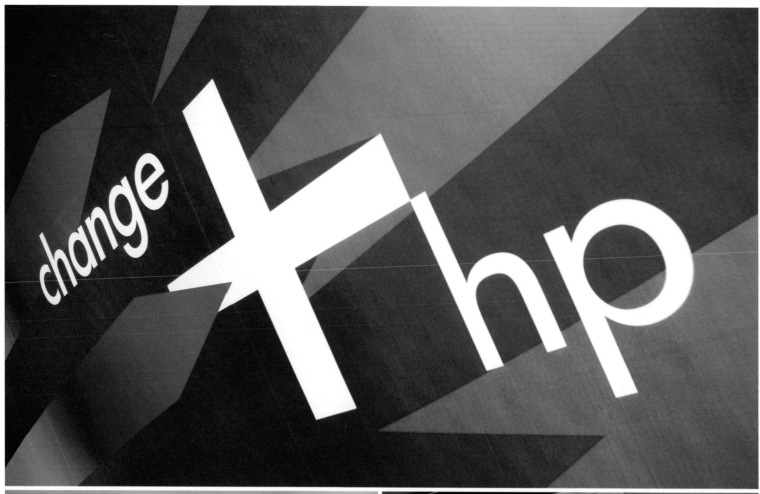

HP+ Campaign // 2004 //

On behalf of the international advertising agency Goodby, Silverstein & Partners from San Francisco, the Dutch design studio NLXL designed one thousand(!) full-size advertising graphics for the computer brand, Hewlett Packard International that were installed at the airports in Milan and Rome in all imaginable areas. Walls, doors, stairs, counters, tables, elevators, closed-off areas and much more besides became advertising media in this way. In Rome even taxis were printed with the designs.

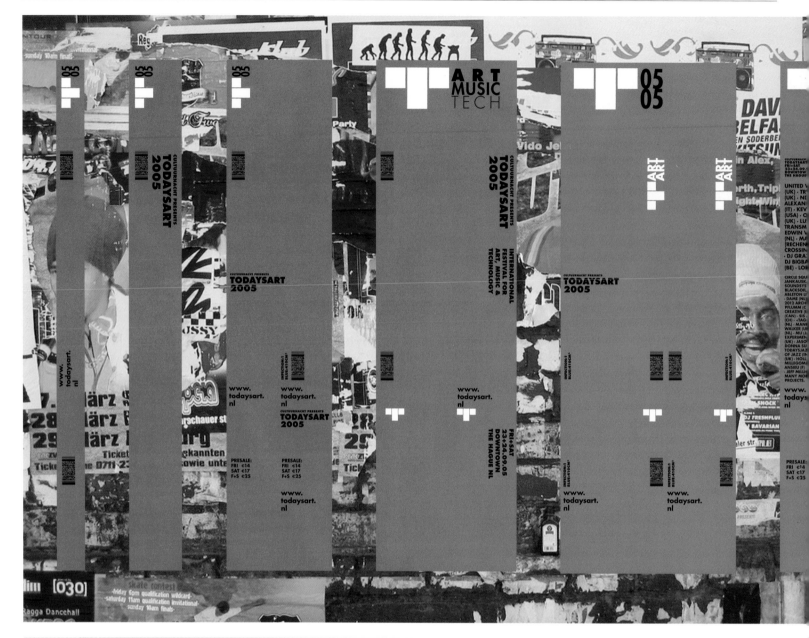

TodaysArt Festival // 2005 //

The Dutch design firm, Lust-known for its affinity to new technologies-developed the complex visual identity for the Art, Music and Technology Festival TodaysArt around the idea of a computer virus. Lust created a generative program that was used to affect and guide all aspects of the festival identity: from its visual language to the means of spreading information. Parameters affecting the virus included hits to the website, number of visitors per venue, number of artists and perform-ances playing, etc. The virus resided on the festival website and could be viewed at all times. Additionally, installations throughout the city showed its development. Each generation of the virus was plotted and thus the growth of the festival and the spread of information were tracked. The virus was symbolized as a grid that could be projected over the whole city or just a single building.

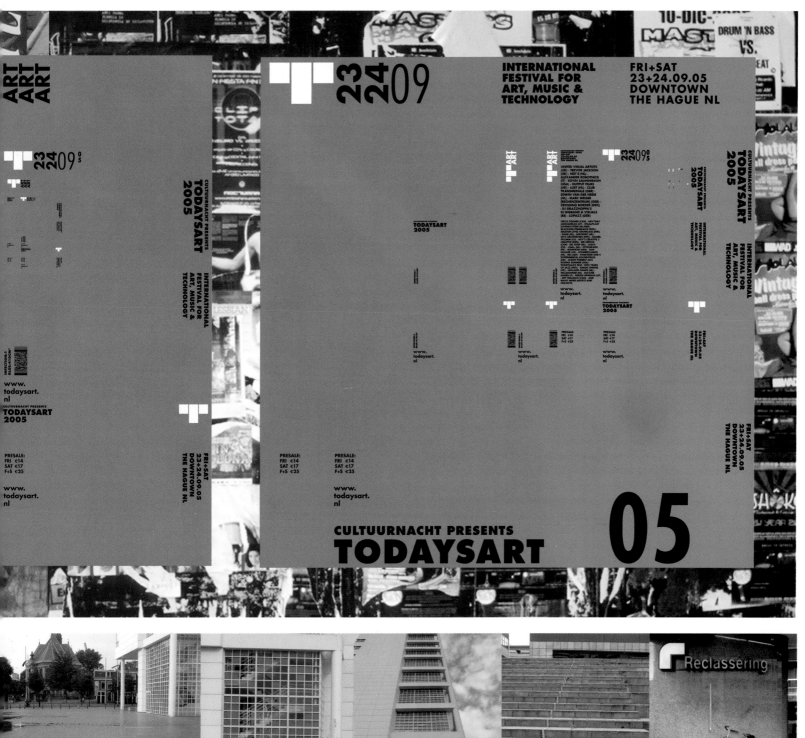

Hoek van Holland // HotelOscarEchoKiloVictorAlphaNovemberHotelOscarLimaLimaAlphaNovemberDelta // 2001 //

In 2001, Rotterdam's year as Cultural Capital, a map of Hoek van Holland was pub-lished to reveal the many facets of this beach and water recreation area of Rotter-dam. In order to cover the broad scale of information the map became 2 meters long. To keep it manageable, the creators of the map—The Hague's design agency Lust—invented a special folding system that allows for the map to be used as four individual maps of increasing detail: Hoek van Holland, the North Sea, Europe, and the World. Each folded variant shows information pertaining to that specific area, as well as showing the relation to the bigger area around it. On its backside, the map shows a full year's tidal and lunar information of Hoek van Holland. A full moon is given a solid blue, a new moon 10 percent blue, and all the steps in be-tween are colored accordingly. Seen as a whole, the ebb and flow of the tides be-come visible.

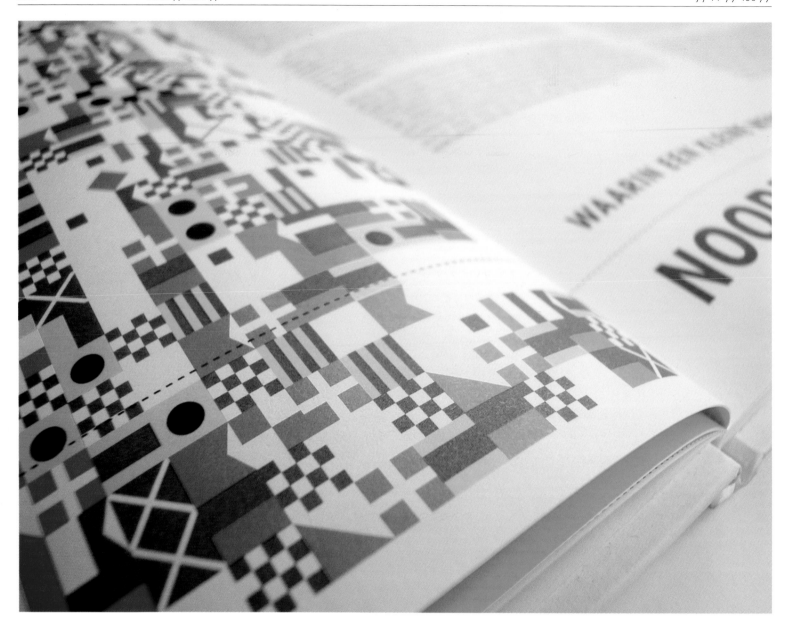

The North Sea; Cartography of One of the World's Great Seas // 2004 //

"The North Sea; Cartography of One of the World's Great Seas" is a project initiated by Lust, a design firm in The Hague, and developed in cooperation with Steven van Schuppen and Jan de Graaf. It consists of an atlas and a multipurpose map. Apart from its obvious purpose of charting this relatively small and young "World Sea," the map describes it from a total of 21 different points of view ranging from a "sea-floor map" to a "dirt map" and a "scary map." The combination of these thematic maps, together with the grid maps, yields 421 unique perspectives and reveals many intriguing links. The companion atlas contains 21 separate essays highlighting multiple cross-links. The atlas is illustrated with visual essays: 70-plus maps, including old ones from archives, new ones made by others as well as new ones handmade for this project.

Lust // Thomas Castro, Jeroen Barendse, Dimitri Nieuwenhuizen // The Hague, Netherlands // www.lust.nl //

Lust is a three-person graphic design practice established by Thomas Castro, Jeroen Barendse and Dimitri Nieuwenhuizen in 1996. They work in a variety of media including printed materials, interactive installations and architectural graphics. Lust considers design a process. To them, each design stems from a concept that results from extensive research. They have developed a process-oriented design methodology based on generative systems. This entails an analytical process which eventually leads to something that designs itself. They like new technologies and have a skill of boiling down huge amounts of data into comprehensible bits of design.

Haunch of Venison //

The gallery Haunch of Venison, based in London and Zurich, assigned the graphic design firm Spin with the development of a corporate identity, which was to be either business-serious or creative, depending upon the context. The elements identity developed by Spin–logo, lines and address typography–can be combined in various ways, thereby adapting themselves to each new context.

Spin // Tony Brook // London, United Kingdom // www.spin.co.uk //

I was a punk in my distant youth, so I really enjoyed the French agency Grapus. They had an anarchic and provocative approach which appealed to me at the time (still does). Although Spin's work now is more restrained in many ways I'd like to think that it still has some spirit in it. I also enjoyed the Peter Saville's Joy Division record sleeves, very iconic and beautiful.
I like work that is confident, fresh and direct.
Do I have a motto? No, but I'll give it a go: Listen to the brief, challenge the brief, make something good.

My nightmare? Being back at college
My advice to students of graphic design is: read about your subject, know about your subject and love it. College is only the start and the smallest part of your potential career, but it is the key to getting in, so try not to mess it up. If you do mess it up it, isn't the end though. I know.
Upon your request, here are five things I am crazy about:
Wim Crouwel / Ben Bos / Karl Gerstner / Josef Müller-Brockmann / Clams.

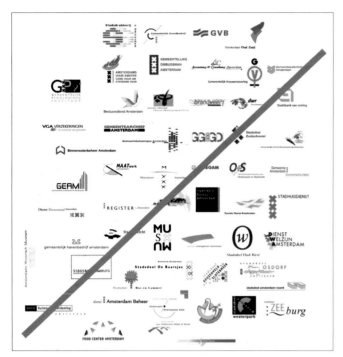

City of Amsterdam:
20.000 civil servants
3 bilion euro annual budget
55 servives and boroughts
~~55 logos~~

 Gemeente Amsterdam

One logo

Gemeente Amsterdam
Dienst Waterleiding

Gemeente Amsterdam
ProjectManagement Bureau

One name pattern

One differentiating system

 Gemeente Amsterdam
Dienst Waterleiding

 Gemeente Amsterdam
ProjectManagement Bureau

One corporate identity

Gemeente Amsterdam // 2002 //

In the year 2002 every official agency of the city of Amsterdam had its own visual identity: 55 different appearances, including logo, color and writing in each case. Then the Amsterdam-based design firm Thonik also received the commission to standardize the visual communication of the city and designed a coherent system for all components. The city's new logo superordinates in red (Pantone 032), 17 additional colors were further defined, and all typographies were set in the typefaces Avenir and Documenta.

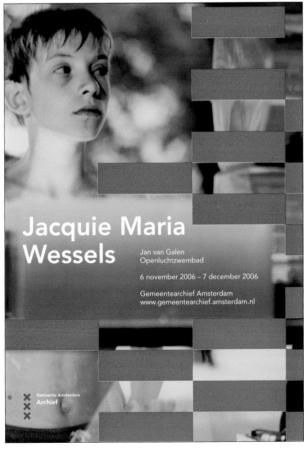

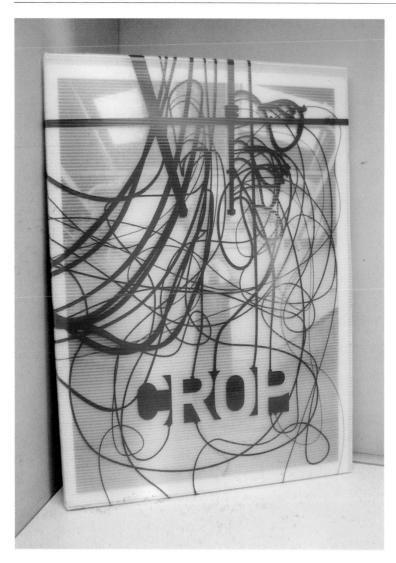

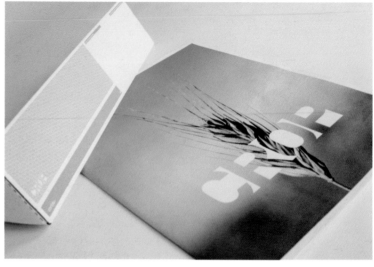

CROP //

Corbis is a leading global image provider, which provides customers in all areas of visual design with image and film material. Under the guidance of the graphic designer Carlos Segura of Segura Inc. Visual Communications in Chicago, the corporate identity was completely renewed. The series of the large-format, CROP catalogues, which were created in this context, uses an exceptional amount of paper types and print methods. Each issue of the seven-part series is housed in an individual package many are enclosed as additional inserts in other formats and materials.

Segura Inc. // Carlos Segura // Chicago, Illinois, United States // www.segura-inc.com //

Although comparatively small, Segura Inc. from Chicago is one of the most prominent design companies in the USA. It bears the name of its founder, Carlos Segura, who came to the USA from Cuba at the age of nine, first beginning his career as production artist and then—after moving to Chicago in 1980—making his name in numerous well-known design firms such as, BBDO, Marsteller, Foote Cone & Belding, Young & Rubicam, Ketchum and DDB Needham. In 1991, he went out on his own with Segura Inc. to obtain more creative freedom and also to be able to integrate artistic requirements into his work. The innumerable international honors as well as the exhibition of his work in museums from Denver to Tokyo prove that he has succeeded in achieving his objectives. In 1994, he consolidated his typographic efforts in another company, the T-26 Digital Type Foundry, which distributes its own typefaces worldwide.

AS
FOUR
DENIM

06

SPRING/
SUMMER

AS
FOUR
DENIM

06

SPRING/
SUMMER

COUTURE DENIM
WWW.ASFOUR.NET

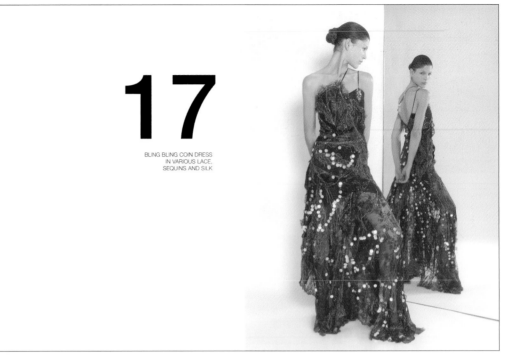

17

BLING BLING COIN DRESS
IN VARIOUS LACE,
SEQUINS AND SILK

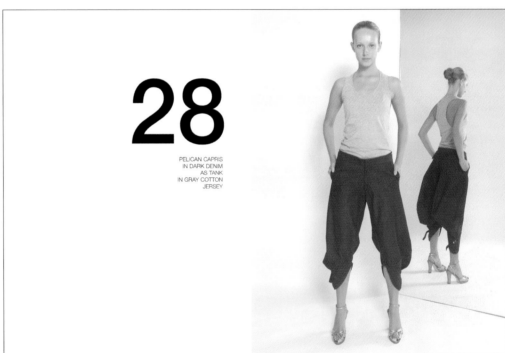

28

PELICAN CAPRIS
IN DARK DENIM
AS TANK
IN GRAY COTTON
JERSEY

KITE SWEATSHIRT
BRUSHED BACK TERRY 70% COTTON 30% POLYESTER
AVAILABLE IN CHOCOLATE, BLACK
SIZE ZERO ONE TWO THREE FOUR

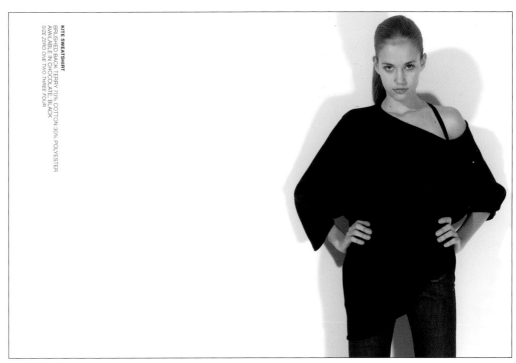

PARADISE BIRD COCKTAIL TUNIC
IN CARAMEL SILK
ALSO AVAILABLE IN ESPRESSO WITH
FUSCHIA TRIM
SIZE ONE FOUR

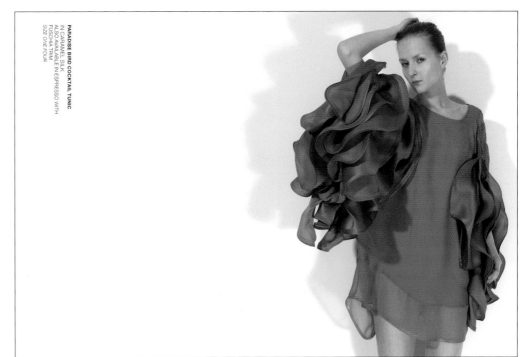

THREEᴀsFOUR //

The international fashion label THREEᴀsFOUR ships exclusive fashion from New York City to the entire world. The label's complete corporate identity is designed by the graphic design firm Stiletto. In addition to the usual components of a "corporate identity," such as logo, business cards, invitations and posters, special requests such as packaging for perfume or labels for articles of clothing are included. The designers of THREEᴀsFOUR have the task of capturing the playfulness and elegance of the label without bringing their own design in competition with the fashion itself.

A SWEATER BY **ANTOINE PETERS**

1½. OR GO TO **(MORE FUN!)** ANTOINE PETERS.COM, DOWNLOAD THE PATTERN AND CREATE YOUR OWN **S.F.T.W!**

1. CHECK THE TOUR-DATES OF THE **S.F.T.W.** >>>

2. JUMP IN THE SWEATER, 2 ♡♡ @A-TIME

3. SMILE SMI LE SM**:)**LE S M**:)**LE SM**:)**L E SMILE S M**:)**LE SM**:)**L E SMILE S MILE SM**:)**L E SM**:)**LE S

5. TAKE *OFF!* THE SWEATER

PHOTOGRAPHY *jochemsanders.com*
SHOES *daphne bikker for antoinepeters*
MAKE-UP & HAIR *jaqueline \ house of orange*
MODELS *sharan & mirte \ de bockers*
GRAPHIC DESIGN *karenvandekraats.com*
copyright © antoinepeters 2006

4. MAKE A PICTURE **(CLICK)**

6. CHECK ANTOINE PETERS.COM AND JOIN THE UNION! *A SWEATER FOR THE WORLD!*

Antoine Peters // 2006 //

In the design of a corporate identity for the fashion designer Antoine Peters, the Dutch designer Karen van de Kraats drew primary inspiration from the colorful, lively mood of the designer and his products and translated this into the integrated corporate logo smile. Moreover, in her design concept she was guided by the idiosyncratic shapes and lines of the articles of clothing.

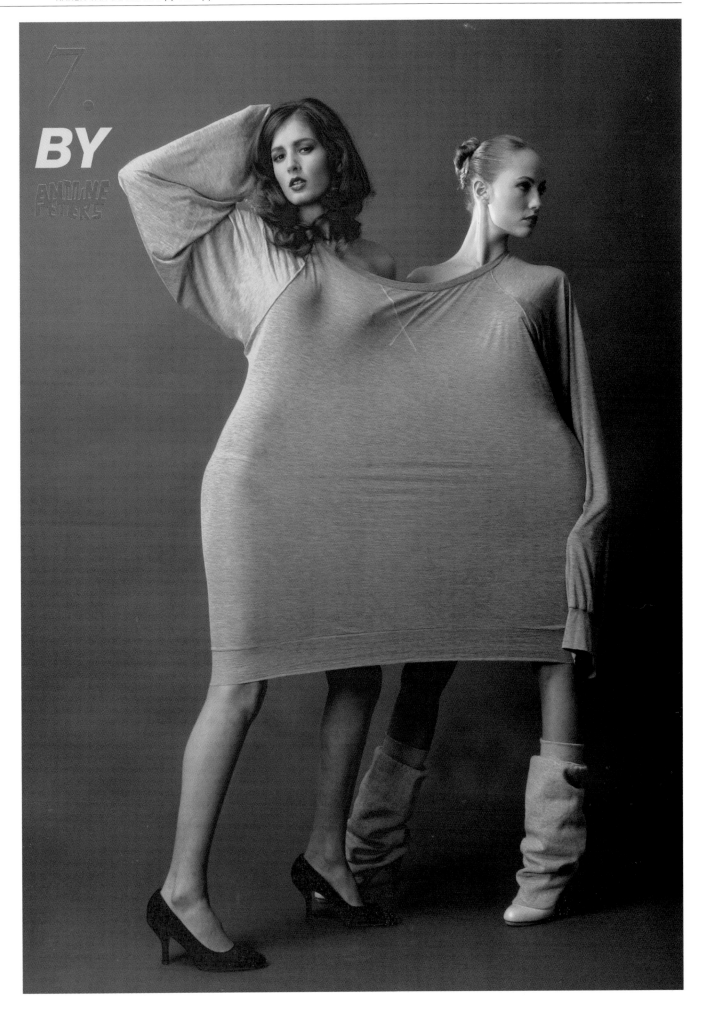

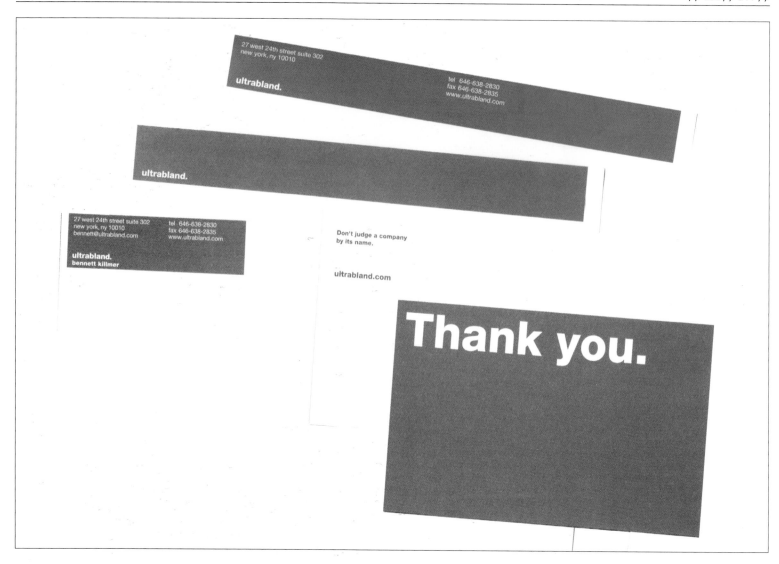

ultrabland //

The New York-based design firm Stiletto used the brand name of the post production firm Ultrabland in their considerations regarding a corporate identity directly as a design direction, and followed the principle of utmost simplicity in the design of the logo, letterhead, business cards, CD covers, information brochures and websites.

Stiletto NYC // Stefanie Barth, Julie Hirschfeld // New York, United States // www.stilettonyc.com //

We are a design studio based in New York and Milan and have specialized in motion, live-action and print projects. We want Stiletto to be an inspiring place. We call it a UN office—very multinational.

As far as design is concerned, we detest pointless design, design for design's sake. In the office, we refer to it as jerk-off design. Instead, we appreciate new ways to do things, well-crafted fonts, unusual colors and quality printing, new ways of handling materials, etc. We are usually happy with ideas that feel original. The panda-tone piece you selected for *The Layout Look Book* is actually a good example: a fun translation that is nicely crafted.

Early influences? For Stefanie: family & friends, 1970s German kids tv shows, arts & crafts, travel, nature. For Julie: Star Wars (the original), *The Gnome Book*, Blondie and Pat Benatar, Richard Diebenkorn and the California school.

Advice for students of graphic design? Listen to yourself. Try to find an expression that is unique to you. Don't rush to match current design styles. Work on finding smart conceptual solutions. Take your time to really craft things.

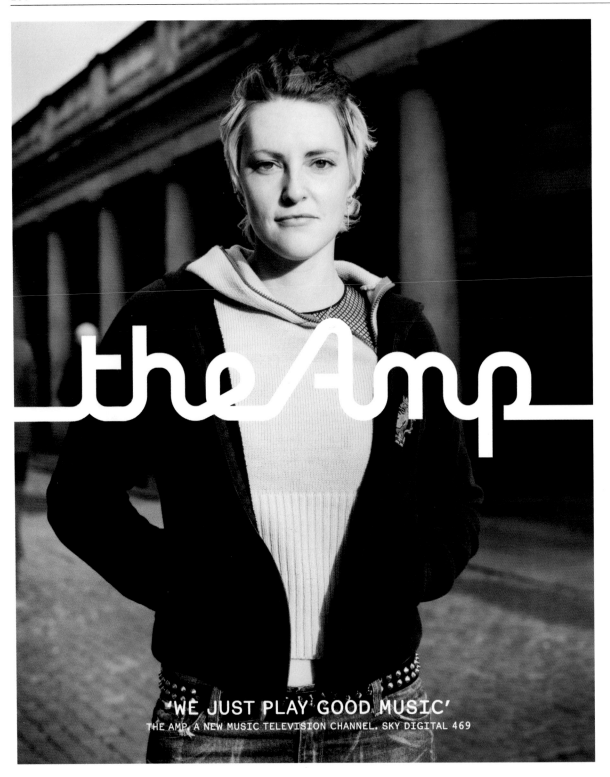

The Amp //

The digital music TV channel The Amp wants to address fastidious fans of "authentic, unmanufactured music." Accordingly, the poster series developed by the London-based graphic design firm Blue Source differentiates itself at the start of the new channel, not only by striking visual sleekness from the usual competitors but also by not showing the popstars and focusing instead on the music lovers. Blue Source thereby produces an immediate impression of friendly individuality and transports the image of the broadcast station. The logotype was also developed by Blue Source.

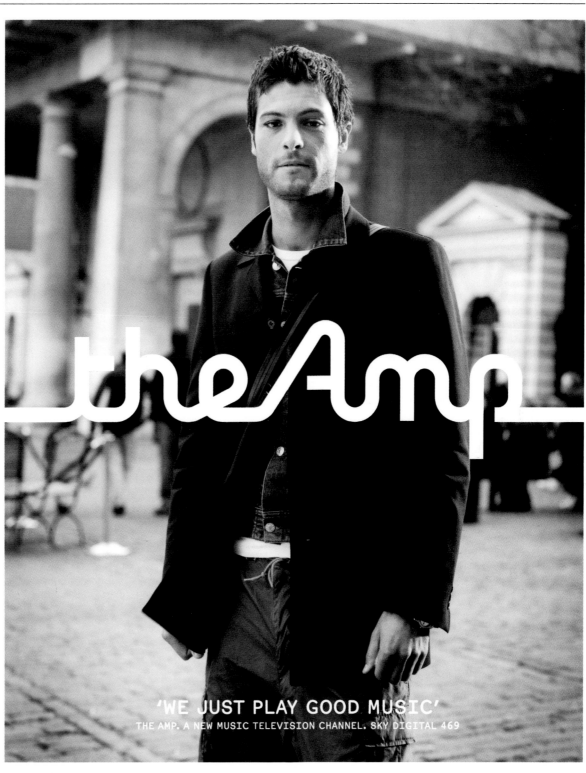

'WE JUST PLAY GOOD MUSIC'
THE AMP. A NEW MUSIC TELEVISION CHANNEL. SKY DIGITAL 469

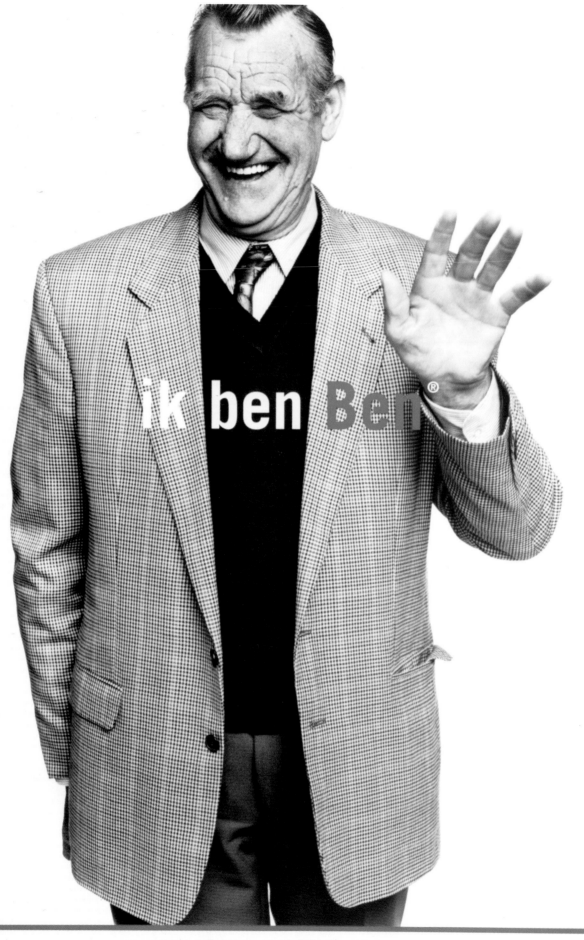

een nieuw mobiel netwerk

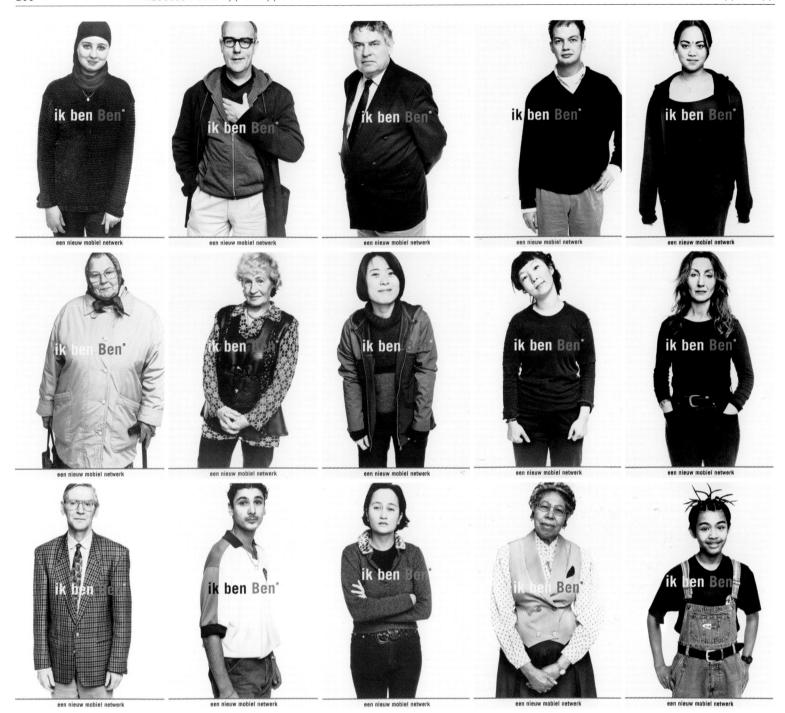

Ben Phone //

In the case of the Dutch mobile telephone brand Ben the Amsterdam-based design firm KesselsKramer invented not only the advertising campaigns but also the names of the product. "Ben" is Dutch and means, "I am." Ben is also a man's name. Building upon this simple combination, KesselKramer developed advertising ideas, which place the focus on the telephone users. Many of the announcements and posters do not show any telephones but show human beings instead.

KesselsKramer did not cast models for photos and TV commercials but chose amateurs instead. An example of this principle is the *Ben Phone Book*, an alternative telephone listing, in which the participants can be presented with large portrait photos and personal quotations instead of only a name and number. The advertising strategy was so successful that the telephone company could not manufacture enough telephones in the beginning to keep up with the demand.

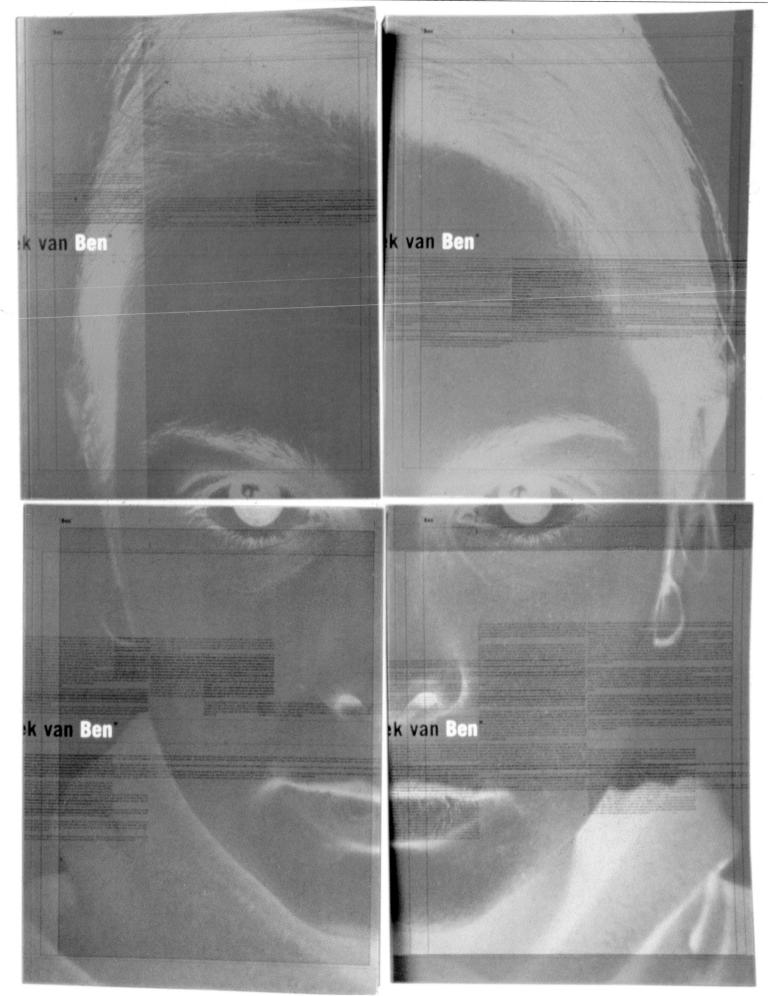

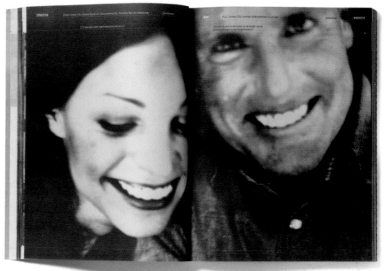

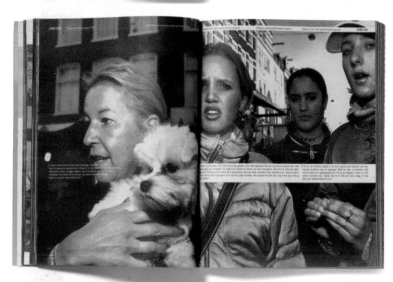

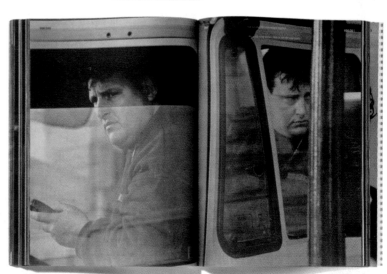

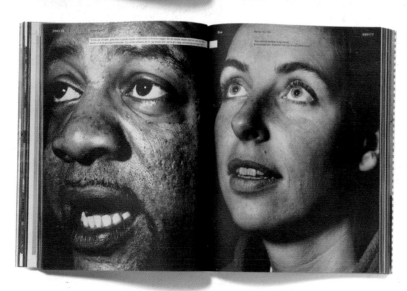

Photo Credits
Many thanks to the producers of print design featured in this book, especially for
granting us the right to reproduce their images. Should any third-party copyrights
have been overlooked despite of our thorough research, we ask the owner of these
rights to contact the publisher.

2×4 202, 204, 205, 206, 207, 214, 215
2points 68, 69, 70, 71, 180
33RPM 109, 110, 111, 178
Philippe Apeloig 132, 133, 134, 140
Bang Bang Design 124, 125
Base 14, 15, 16, 17, 217
BBWS 44, 45
Blue Source 100, 101, 158, 159, 168, 169, 200, 201, 250, 251
Sara De Bondt 75, 86, 87, 105
Brighten the Corners 52, 53, 62, 63, 136, 137, 142
Buro Destruct 163, 184
Catalog Tree 148, 149, 150, 151, 162
Design by Build 152, 153, 190, 191, 192, 193
Duel 102, 103, 120, 179
Patrick Duffy 32, 33, 34, 35, 143, 170, 171
Daniel Eatock 156, 157
Laurent Fetis 26, 27, 98
Albert Folch 64, 65, 66, 67
Fused Magazine 36, 37, 38, 39
Gas as Interface, Ltd. 56, 57, 58, 59, 60, 61
Giampietro + Smith 78, 79, 117
Tom Hingston Studio 74, 84, 85, 181, 183, 188, 189
Ipsum Planet 28, 29, 30, 31
Kalrssonwilker Inc. 104, 176, 177
Kesselskramer 222, 223, 224, 225, 226, 227, 252, 253, 254, 255
Karen van de Kraats 76, 121, 135, 246, 247
Rosa Lladó i Surós 72, 73
Uwe Loesch 92, 93, 94, 95, 96, 97
LUST 77, 138, 139, 232, 233, 234, 235, 236, 237
Made **Magazine** 80, 81
MetaDesign 208, 209
Milkxhake 10, 11, 12, 13, 46, 47, 48, 49, 50
NLXL 99, 106, 107, 122, 230, 231
Non-Format 172, 173, 174, 175, 194, 195, 196, 197
No Office 220, 221
Pleaseletmedesign 185, 186
Plus 81 23, 24, 25
Power-Graphixxs 88, 89
Project Projects 116, 228, 229
Qian Qian 82, 83
Rinzen 40, 41, 42, 43, 108, 166, 167, 218, 219
Rumbero Design 126, 127
Sagmeister Inc. 18, 19, 20, 21, 187
Segura Inc. 242, 243
Shinnoske Inc. 141, 144, 145, 146, 147, 154, 155
Sonido Gris 112, 113, 114, 115
Spin 51, 203, 238, 239
Stiletto NYC 182, 244, 245, 248, 249
Surface 118, 119, 160, 161
Thonik 123, 128, 129, 130, 131, 210, 211, 212, 213, 240, 241